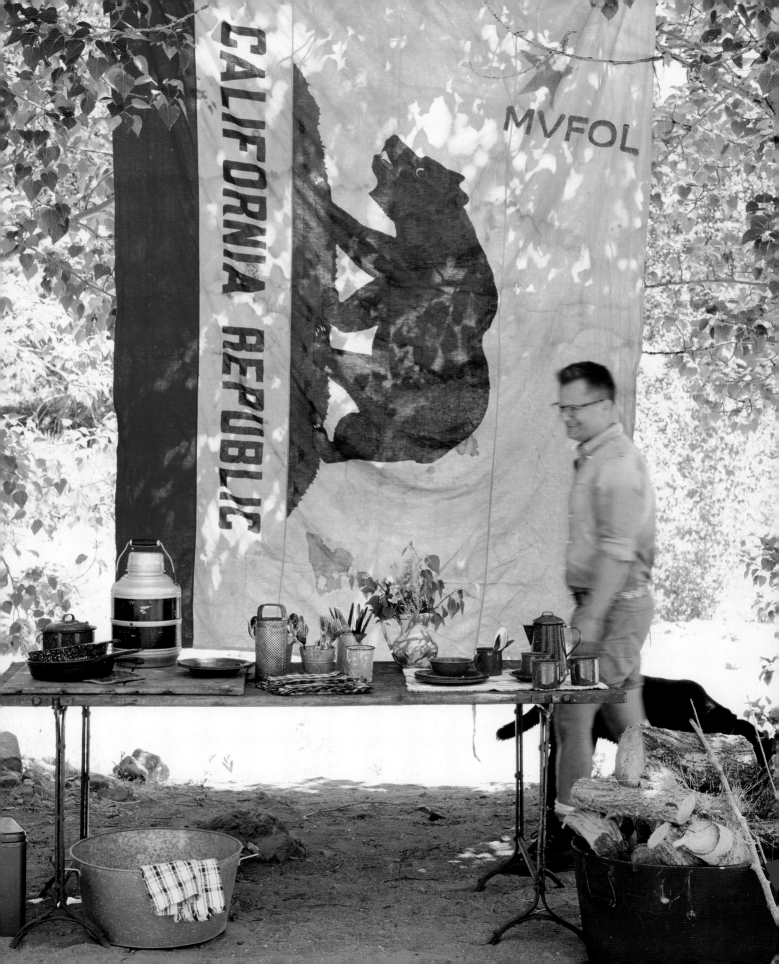

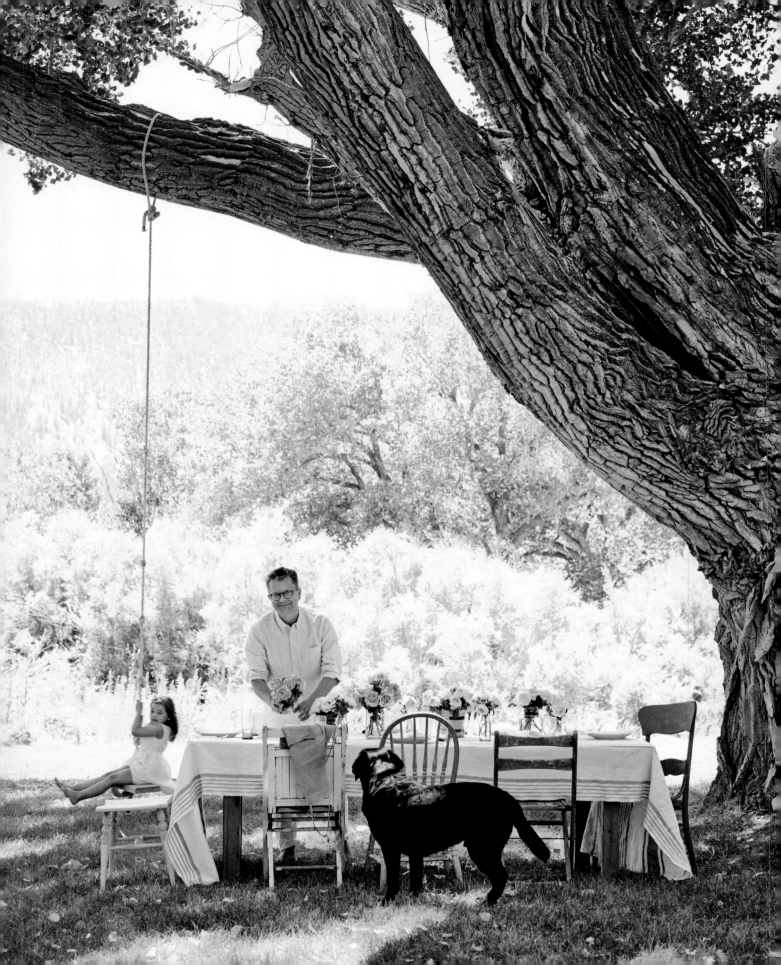

NATHAN TURNER'S

I LOVE CALIFORNIA

LIVE, EAT, AND ENTERTAIN
THE WEST COAST WAY

WITH KERSTIN CZARRA

PHOTOGRAPHY BY VICTORIA PEARSON

abrams, new york

Moreno Valley Public Library

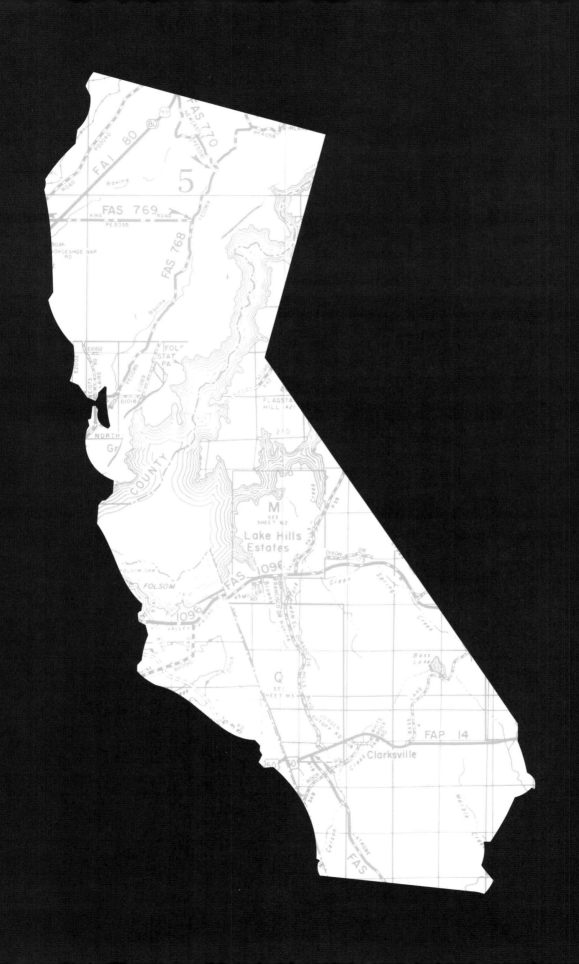

INTRODUCTION

I'M JUST ANOTHER LA MULTIHYPHENATE. NO . . . not an actor-model-waiter. But a decorator-shopkeeper-author-entertainer. To me, style goes beyond design and decoration. It is all-encompassing in one's life—and a pretty home is only the beginning. That includes a welcoming, beautiful table and lots of delicious food to share with friends and family.

And I am not talking about anything fancy or extravagant. It's simply about figuring out what "style" means to you.

For me, it's a relaxed, barefoot sensibility. Which is only natural given I was born, bred, and still live in California. The California lifestyle has inspired what is in my home, what is on my table, and what comes out of my kitchen.

We live a bit differently on the West Coast, and this relaxed chic is not only super approachable but translatable anywhere. You can re-create these looks wherever you live. The decor, tables, and menus in this book are inspired by the state, but really it's a state of mind . . .

Looking back on my life in California, it's easy to see how design and entertaining became so central to my work and my life. My fondest memories revolve around the kitchen and dining table. When I opened my eponymous Los Angeles antiques shop in 2002, the first thing I did was install a kitchen. It was tiny and had no high-tech equipment, but it worked!

For fourteen years, I shared my love of design, food, and entertaining with clients, friends, and, well, anyone who walked in.

My first job was accompanying a family friend on antiques buying trips to Europe. Traveling around France and Italy, I was so inspired by the dealers I met. There was such a genuine warmth and welcomeness about them.

Like the eighty-year-old French lady who dealt antiques from her barn. She had unique pieces and a quirky personal style, and she insisted that we sit down and share lunch (or at least some wine, bread, and cheese) before we got down to business.

The American in me was dying to see what was in the ancient barn, but she said, "No, no, no. Sit; the cheese is very good today." I spread the soft, buttery Camembert on a crusty baguette, we chatted, and I came away with something more than a settee; it was a memorable experience with others over a simple, delicious meal.

This happened time and time again from Aix-en-Provence, France, to Parma, Italy. There was always a beautiful plate of food, a lovely glass of wine, and meaningful conversation. It's why I fell in love with the antiques business. And I wanted to re-create it at my design shop. While I didn't have the eighteenth-century farmhouse, the charm of an older French lady, or the Camembert, I had my own thing. I'm a native Californian with a love for the laid-back way we do things.

Where the French have cheese, we have the country's freshest fruits and vegetables, seafood from Santa Barbara, and local farms galore. I can do this too, I thought. I can be the old French lady of Los Angeles.

So I started small, hosting dinners with friends. (I knew they wouldn't judge if it was a little awkward eating in a shop.) My first dinner was me, my dear friend Mary McDonald, and four other decorators. I set an eighteenth-century Spanish rectory table with china I brought from home and strewed the table with garden roses from Rose Story Farm, a sublime farm in Carpinteria. It was fall, so I made pesto-crusted lamb chops with scalloped potatoes. We had a blast, eating and drinking, and finished the night on the sidewalk in front of my shop, enjoying cheese drizzled with local honey. That night I went to sleep feeling blissful. I had done it. I was the old French lady . . . just thirty years old and barefoot in Los Angeles.

Shortly after, the *LA Times* Home section did a cover story on how I was cooking and hosting dinners in my shop. The phone started to ring and callers would say, "I'd like a table for four next Thursday." I'd tell them that I was not a restaurant, just someone who loved to cook for friends and clients. Some pressed, asking, "How do I become a friend or client?" to which I always replied, "Just come on in . . ." So they did, and it became an extension of my home.

Things grew from there. But no matter who or what was being served, business was never discussed at the table. For me, it was always about showing appreciation and getting to know people. If someone was interested in a piece, they could call the shop the next day. I never wanted it to be a sales technique. I did it because I loved it. Dinners turned into big parties. Parties turned into elaborate themed affairs (I've never met a theme I didn't like).

In my first book, *Nathan Turner's American Style,* I talked about how my shop was my design lab. I experimented with different textures, colors, and patterns to find my style.

It's the same with entertaining. I love to play with various elements, including food, to create a layered table and fun meal for all (including me). The environment is just as important as the food. It's always been bigger than what is on the table.

From cooking by myself out of that closet of a kitchen, I ended up hosting events for clients and friends all over town. But my fondest memories are still those cozy dinners in the beginning. Or any afternoon, when I'd be cooking white bean soup barefoot in the shop's kitchen, my dogs on the sofa, the fire going.

Although cooking and entertaining did come naturally to me, it's not like I woke up one day and made pesto-crusted lamb chops. I started cooking at a very young age (so young that I wonder whether I should have had access to a gas range . . . nice, Mom). So many things (and people) influenced my love of food and style: my mother, my grandmother, and my surroundings. And California, especially Northern California, has played a huge role in the way all of America eats. Growing up on and around the region's farms gave me a quick and lasting education on where our food comes from.

California is also very much a house culture, even in the big cities like Los Angeles and San Francisco. I grew up in a home where there was always lots of entertaining, and I would often visit other homes. I absorbed the rooms, the table settings . . . everything that goes into creating a gracious, warm environment.

And I wanted to share it all with you in this book.

WESTERN ROOTS

IT MAY HAVE BEEN PREDESTINED THAT I WOULD CREATE a life around design and food.

I grew up in and around a lot of agricultural families. And design runs in my family. (My great-great-uncle was an architect on the Golden Gate Bridge, and my aunt was an antiques dealer in Berkeley.)

When I was little, I spent the most time on my mom's family cattle ranch near Stockton. Although it was a working ranch with cows and fields of alfalfa, for me it was always a place for adventure. There were long days helping bale hay, feeding cows, or just playing with my brothers in the barns. And there was always my family gathering with food. From Sunday dinners of roast beef and Yorkshire pudding to picnic lunches of ham sandwiches and pea salad.

Like most American families, we have a mix of cultural influences that shaped our table and how we eat. And they are reflected throughout this book, not only in the recipes, but also in the casual way I like to set a table, like a platter piled high with jalapeño corn bread alongside a steaming pot of chili con carne (both on page 104). These dishes were often waiting for us when we arrived at the ranch.

That time in my life also had an impact on my design sensibilities. The ranch was super traditional, with a white Victorian house and a simple farmhouse on the property. It was Americana, but in a distinctly California sense. The woven rugs, faded striped fabric, and simple farmhouse furniture is much like my work today, classic but always cozy and comfortable. It was also my first introduction to indoor-outdoor living, with the back door constantly flung open and tables and chairs set under the big oak trees.

On the other side of my mother's family tree, my Italian great-grandmother Marion (who I cheekily called Mare) had a huge impact on me in the kitchen. She was loving with just the right amount of sass (which I inherited). I'd spend hours in the kitchen helping her roll out sheets of homemade ravioli. She taught me that cooking is a way to show the people around you that you care. It came through in her food. The simplest dishes tasted better when cooked by her. Several of her recipes are in this book, including her cioppino (page 39) and her Sicilian meatballs (page 76). That's what I love about cooking. It's more than a meal. When I make any of her dishes, the smells that fill my home transport me right back to her kitchen and connect us forever.

From my family's ranch to those first dinners at my shop to the meals I cook now for friends and family, it's all influenced the way I entertain and live . . . which I call California Casual. To me, it means a laid-back room, a friendly host, and a beautiful table with simple recipes and fresh ingredients. Being a decorator, I love to create stylish, effortless design that enhances, not distracts from, the meal. It's a table you'd love to sit at.

Cooking, decorating, and entertaining come together to create a lifestyle. And I love the California approach to it all, which I'll share here.

The barefoot part is up to you. ★

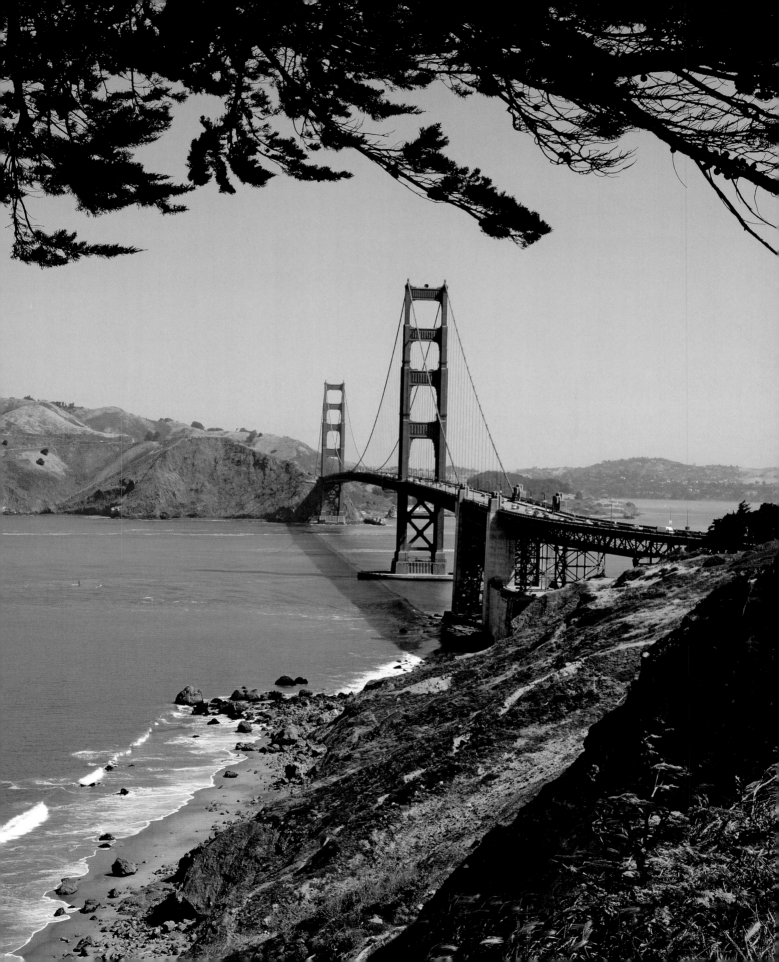

NORTHERN ★ CALIFORNIA

Though I've spent the last fifteen years in Los Angeles,
I grew up in Northern California, and it still amazes me
how different they are from each other. They
could be different states entirely. While all of California
shares a laid-back attitude, the landscape, architecture,
and culture in the north is entirely its own.

GROWING UP HERE, YOU ARE TOTALLY INFLUENCED BY the weather. Maybe it's because I now live in perpetual warm sunshine, but I always relate Northern California to fog, rain, and cold. (Yes, it actually gets cold here.) The kind of cold where you run from the shower and get dressed under the covers, which I often did when I was eight.

Where we lived in Martinez, the fog rolled in each night from the San Francisco Bay. It was oddly comforting, really. As if it was telling us it's time to go to bed. So things in our home were really cozy. Though I hadn't heard the Danish term *hygge*—a sense of feeling cozy, charming, or special—we were living it every day.

The other constant growing up in Northern California was being outdoors. We had a sailboat that we kept in Berkeley Marina and we'd be out on it most weekends (even if it was freezing). Seeing my surroundings by boat helped me discover all of the fantastic places in Northern California, like Tomales Bay, where we'd go clamming and eat fresh oysters. When we were on dry land, we would take Sunday hikes in Point Reyes National Seashore.

It's funny—whenever I tell people I'm from California, I can practically see them imagining a scene from *Baywatch*. In reality, I was often bundled up in a jacket, shivering on a beach, mountain, or boat. A different experience from barefoot life in LA, but just as wonderful and inspiring.

The diversity in Northern California is amazing. You have San Francisco, one of the prettiest cities in the country (in my opinion), with its incredible ethnic neighborhoods, crooked streets, and painted row homes. A few hours away, you're in Sonoma, which feels like Tuscany or Southern France. Farther south, there are the rugged coastline and mountain views of Monterey and Big Sur.

This variety is seen in the architecture and design here too. It was during the Victorian era that California had its big boom. That's why San Francisco and the surrounding areas are filled with Victorian homes, highly embellished with bay windows, decorative trim, and turrets. I do love the scale of these homes . . . the high ceilings and large parlor rooms. But I usually want to strip away some of the ornate detail and make things cleaner.

In places like Calistoga in Napa Valley, many of the whitewashed houses and barns have a Scandinavian feel. And you'll always find the earthy, sixties architecture around the northern beach and hillside towns . . . structures created from redwood, driftwood, glass, and stone.

This atmosphere and lifestyle completely shaped the way I live, the way I design, and the way I cook and entertain. I believe a deep knowledge of your surroundings and what you can pull from those places helps create an authentic interior and a memorable event.

ECLECTIC, ADVENTUROUS STYLE

AS I'VE SAID, NORTHERN CALIFORNIA HAS A DESIGN mix like nowhere else—from a post-and-beam hillside cottage in Big Sur to an old Victorian mansion in San Francisco to a charming farmhouse in Castroville with painted window boxes and a Dutch door.

There are totally traditional homes, woodsy hippie hideaways, and redwood-and-glass moderns. One constant among them all is a use of natural elements, like reclaimed timber and stone. The houses are warm and feel like they are part of the landscape.

A city like San Francisco has a heavy influence on design here, obviously. I think the East Coast or traditional side of my designs that people recognize actually comes from my time in San Francisco. Antiques are a big part of design culture in the Bay City. There are legendary dealers up there and it's one of my favorite places in the world to hunt for unique pieces.

There is another side that comes from the counterculture and hippie-boho lifestyle that's long been associated with San Francisco and Berkeley. That means what's traditional or preppy here is not like the typical East Coast look. It's the laid-back cousin—a looser, less fussy design.

Because people in Northern California have such a close relationship with the outdoors, there's always a sense of ease and a spirit of adventure in design here. The first part of my childhood was spent in a midcentury modern ranch overlooking the water. It was the eighties, and designer Michael Taylor—creator of the California Look—was super influential. It was very beige on beige, and the outdoor spaces always connected to the interiors. Our rooms opened up to the deck, patio, and front courtyard.

Looking back, I realize it had a huge impact on my designs. I always look to what's outside to inspire furniture, fabrics, and accessories. While living near San Francisco gave me an education in elegance, being outdoors ensured things never got stuffy or precious.

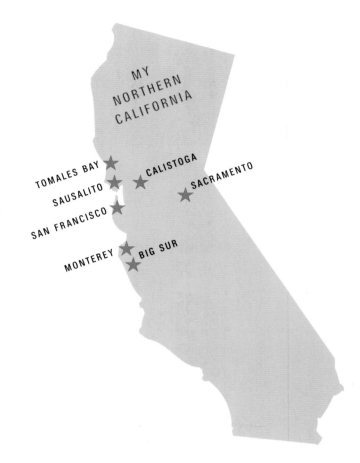

I like to keep spaces (and tables) loose, even if I'm using a Chippendale chair or English silver.

I embrace the Northern California mix to this day, whether I am decorating or styling a table. If I'm doing a classic interior, there will be something super casual thrown in. Same with entertaining. I like a well-laid-out setting, but I will leave the tablecloth ends frayed or use some beat-up bowls for flower arrangements. I mix weird things together because I grew up with permission to have a little bit of fun with everything. ★

Scenes from Northern California (clockwise from top left): San Francisco's iconic pisco punch; the mighty redwoods; Chinatown in San Francisco; Point Reyes Lighthouse; a cable car with Alcatraz Island in the background; the Japanese Tea Garden in Golden Gate Park.

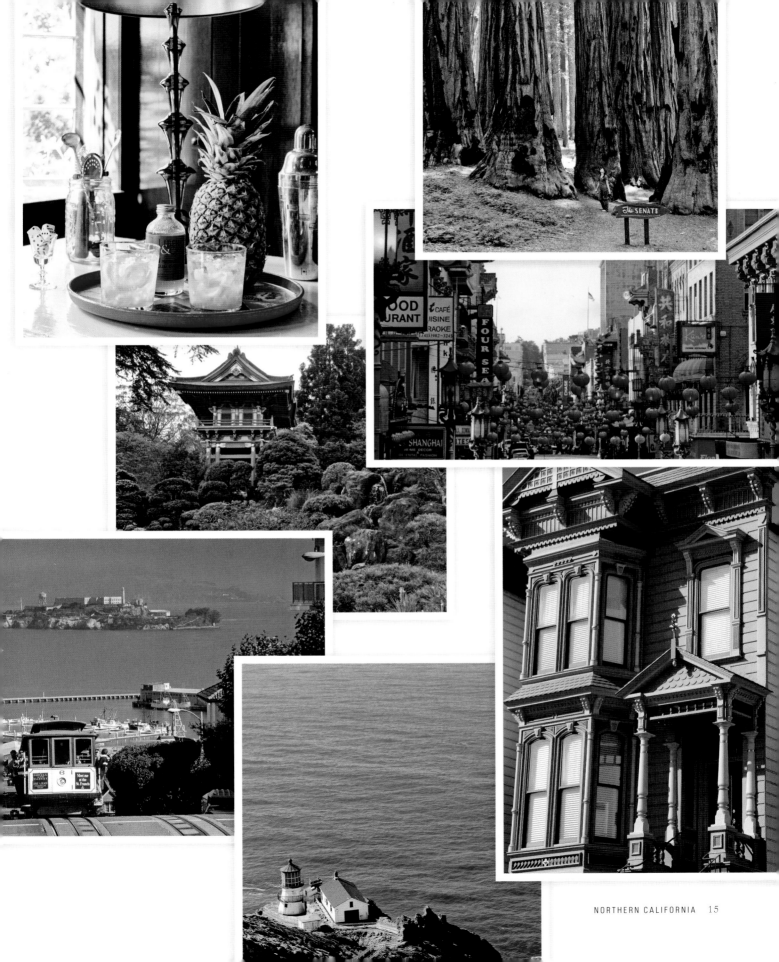

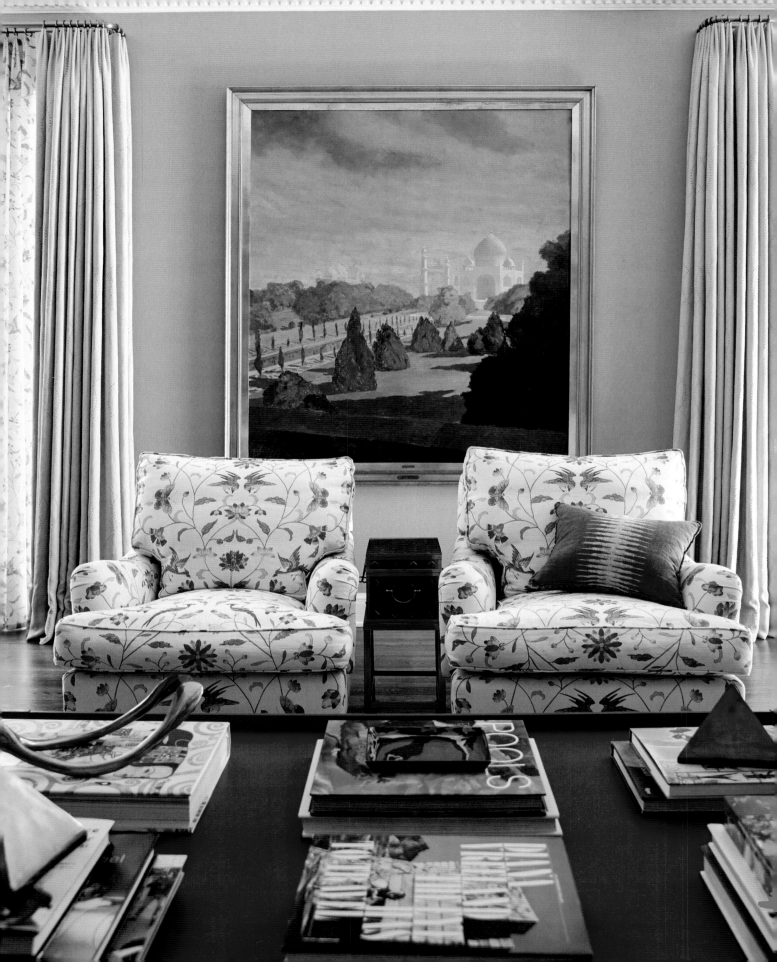

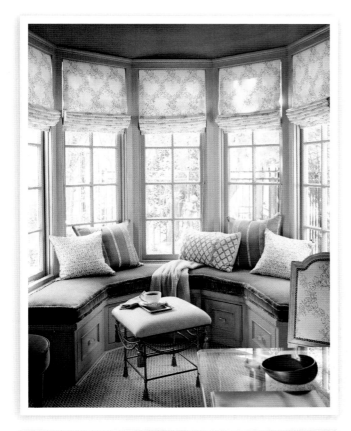

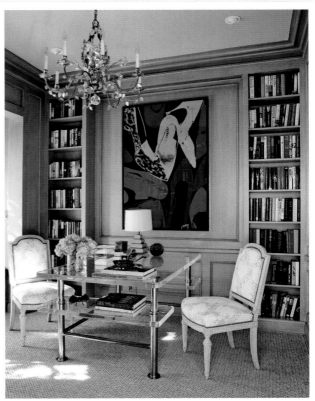

Opposite: A painting from Christie's gives this room a well-traveled feeling and acts almost like a window. This page (clockwise from top left): Built-in seating instantly makes a space feel cozy; sometimes, one good fabric is all you need; this bold paint color is tempered with a grey undercoat; details matter—a box fringe on this velvet chair cushion adds so much.

NORTHERN CALIFORNIA STYLE MADE SIMPLE

EMBRACE ORGANIC

Natural, relaxed silhouettes and materials add soul to a space or table setting. Pottery bowls, sheepskin throws, and sisal rugs are great choices for bringing a little organic allure to a room. My trick is to always temper it with something a bit more modern or structured so it doesn't start looking like an artsy commune. I love using a vintage indigo cloth paired with a sleek table or chair.

RESPECT TRADITION

I think of antique pieces like characters at a party: They always add personality and presence. You can't help but notice a great chinoiserie console or a pair of Louis chairs, even in a more contemporary house. And don't be afraid to mix periods either. A French farmhouse table looks fantastic with midcentury chairs in a classic space. For a modern home, choose antiques with clean lines like Directoire chairs or early English Jacobean chests.

BE BRAVE

Whenever I feel hemmed in or blocked with a space, I tend to make a bold, unexpected choice. Pushing the design envelope doesn't have to mean outrageous spaces. Just use more traditional pattern and motif. For example, a colorful, oversize floral feels fun but classic. To start, you can cover a sofa or chair. Feeling more daring? Try covering a wall. When mixing patterns like chintz with stripes or plaid, be sure they are in the same palette. It reads dramatic not deranged.

What makes this room work for me is the mix of antique furniture, modern art, found paintings, and vintage textiles.

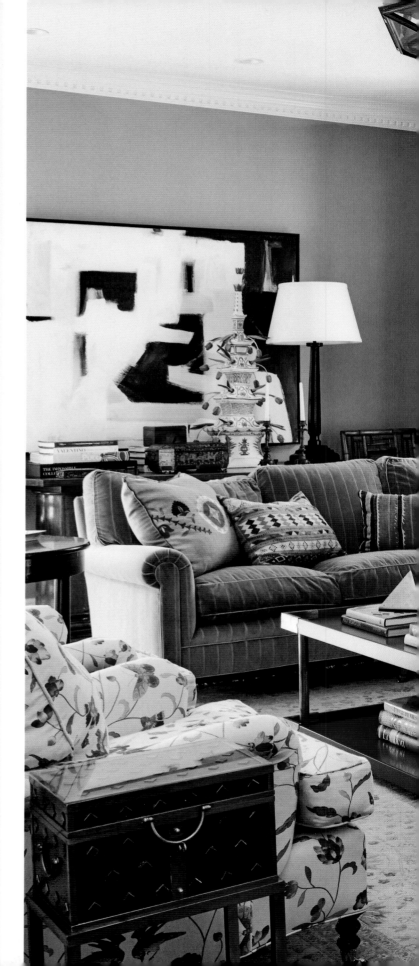

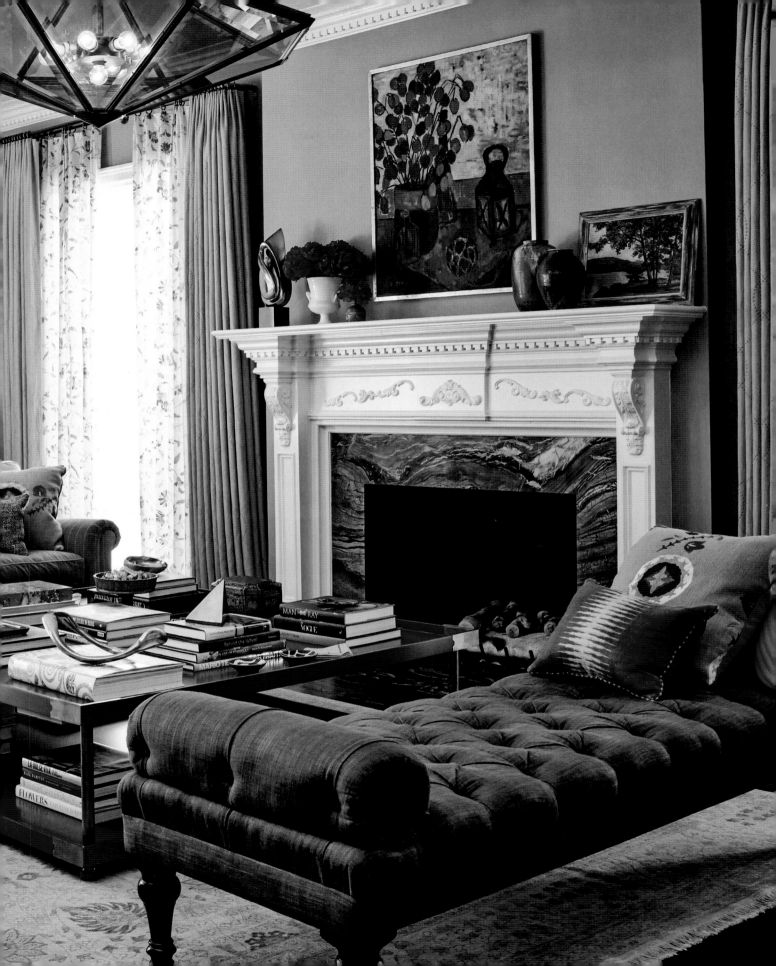

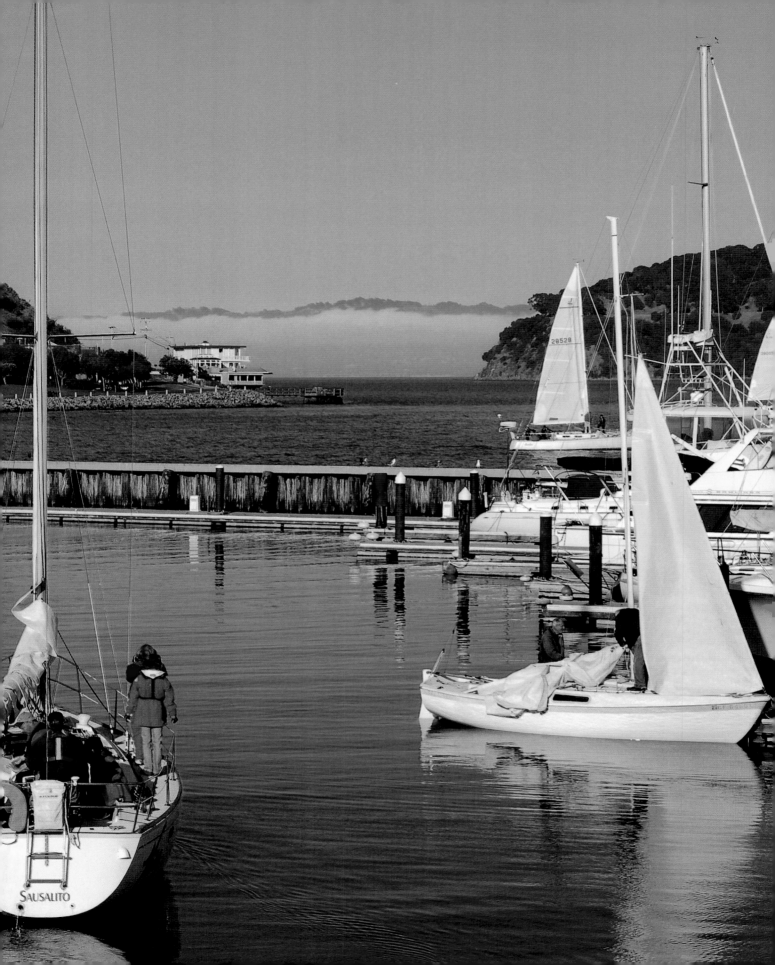

SAUSALITO

★

menu

DECONSTRUCTED SEAFOOD LOUIE

PISCO PUNCH

JAMIE'S MUD PIE

Located just across the Golden Gate Bridge,
this town makes you feel as if you can touch San Francisco
from its shores. The lucky residents of this
bedroom community commute to the city by ferry.

QUAINT AS CAN BE, IT'S CALIFORNIA'S VERSION OF A
Cape Cod village: charming cottages tucked into the hills,
picturesque houseboats on the water, perfectly weathered
piers. It instantly feels like a place where you want to
spend a lazy afternoon browsing the galleries and shops.

CHINOSIERIE CHIC SEAFOOD LUNCH

I love chinoiserie—a decorative style that is a European,
romantic take on Chinese and East Asian motifs that's
become a look all its own. The mix of gentility and Far
East flair looks good anyplace, anywhere. And I've never
met a blue-and-white pattern I didn't like.

I dub this look Fancy Lady. To me, it's the perfect
balance of exotic and elegant. It's also really easy to pull
off. Because you're working in a cohesive palette, you
can keep layering and it looks fantastic. To me, blue-
and-white is a neutral, so feel free to mix patterns and
shapes—it will never get too crazy. If you don't have
an authentic chinoiserie print, no worries—any blue-
and-white floral pattern works just as well. The goal
is to make it look pretty and a little fantastical.

For the table, I want it to feel special but not stodgy.
I use a chinoiserie-inspired piece of fabric as a tablecloth
and then add vintage blue-and-white ginger jars in the
center of the table. You can often find affordable versions
on eBay. Just like with an interior, mixing old and new
accents gives a space more oomph.

I fill the jars with deep purple tulips and anemones—
it feels bolder than light pink. The plates are blue-and-
white too, but more floral than Far East. Choosing white
napkins with a thick navy stripe adds a modern touch.
A lotus flower is unexpected and plays against the blue-
and-white nicely.

Bamboo flatware is fun and feels a tad more casual.
The delicate crystal glasses remind me of the ones in my
grandmother's china cabinet. But any clear glasses look
good. For seating, I love the look of Chippendale garden
chairs to play off the table. But I've also used whatever
I have on hand at the time.

The menu has to include a Seafood Louie. To me,
there's nothing more quintessentially San Francisco. It's
a salad made with shellfish, egg, tomato, and creamy
dressing. And it's the dish you see nice old ladies ordering

Opposite: On the table, I used Ralph Lauren's Nanking fabric as a tablecloth under
Japanese Garden dinnerware from Williams Sonoma.

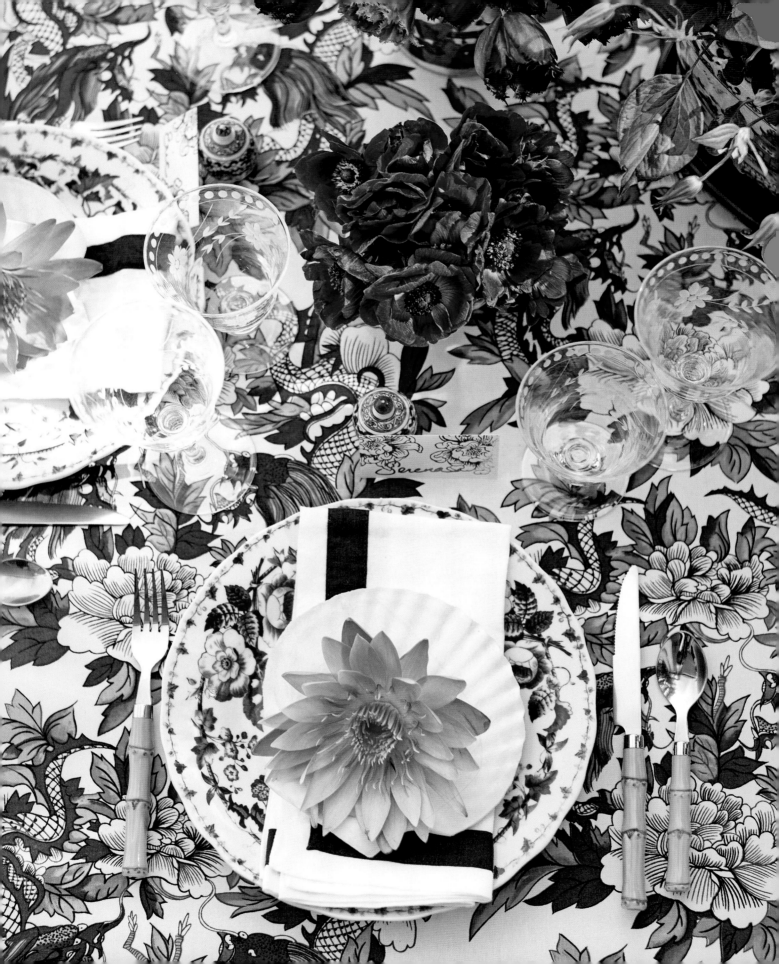

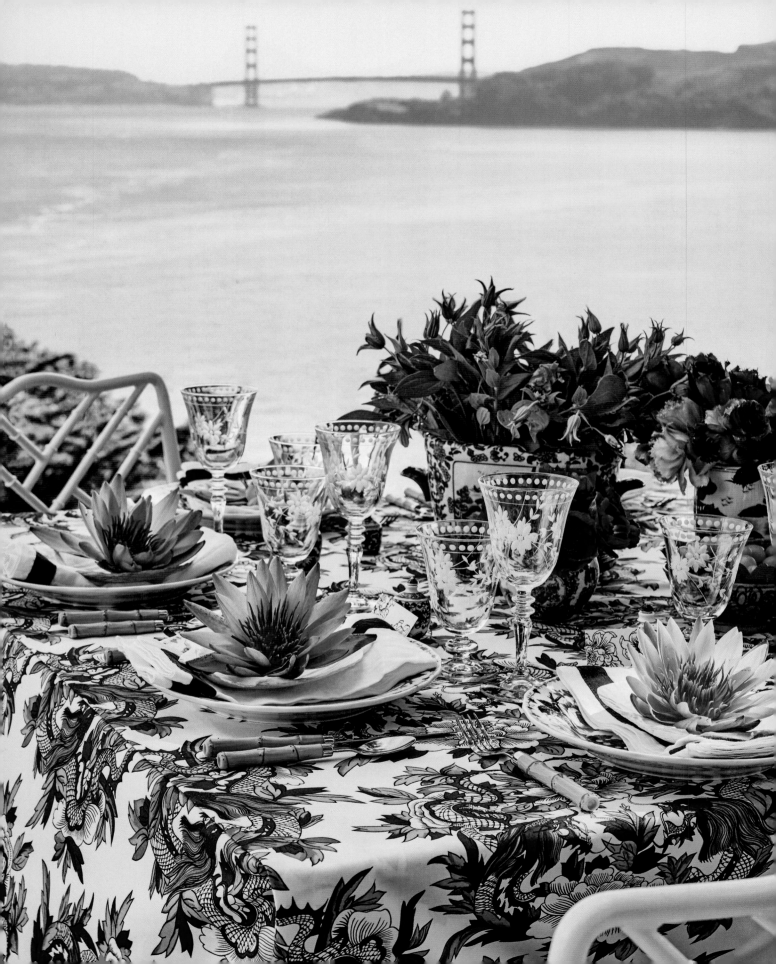

all the time around town. Since I am an old lady at heart, I love it too.

My version is a classic with a twist. I serve it deconstructed, so everyone can build his or her own. I've adjusted the size to feed two or twenty. And if a guest brings someone who doesn't like seafood (imagine!), they can make a meal out of the other fixings. The dressing is my grandmother's—a spiced-up Thousand Island.

To serve, I set up all of the Louie fixings on a sideboard or long table and let the guests create their perfect salad. It's one of those dishes that looks so impressive when it is laid out but in reality is super easy to do. The buttery croutons are addictive. I've witnessed people hoarding them on their plates and eating them like potato chips . . . so make a lot. Pour the pisco punch from a pitcher on the table. That's it. Now everyone can sit down and start chatting. ★

Opposite and right: A lot of colorful flowers would fight with the bold patterns here. So I chose to use one color, a light purple for the centerpieces and place settings.

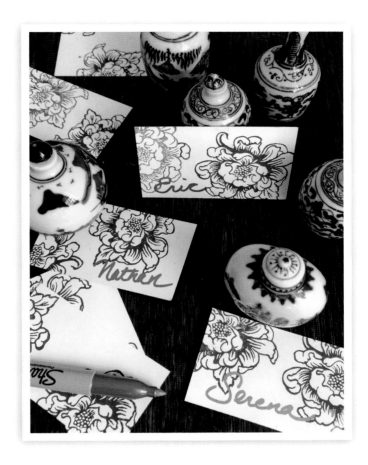

PLACE CARDS

I think there is a time and place for them. Because I usually entertain so casually, I don't use them a lot. But here, they feel right as part of a slightly fancier table. And they're great for encouraging new friendships. They can help you control the energy of the table, like sitting a chatty person next to a quieter one. This way, the conversation is balanced and everyone has a great time.

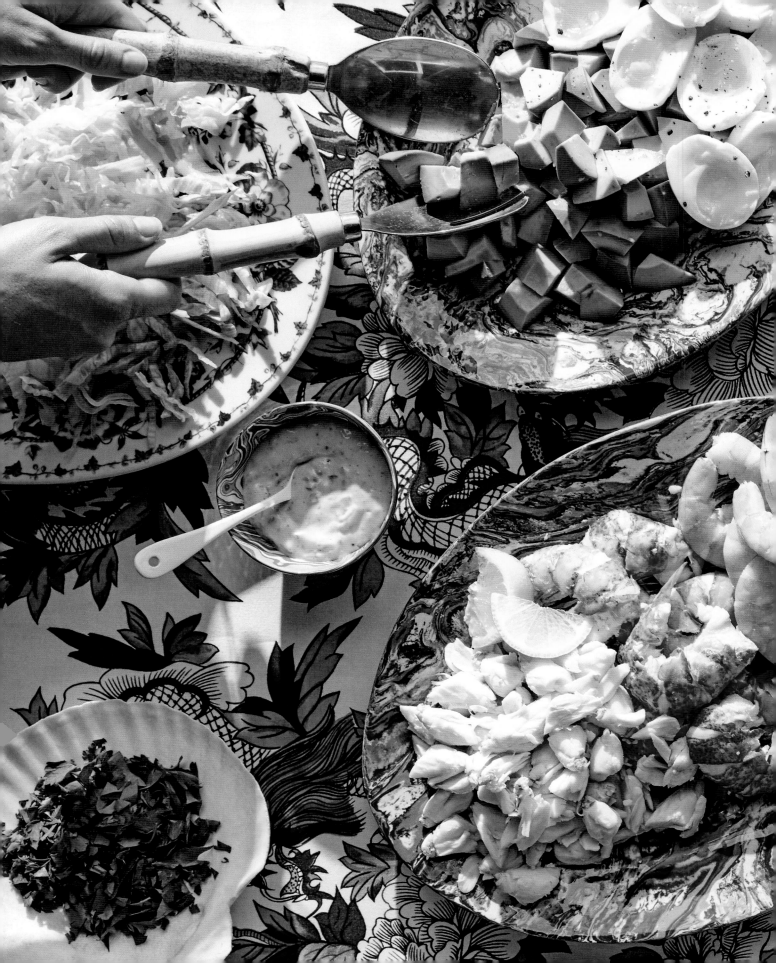

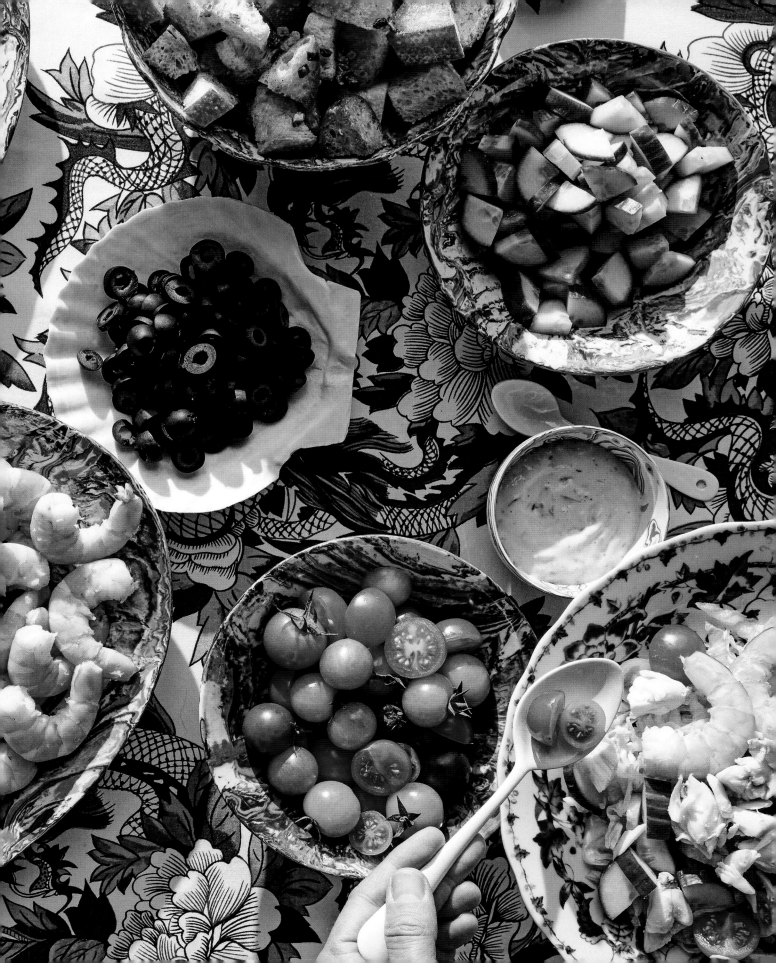

deconstructed seafood louie

SERVES 12

It's almost a scam to call this a recipe. It's more of an assembly job.
It was the house specialty at our Malibu place, and I promise
it will be your go-to for entertaining, too, because it's so easy but
looks incredibly impressive. (My favorite kind of dish.)

for the dressing:

1 CUP (240 ML) MAYONNAISE

½ CUP (120 ML) KETCHUP

¼ CUP (60 G) DILL PICKLE RELISH

1 TABLESPOON LEMON JUICE

1 TABLESPOON HOT PEPPER SAUCE

½ TEASPOON SALT

½ TEASPOON CELERY SALT

½ TEASPOON GROUND BLACK PEPPER

for the croutons:

1 LOAF SOURDOUGH BREAD, CUT INTO 2-INCH (5-CM) CUBES

½ CUP (115 G) UNSALTED BUTTER, MELTED

1 SHALLOT, DICED

1 TABLESPOON OLD BAY SEASONING

½ TEASPOON SALT

6 SMALL LOBSTER TAILS, COOKED IN OLD BAY,
SHELLED AND CHILLED

12 JUMBO PRAWNS, COOKED IN OLD BAY,
PEELED AND CHILLED

1 (8-OUNCE/255-G) CAN LUMP CRABMEAT, DRAINED

6 BOILED EGGS, PEELED, HALVED, AND CHILLED

3 CUPS (165 G) SHREDDED ICEBERG LETTUCE

1 CUP (145 G) HALVED CHERRY TOMATOES

½ CUP (25 G) CHOPPED FRESH FLAT-LEAF PARSLEY

2 LARGE AVOCADOS, PEELED AND CUBED

1 ENGLISH CUCUMBER, CUBED

1 (3.8-OUNCE/108-G) CAN SLICED BLACK OLIVES

Preheat oven to 400°F (205°C).

In a medium bowl, whisk together dressing ingredients until well combined. Refrigerate until ready to serve.

In a large bowl, combine bread, butter, shallot, Old Bay, and salt and toss to evenly coat bread cubes. Transfer to a rimmed baking sheet lined with parchment paper and toast in the oven for 12 to 15 minutes or until golden brown and crispy. Let cool.

Serve all ingredients, dressing, and croutons in assorted bowls so guests can build their own salads.

pisco punch

SERVES 12

This is a classic San Francisco cocktail. It was made famous during the
Gold Rush at the Bank Exchange Saloon. I love a punch because you
can make it beforehand, and during the event everyone just grabs glasses.
And booze-soaked fruit is always a winner to me.

1 (750-ML) BOTTLE PISCO

1 LARGE PINEAPPLE, PEELED AND CUBED

⅔ CUP (165 ML) FRESH LIME JUICE

3 CUPS (600 G) GRANULATED SUGAR, DIVIDED

⅔ CUP (165 ML) FRESH GRAPEFRUIT JUICE

½ CUP (120 ML) FRESH LEMON JUICE

1 CUP (240 ML) CLUB SODA

ICE, FOR SERVING

1 LIME, SLICED, AND 12 PINEAPPLE WEDGES,
FOR GARNISH (OPTIONAL)

In a large lidded jar, combine Pisco and pineapple and refrigerate
for 2 to 4 days, shaking occasionally.

In a medium saucepan, combine lime juice, 1½ cups (300 g)
of the sugar, and ½ cup (120 ml) water and bring to a boil.
Reduce to a simmer and cook for 10 minutes, until mixture has
reduced to about 1 cup (240 ml). Let cool completely (can be
made up to 24 hours in advance).

In another medium saucepan, combine grapefruit juice,
remaining 1½ cups (300 g) sugar, and ½ cup (120 ml)
water and bring to a boil. Reduce to a simmer and cook
for 10 minutes, until mixture has reduced to about 1 cup
(240 ml). Let cool completely (can be made up to 24 hours
in advance).

Strain Pisco into a large pitcher and add lemon juice, club
soda, and cooled lime and grapefruit syrups. Stir to combine.
Serve over ice, and garnish with additional sliced citrus and
pineapple if desired.

jamie's mud pie

SERVES 10 TO 12

My best friend Jamie and I met in sixth grade, and we've been
sharing recipes and cooking together ever since. This is her tried-and-true
mud pie that I insist on every time I am back home for a visit.

for the crust:

24 OREO COOKIES

¼ CUP (55 G) UNSALTED BUTTER, MELTED

¼ TEASPOON SALT

for the filling and topping:

1 GALLON (3.8 L) COFFEE ICE CREAM, SOFTENED

½ CUP (120 ML) HEAVY CREAM

¼ CUP (50 G) CONFECTIONERS' SUGAR

1 TABLESPOON INSTANT ESPRESSO POWDER

1 TEASPOON VANILLA EXTRACT

4 OUNCES (115 G) BITTERSWEET CHOCOLATE, GRATED

In a food processor, process Oreos to a fine crumb.
Transfer to a bowl and add butter and salt. Stir to combine
and press into a 9-inch (23-cm) deep-dish pie plate.

Fill crust with softened ice cream, smoothing the top with
an offset spatula, and place in the freezer while preparing
the topping.

Whip together cream, confectioners' sugar, espresso
powder, and vanilla until stiff peaks form. Dollop on top
of ice cream filling and swirl all over. Sprinkle with grated
chocolate and freeze for at least 4 hours before serving.

SAN FRANCISCO

★

menu

CIOPPINO

LITTLE GEMS WITH RED ONION AND
GREEN GODDESS DRESSING

ITALIAN CHEESY PULL-APART BREAD

LIMONCELLO

FIG COMPOTE WITH
LEMON MASCARPONE MOUSSE

My great-grandmother Marion grew up in the heart
of San Francisco. And I spent a lot of time there when
I was growing up. The city was always a magical place
to me—the windy streets, the mix of cultures, and,
of course, those amazing Victorian houses (just like theirs)
painted in pastel shades and tucked in tightly together.

SAN FRANCISCO IS RIDDLED WITH HILLS, SO THE
architecture accommodates the landscape. Inside these
houses, everything is built up and have quirky details
I love. (I used to think that the stairs went on and on
forever.) My love of what I call Victorian grandma chic
was born here, and I continue to embrace it to this day.

COZY KITCHEN SUPPER

This menu and table were inspired by my time in my
great-great-grandparents' home. Though the layout was
vertical, the kitchen in the back was huge! And looking
back now, it was a good thing as that space was made for
production work and cooking. There was a huge white
gas range always topped with pots of simmering water or
tomato sauce and one of those deep porcelain work sinks
with ribbed sides to catch water and run it right down
the drain. Stuff was going down here! Raviolis were being
rolled out, tomatoes were being chopped, sauces were
bubbling away. There was a rather uncomfortable stool
where I would watch the ladies cook, and eventually I
would join in to stir sauces or roll out pasta.

The menu and setting is cozy personified. It's the meal
you want to have in front of a fireplace with good friends
and family. My great-great-grandparents' house—which
was later my great-grandmother Marion's home—was the
hub of the family. Everyone gathered once a month for a
big family dinner. And cioppino was often on the menu.

I call this look Victorian grandma chic because its core
comes from the charm of those San Francisco row houses
where you find lots of carved wood, floral chintz, and
quirky and sentimental pieces (velvet armchairs mixed
with lighter rattan furniture, lots of family photos, china
passed down from generation to generation) inside.

For the tablecloth, I used an old Victorian chintz
pattern in blue and white. It makes me think of my
great-grandmother and her family. Living in LA now,
where midcentury design is so revered, I realize I am such
a traditionalist. Don't get me wrong; I love the mix of the
two, but when I can do a straight-up traditional table, I
go for it.

As I have said before, Victorian design can be heavy.
It helps to add some simple color and lines to break it
up. I used a Ralph Lauren Evelyn plate with my great-
grandmother's Limoges china. (Try mixing fine china and
everyday plates anytime. It really works.) I used some
shallow bowls to serve the cioppino.

Since this is a kitchen dinner, I did not want fancy
flower arrangements, or even flowers. Again, I used what
was available and what would echo the meal. So, figs it
is. I think they look beautiful when piled high in a bowl.
And since fig leaves are just as beautiful as any flower, I
used them on the mantel in a simple cylinder vase. (A
farm-to-table menu can translate to your decor too.)

Get cozy (opposite): Using upholstered furniture, like a comfy armchair, tells guests
to relax and stay awhile.

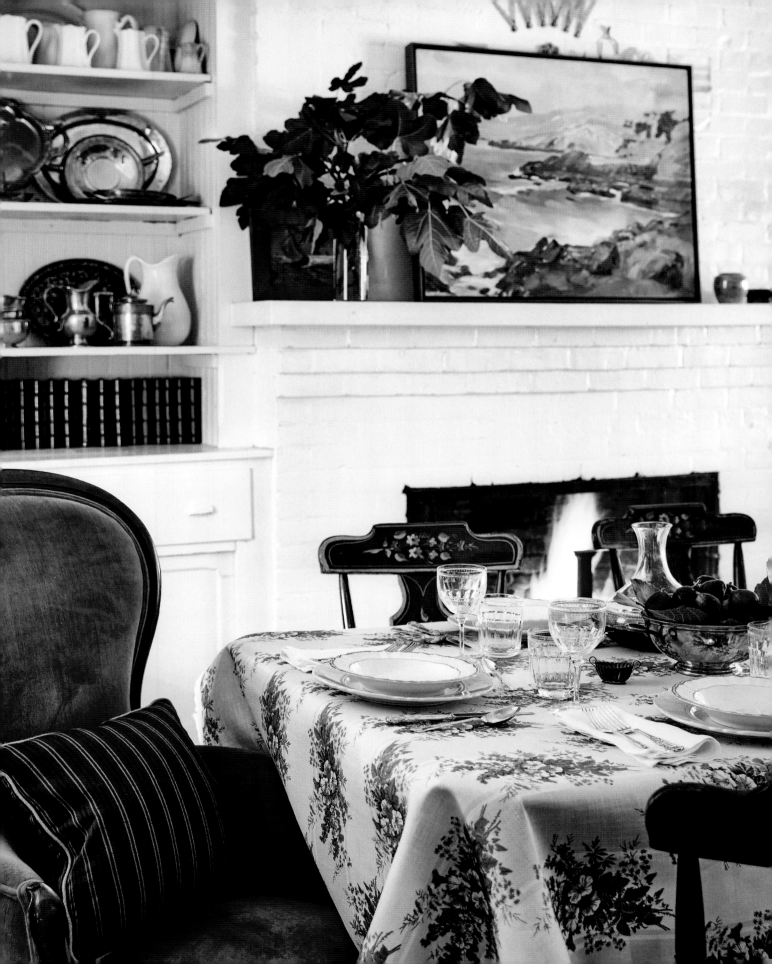

These dishes are so personal to me . . . like all the recipes in the book. Each dish is linked to a memory. Maybe none more than this one. I can create this dish anywhere, and I am back in that kitchen or just outside in the back garden, plucking ingredients from the bay tree, fig tree, or lemon tree there. (I was so proud I knew the difference among the three.) I believe that food is social and family history, a common thread from generation to generation; a part of your DNA like anything else. And when I teach my niece to make a dish, it's continuing the story.

Cioppino is a very San Francisco thing. It's like clam chowder in that everyone has their own version. Almost the entire meal can be grown in the garden—except for the seafood. That has its ritual. Because San Francisco is known for their amazing seafood, people here are picky about who has the best. I remember being dragged (willingly) along by my great-grandmother from place to place to get the scallops here, prawns there, crab elsewhere, and so on. It's what I love about food and food culture in San Francisco: Getting the best quality and supporting local growers is a source of pride.

The little gems with red onion and green goddess dressing is a Northern California culinary icon. Green goddess dressing was invented in the city in the 1920s, but it didn't have its big moment until the '70s when companies started bottling it. I guess that's why it always has a kind of hippie reputation.

My contribution to this family menu is cheesy Italian pull-apart bread. Sourdough bread with cioppino is typical in San Francisco, but this takes it to another level. I slit the top with a crosscut design and stuff it with cheese, sautéed onions, and fresh herbs. It's wrapped tightly before being put in the oven so when it bakes, everything melts together (without oozing out).

The fig compote with lemon mascarpone mousse is something I whipped up on the fly. I've been lucky to live in many houses that have old fig trees that produce lots of fruit. I had to figure out a way to preserve it all. Here, I mixed it with a creamy, lemon mascarpone, which is an Italian cream cheese. The smooth texture goes well with the fig compote, and the lemon brightens it up a bit. ★

Above: I propped some photos on a picture rail to keep family members close to us during dinner. Opposite: Who says vintage china doesn't work with an old rough-hewn table? I love the way the two juxtapose.

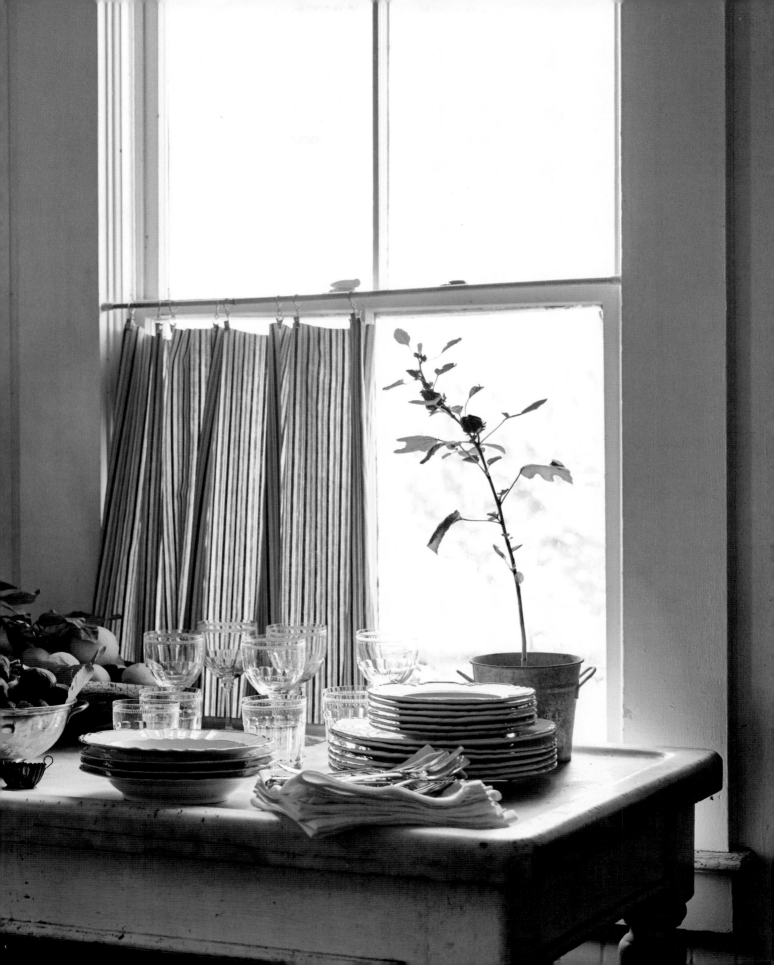

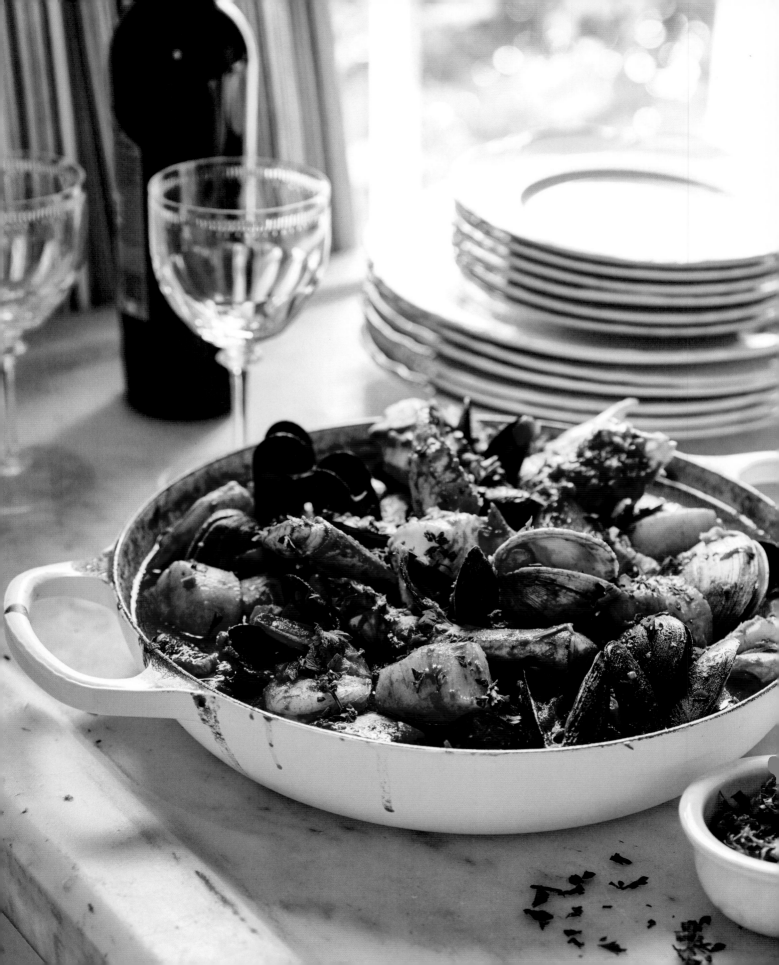

cioppino

SERVES 6

Where I grew up, every family has their own version of cioppino.
And everyone has strong opinions on where to get the best seafood. My advice
is to get the best you can find as it's the main event in this dish.

¼ CUP (60 ML) OLIVE OIL

1½ CUPS (165 G) CHOPPED ONION

6 CLOVES GARLIC, MINCED

¼ CUP (60 ML) TOMATO PASTE

2 TEASPOONS SALT

2 TEASPOONS GROUND BLACK PEPPER

1 TEASPOON RED PEPPER FLAKES

1½ CUPS (360 ML) DRY WHITE WINE

1 (28-OUNCE/795-G) CAN CHOPPED SAN MARZANO TOMATOES

2 (8-OUNCE/236-ML) BOTTLES CLAM JUICE

2 BAY LEAVES

12 MUSSELS, RINSED AND SCRUBBED WELL

12 CLAMS, RINSED AND SCRUBBED WELL

1 POUND (455 G) LARGE SHRIMP, SHELLS ON

½ POUND (225 G) LARGE SCALLOPS

1 POUND (455 G) HALIBUT, CUT INTO 1-INCH (2.5-CM) CUBES

1 (8-OUNCE/225-G) CAN LUMP CRABMEAT, DRAINED

1 CUP (50 G) FLAT-LEAF PARSLEY, CHOPPED

In a large pot or Dutch oven, heat olive oil over medium-high heat. Sauté onion for 8 minutes, until softened. Add garlic and sauté for 2 minutes more. Add tomato paste, salt, pepper, and red pepper flakes and sauté for 1 minute, until fragrant. Deglaze with white wine and cook for 5 minutes until slightly evaporated. Add tomatoes, clam juice, and bay leaves and bring to a boil. Reduce to a simmer and cook for 30 minutes, until liquid reduces by half. Increase heat to medium-high, add mussels and clams, and cook for 5 minutes, until they start to open. Add shrimp, scallops, and halibut and cook for 8 minutes, until shrimp turns pink. Stir in crabmeat and parsley and heat for 5 minutes.

Divide between bowls and serve immediately.

little gems with red onion and green goddess dressing

SERVES 8

People always associate green goddess dressing with the '60s or '70s, but it was actually created at San Francisco's Palace Hotel in 1923. Mine deviates from the classic in that I use crème fraîche and avocado. Sometimes I add more avocado and serve it as a dip.

¼ CUP (60 ML) SOUR CREAM

¼ CUP (13 G) FRESH TARRAGON, CHOPPED

1 MEDIUM AVOCADO, DICED

3 ANCHOVIES

2 GREEN ONIONS, CHOPPED

1 TABLESPOON DIJON MUSTARD

2 CLOVES GARLIC, MINCED

JUICE OF 1 LEMON

1 TEASPOON WORCESTERSHIRE SAUCE

1 TEASPOON HOT PEPPER SAUCE

½ TEASPOON SALT

½ TEASPOON GROUND BLACK PEPPER

¼ CUP (60 ML) OLIVE OIL

14 HEADS LITTLE GEM LETTUCE, LEAVES SEPARATED, WASHED, AND DRIED WELL

1 SMALL RED ONION, THINLY SLICED

In a blender, combine sour cream, tarragon, avocado, anchovies, green onions, mustard, garlic, lemon juice, Worcestershire, hot pepper sauce, salt, and pepper. Pulse to chop and combine ingredients. With blender running, add olive oil in a steady stream and blend until smooth. Continue blending and add ¼ cup (60 ml) to ½ cup (120 ml) water to reach desired consistency.

In a large bowl, toss lettuce with dressing to coat the leaves well. Sprinkle with red onion and serve immediately.

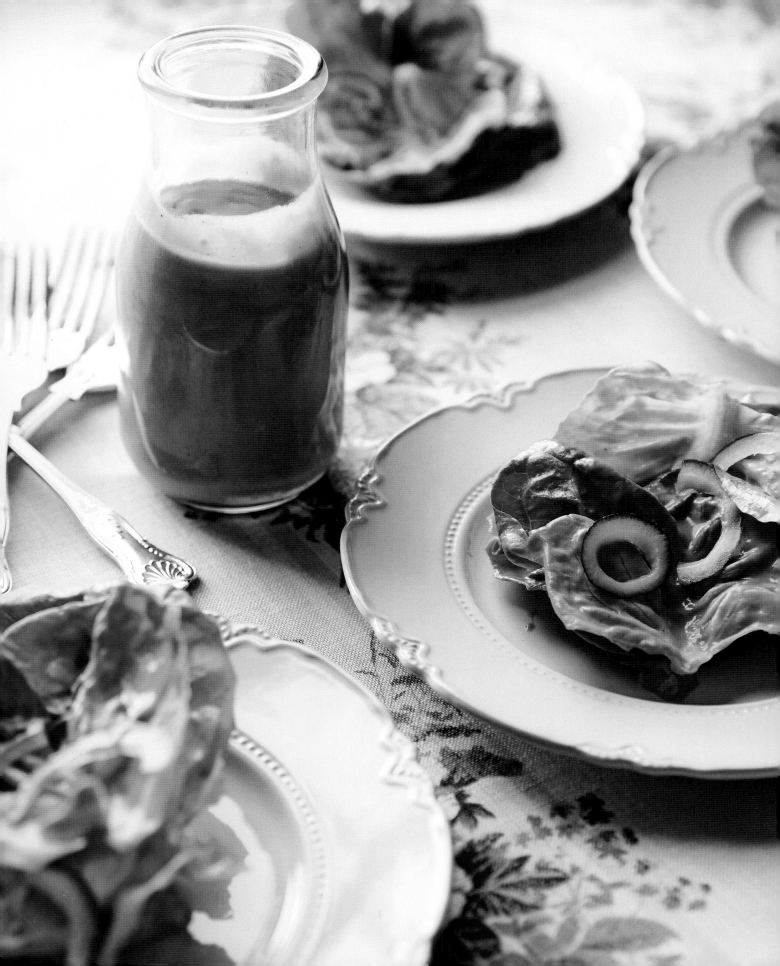

italian cheesy pull-apart bread

SERVES 8

This is my pumped-up version of the sourdough bread
that everyone in San Francisco serves with cioppino.
It could basically be a meal in itself, but when you dip
pieces into the spicy tomato broth? Heaven.

3 TABLESPOONS OLIVE OIL

2 TABLESPOONS BUTTER

½ CUP (65 G) FINELY CHOPPED RED ONION

2 CLOVES GARLIC, MINCED

1 TABLESPOON CHOPPED FRESH ROSEMARY

1 TABLESPOON CHOPPED FRESH THYME

1 TABLESPOON CHOPPED FRESH FLAT-LEAF PARSLEY

1 CUP (110 G) SHREDDED GRUYÈRE CHEESE

1 CUP (115 G) SHREDDED CHEDDAR CHEESE

¼ CUP (25 G) GRATED PARMESAN CHEESE

1 (1-POUND) LOAF SOURDOUGH BREAD

Preheat oven to 350°F (175°C).

In a skillet, heat olive oil and butter over medium heat.
Sauté onion for 4 minutes. Add garlic and cook for 2 minutes
more. Add rosemary, thyme, and parsley. Remove from heat,
and stir well.

In a medium bowl, mix Gruyère, Cheddar, and Parmesan and
set aside.

Make a crosshatch of cuts all over the loaf, stopping ½ inch
(12 mm) from the bottom (not cutting all the way through).

Spoon herb oil mixture all over the loaf and in between the
cuts. Sprinkle cheese all over the loaf, pushing it down in
between the cuts, really packing tightly to keep the cheese
inside the loaf. Wrap in foil and bake for 30 minutes. Let
cool for 5 minutes before serving.

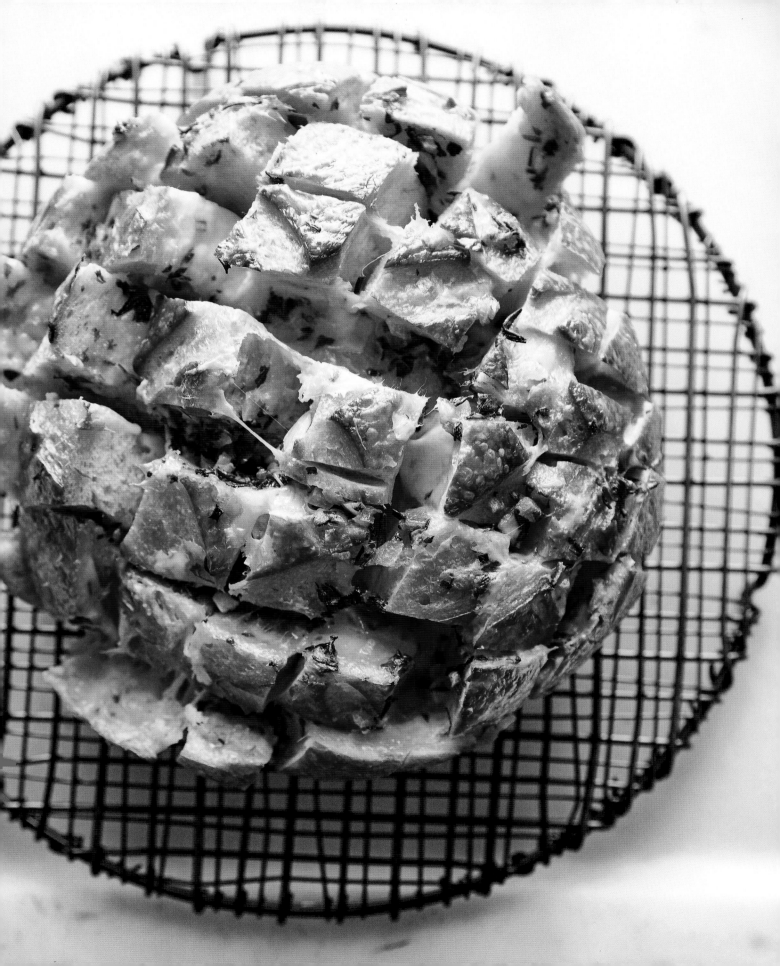

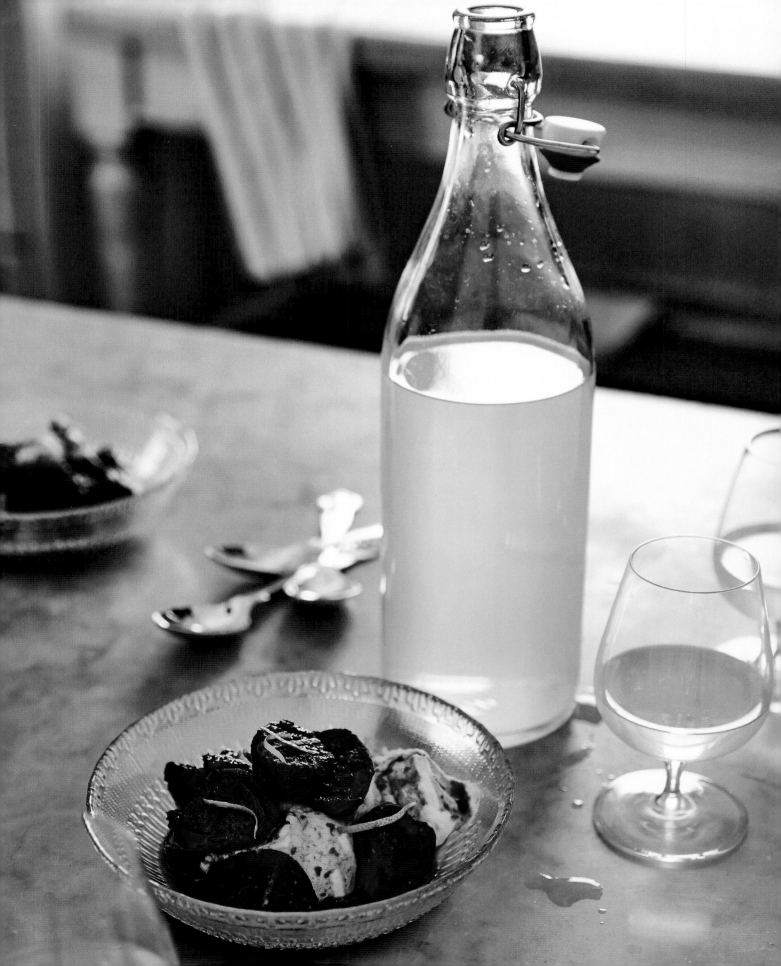

limoncello

MAKES ABOUT 34 OUNCES/1 LITER

In addition to serving this with meals at my table, I also store some so I have it ready to give as a hostess or birthday gift.

9 ORGANIC LEMONS,
WASHED WELL AND LIGHTLY SCRUBBED

1 LITER 95 PERCENT GRAIN ALCOHOL,
SUCH AS EVERCLEAR

¾ CUP (150 G) GRANULATED SUGAR

Peel the lemons, making sure to remove just the peel and not the white pith. In a large lidded jar, combine lemon peels with the alcohol. Shake well. Let sit for 20 days in a cool dark place, shaking every few days.

In a small saucepan, combine sugar with 1 cup (240 ml) water and bring to a boil over high heat. Boil about 5 minutes, stirring occasionally, until sugar has dissolved. Let cool completely.

Strain lemon peels from alcohol and add cooled simple syrup. Store in a 34-ounce/1-L glass bottle in the freezer and serve chilled.

fig compote with
lemon mascarpone mousse

SERVES 8

I make this compote in big batches after a fig harvest. That way I can enjoy it and share with others all winter. It's also great over vanilla ice cream or dolloped on a cracker with manchego or goat cheese.

2 POUNDS (910 G) BLACK MISSION FIGS,
STEMMED AND CUT IN HALF

½ CUP (120 ML) DRY RED WINE

½ CUP (110 G) LIGHT BROWN SUGAR

½ CUP (120 ML) LEMON JUICE, DIVIDED

4 TABLESPOONS (60 ML) LEMON ZEST, DIVIDED

1 CUP (240 ML) HEAVY CREAM

¼ CUP (30 G) PLUS 2 TEASPOONS
CONFECTIONERS' SUGAR, DIVIDED

1 TEASPOON VANILLA EXTRACT

8 OUNCES (225 G) MASCARPONE CHEESE,
AT ROOM TEMPERATURE

1 TABLESPOON LIMONCELLO

8 SHORTBREAD COOKIES

In a medium saucepan, combine figs, red wine, sugar, ¼ cup (60 ml) of the lemon juice, and 2 tablespoons of the lemon zest and bring to a boil. Reduce to low and simmer for 15 minutes, until figs are tender and juice is slightly thickened. Let cool completely.

In a large bowl, combine cream, 2 teaspoons of the confectioners' sugar, and vanilla and whip until stiff peaks form; set aside. In another large bowl, combine mascarpone, remaining 2 tablespoons lemon zest, ¼ cup (60 ml) lemon juice, ¼ cup (30 g) confectioners' sugar, and the limoncello. Whip together until light and fluffy. Gently fold whipped cream into mascarpone mixture.

To serve, divide cooled fig compote between eight bowls and top with a generous dollop of mascarpone mousse.

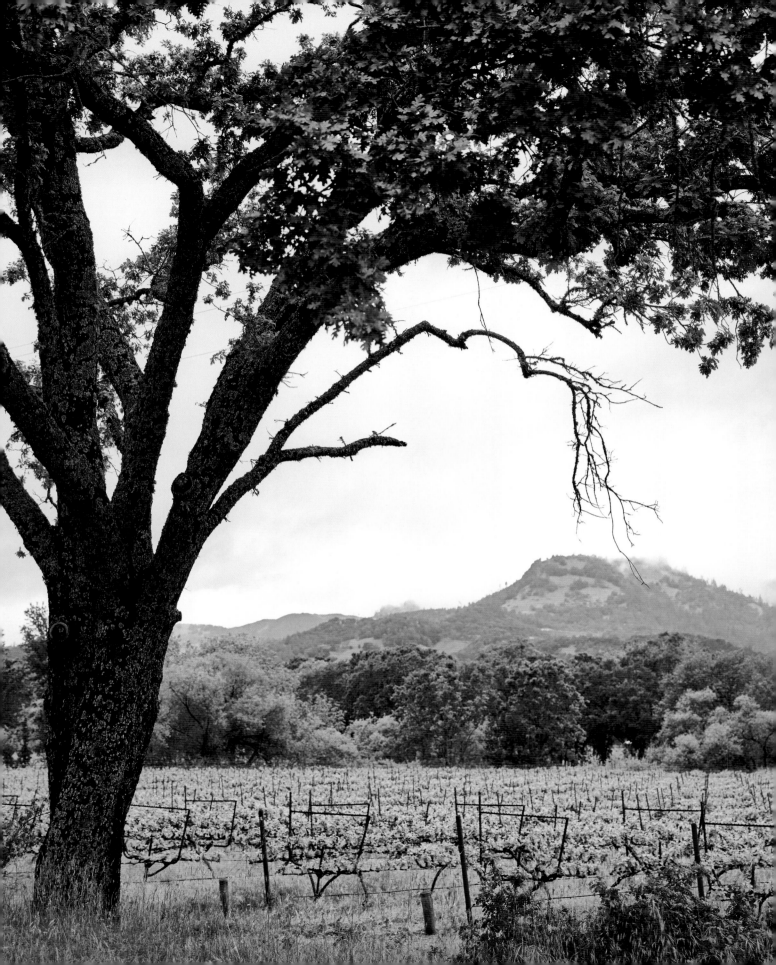

CALISTOGA

menu

ZUCCHINI AND SUMMER
SQUASH ORECCHIETTE

FILLED ZUCCHINI BLOSSOMS

FETA AND ROASTED TOMATO SALAD

ALMOND MILK GRANITA

WHITE WINE SANGRIA

A small town at the tip of Napa Valley (the wine-making region so well known), Calistoga is famous in California for its hot springs, mud baths, and great wine. (What more do you need?)

THE SUN-SOAKED VALLEY IS FILLED WITH WINDING roads lined with grapevines on either side. Higher up in the hills, its lush and verdant towering trees feel like a fairy-tale forest.

My first memories here are of a sleepy, agricultural, hippie town where I would set up a lemonade stand on Route 128. It was the early eighties, long before it became a place where limousines carry wine lovers around from vineyard to vineyard. My godfather lived there and my dad would take us to visit. Arriving each time, I thought . . . we are in the *country*! Later my mom was a member of the food co-op in Berkeley, where she would pick up fresh vegetables and herbs. Now CSAs (Community Sponsored Agriculture) are everywhere, but back then I remember asking, "Can't we just go to Safeway?"

LAID-BACK ALFRESCO LUNCH

Then and now, this place is all about pulling ingredients right from the garden. The food is always the focus. This valley is so important to our food culture. And it's also incredibly beautiful. I think of it as our South of France. Simple, incredible dishes served on a relaxed, lovely table inspired by the nature surrounding it.

I was really inspired to create this table and menu after visiting Larkmead Vineyards, one of the oldest (and most picturesque) family-owned vineyards in Napa Valley. Established in 1895, it feels like you are at a friend's house—a friend who has an excellent wine cellar.

This table pays tribute to a hippie, natural spirit that I remember seeing in Calistoga when I was little. But I give it a twist. I use lots of natural pottery as vases, plus some wooden salad bowls (didn't every house in the seventies have those?). I love a simple linen runner and cotton windowpane napkins in white and tan to highlight, not distract from, the vibrant, fresh food.

For the napkin rings, I had to use some macrame— basically knotted cord or string woven into pretty designs. Gold flatware adds a modern touch and looks great in the sunlight. It's Hippie Deluxe. Simple wildflowers, branches, or grasses in small glass bottles are easy and inexpensive, and look like you just picked them from the field (which I often do).

Opposite: Raiding the Larkmead Vineyards cellars.

The menu is also influenced by fresh squash blossoms, which I tasted for the first time in Calistoga. Like any normal kid, my first reaction was, "Eww. I don't want to eat a flower." Then they told me they were deep-fried, so I was in. Stuffed with goat cheese and fresh herbs, they are a real crowd pleaser. I also add them to a pasta dish with squash and zucchini.

The roasted cherry tomato salad includes another California staple, almonds, plus a little salty feta. Almonds are the star of dessert as well, in a cool Italian granita. I first had this in Sicily. And since I make my own almond milk, I knew I had to try it here.

I like to serve white wine sangria, which to me is a little lighter and a better pairing than red, especially with these delicate flavors. While I'm not a vegetarian, this menu is. But any carnivore—myself included—will love it too. ★

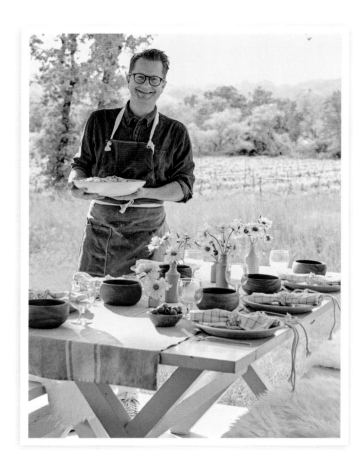

SIT, STAY AWHILE

Your table can be stunning and your food delicious, but if you're sitting in an uncomfortable chair, how can you really enjoy yourself? While I love to serve a meal at an old picnic table or around a coffee table, I think about the seating people will be comfortable in before, during, and after the meal. Here, I laid out cozy, soft sheepskin throws on the wood benches. It fits perfectly with the Hippie Deluxe vibe I was going for. Cushions would work too.

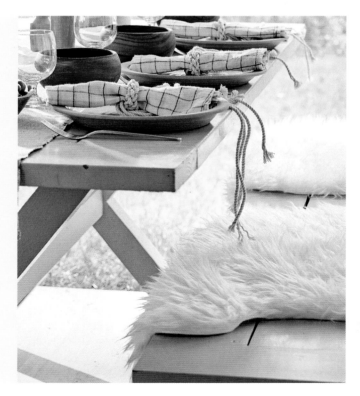

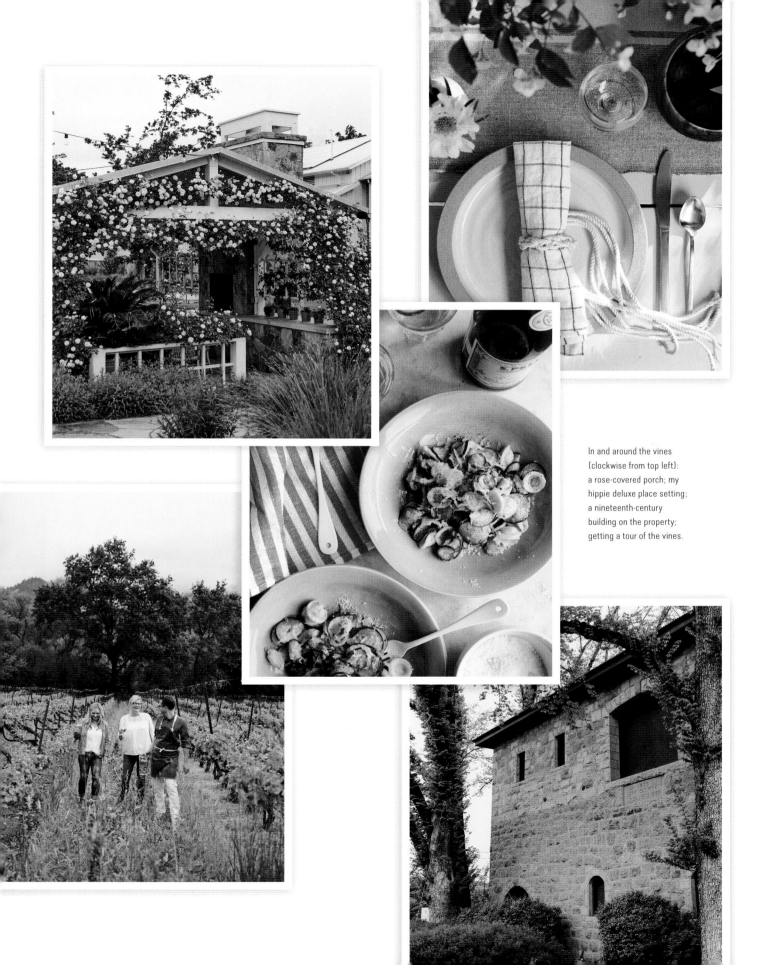

In and around the vines
(clockwise from top left):
a rose-covered porch; my
hippie deluxe place setting;
a nineteenth-century
building on the property;
getting a tour of the vines.

zucchini & summer squash orecchiette

SERVES 6

I learned to make this zucchini dish from my host mother in Italy when I was studying abroad. It was my first lesson in the genius of Italian cooking: How a small amount of simple ingredients can create something amazing.

2 TABLESPOONS OLIVE OIL

3 SHALLOTS, FINELY CHOPPED

½ YELLOW ONION, FINELY CHOPPED

2 MEDIUM ZUCCHINI, THINLY SLICED

2 MEDIUM YELLOW SUMMER SQUASH,
THINLY SLICED

1 POUND (455 G) ORECCHIETTE,
COOKED TO PACKAGE DIRECTIONS AND DRAINED,
½ CUP (120 ML) WATER RESERVED

½ CUP (120 ML) CRÈME FRAÎCHE

½ CUP (50 G) GRATED PARMESAN CHEESE

1 TEASPOON SALT

½ TEASPOON GROUND BLACK PEPPER

Heat olive oil over medium-high heat and sauté shallots and onion for 4 minutes or until softened. Add zucchini and squash and sauté for 10 minutes or until just soft. Add pasta, crème fraîche, and Parmesan and gently fold together. Add a little of the reserved pasta water to create a creamy sauce, and season with salt and pepper.

filled zucchini blossoms

SERVES 6

I usually find these at the farmers' market. Preparing them is not as scary as it looks. Because they are delicate, it's easiest to fill them using a pastry bag or a freezer bag with a tiny corner snipped off.

½ CUP (55 G) GOAT CHEESE, AT ROOM TEMPERATURE

1 GREEN ONION, SLICED

1 TABLESPOON CHOPPED FRESH FLAT-LEAF PARSLEY

1 TABLESPOON HOT PEPPER SAUCE

2 TEASPOONS HEAVY CREAM

½ TEASPOON SALT, PLUS MORE FOR SEASONING

¼ TEASPOON GROUND BLACK PEPPER, PLUS MORE FOR SEASONING

12 ZUCCHINI BLOSSOMS

VEGETABLE OIL FOR DEEP-FRYING

2 LARGE EGG YOLKS

1 CUP (240 ML) LIGHT BEER

1 CUP (125 G) ALL-PURPOSE FLOUR

In a small bowl, combine goat cheese, green onion, parsley, hot pepper sauce, cream, salt, and pepper. Mix until smooth and well combined. Spoon about 2 teaspoons of filling into each blossom and gently twist the petals to seal at the top.

Pour oil into a large heavy pot, about 3 inches (7.5 cm) deep, and heat to 350°F (175°C) on a deep-fry thermometer.

In a medium bowl, beat together egg yolks and beer. Add the flour and continue to whisk until combined. Dip a stuffed blossom into batter to coat completely, letting the excess drip off. Carefully place in the hot oil and fry for 2 minutes, until crisp and golden brown. Drain on paper towels and sprinkle with additional salt and pepper. Continue with remaining blossoms and serve immediately.

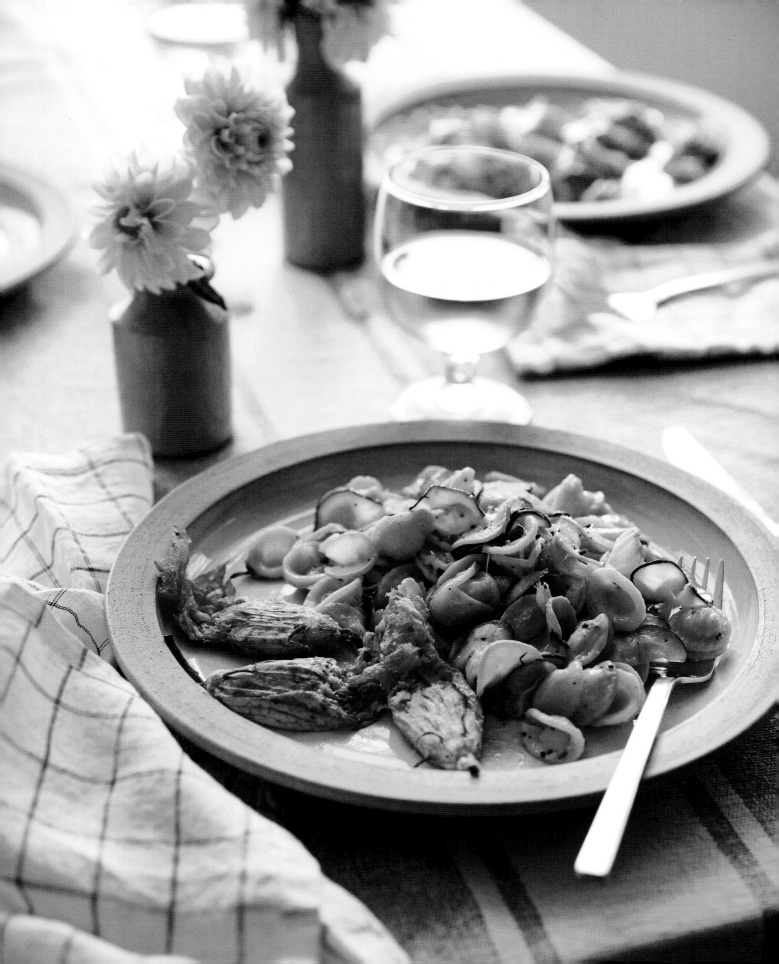

feta and roasted tomato salad

SERVES 8

This is all about the roasting of the cherry tomatoes—
somehow it makes them deeper, more intense, especially if they are out
of season. They make a great addition to any salad.

2 CUPS (290 G) RED AND YELLOW
CHERRY TOMATOES

¼ CUP (60 ML) OLIVE OIL

½ TEASPOON SALT

2 HEADS BUTTER LETTUCE,
LEAVES TORN INTO BITE-SIZE PIECES

½ CUP (55 G) SLIVERED ALMONDS, TOASTED

½ CUP (75 G) CRUMBLED FETA CHEESE

1 TABLESPOON APPLE CIDER VINEGAR

1 TABLESPOON LEMON JUICE

½ TEASPOON GROUND BLACK PEPPER

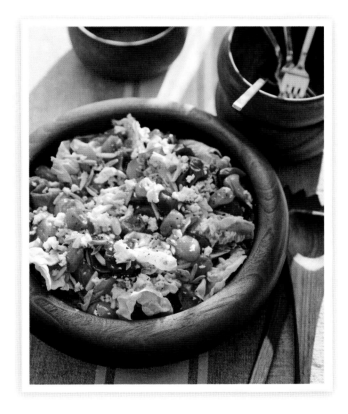

Preheat oven to 400°F (205°C). On a rimmed baking sheet, toss tomatoes with olive oil and salt. Roast for 15 to 20 minutes or until the tomatoes begin to pop open. Cool in pan and lightly smash with the back of a spoon to release more juices.

In a large bowl, combine lettuce, almonds, feta, vinegar, lemon juice, and pepper. Pour tomatoes and all their juices over salad and toss to combine.

almond milk granita

SERVES 8

Making your own almond milk sounds hard, I know.
But I can tell you it is totally worth the extra time. Keep a
little extra to pour over the granita before you serve.

3 CUPS (425 G) RAW ALMONDS

3 TABLESPOONS AGAVE SYRUP

1 TEASPOON VANILLA EXTRACT

1 TEASPOON SALT

½ CUP (50 G) TOASTED ALMONDS, CHOPPED

In a large bowl, cover raw almonds with water and cover bowl with
a kitchen towel. Soak overnight at room temperature. Drain the
almonds and rinse well. In a high-powered blender in batches,
blend almonds with 9 cups (2.1 L) of water. Pour mixture through
a cheesecloth and ring out milk into a bowl. Stir 1 tablespoon
strained pulp back into the milk and add agave, vanilla, and salt.

Pour 4 cups (960 ml) of almond milk into an 8-inch (20-cm)
square baking pan and freeze for 1 hour. Break up ice by scraping
with a fork and return to freezer for another 30 minutes to 1 hour.
Continue scraping and freezing until mixture is frozen but slushy.
Granita can be made 2 to 3 days in advance.

Serve with remaining 2 cups (480 ml) almond milk on the side,
and garnish with toasted almonds.

white wine sangria

SERVES 6 TO 8

This is so refreshing and delicious—and the pitchers
look pretty and festive. I love anything I can make ahead,
so there's no work when people arrive.

1 (750-ML) BOTTLE WHITE WINE

2 CUPS (480 ML) SPARKLING WATER

⅔ CUP (130 G) SUPERFINE SUGAR

½ CUP (120 ML) ORANGE JUICE

½ CUP (120 ML) LEMON JUICE

½ CUP (120 ML) APPLE BRANDY

1 CUP (150 G) GRAPES, HALVED

1 CUP (145 G) STRAWBERRIES, SLICED

1 CUP (125 G) RASPBERRIES

1 LEMON, SLICED

ICE, FOR SERVING

In a large pitcher, combine wine, water, sugar, orange juice, lemon
juice, and brandy and stir well until sugar is dissolved. Add grapes,
strawberries, raspberries, and lemon and stir vigorously to lightly
break up the fruit. Refrigerate for at least 1 hour and up to 5 hours.

Serve with ice and extra fruit for garnish, if desired.

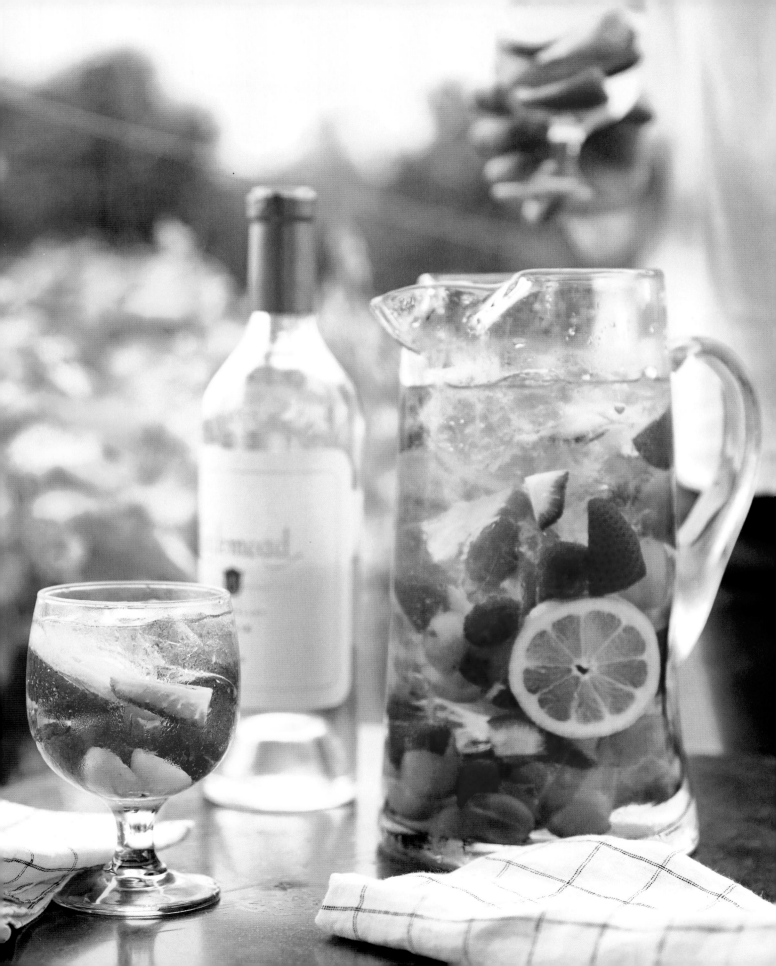

TOMALES BAY

★

menu

CALIFORNIA CRAB

CORN SALAD

LEMON ICE CREAM

This skinny inlet of the Pacific Ocean separates the shore of Marin County (northwest of San Francisco) and the Point Reyes Peninsula. It's a legit fisherman town—a lot of battered cottages cantilevered over the bay. It's perfectly rustic.

BUT IT'S A BOUNTY OF FRESH SEAFOOD, WHICH WE would enjoy on the weekends when we took our sailboat from Berkeley Marina out to the Pacific and up and around Point Reyes. The water here is like a sheet of glass. I used to think you could skate across it.

WEST COAST CRAB FEAST

Unlike many parts of California, it's usually cold and cloudy in Tomales Bay. That's one of the things I love about it! People think you can eat outside only if the weather is warm. But I'll take oysters outside on a cold and cloudy day anytime. I think it adds to the meal. So I encourage you to host alfresco in almost any season. I still love to eat this meal like I did when I was little: in rubber boots and a down jacket, shoveling down briny oysters and clams drenched in melted butter . . . which was likely dribbling down my chin.

This is probably the most laid-back table you'll see me do, but I still like to add some touches that make it feel special.

I use colors that mimic a chilly day by the water: foggy grays and cloud white. Chargers at a crab feast? I know. But in galvanized tin, they just feel right and catch more of the crab shells or drippings from the oysters. The plates are basically vintage enamelware, sturdy but lightweight; people love how they remind them of summer camp or picnics they had on childhood road trips.

For a floral touch, I put found wildflowers in a galvanized pitcher (I don't even bother trimming the ends). I add a little contrast and sheen with copper cups. I love how they look with the tin, and they keep the water or beer nice and cold.

For napkins, I use kitchen towels. Let's face it . . . you need maximum coverage here. Instead of place cards, I write each name on a piece of tape and put one at the top of each plate. To finish the table, I just sprinkle crispy, spicy potato chips all over the table so people can grab them when they want.

This menu is inspired by our weekends on the sailboat with grilled oysters and Dungeness crab—

Page 58: Strolling down to Nick's Cove for the sunset with my pal Jamie.

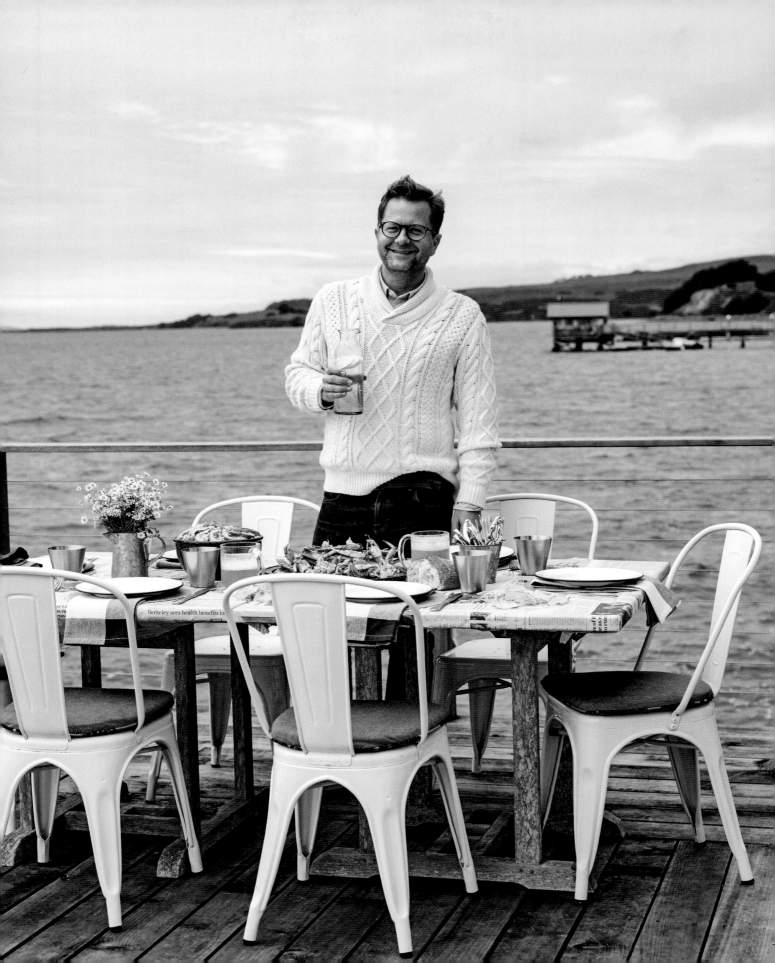

which has such sweet and tender meat. I wanted to do a California twist on the crab boils that people have on the East Coast. I make an easy corn and avocado salad (corn and crab are a fantastic combo) to go alongside. For drinks, beer is really the best with this meal, but I always have wine on hand too.

Part of the fun and a must for this meal is a table covered in newspapers so everyone can crack and crunch away. Then just roll it all up and throw it away at the end. It's the kind of super casual meal I love—interactive, fun, and relaxed.

When it's dessert time, everybody grabs a glass jar of lemon ice cream that's been kept cold in a galvanized bucket filled with ice. ★

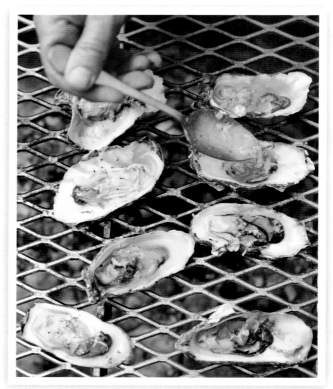

Above: The Bay at a relatively calm moment. Right: Fresh score from Hog Island Oyster Co. Opposite (clockwise from top right): Post-crab feast carnage; the boat house at Nick's Cove; typical fisherman houses over the Bay.

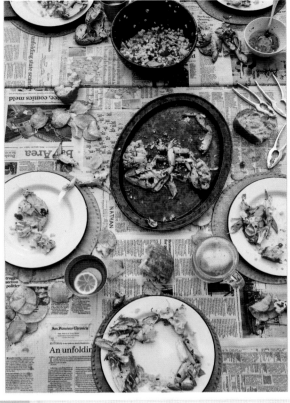

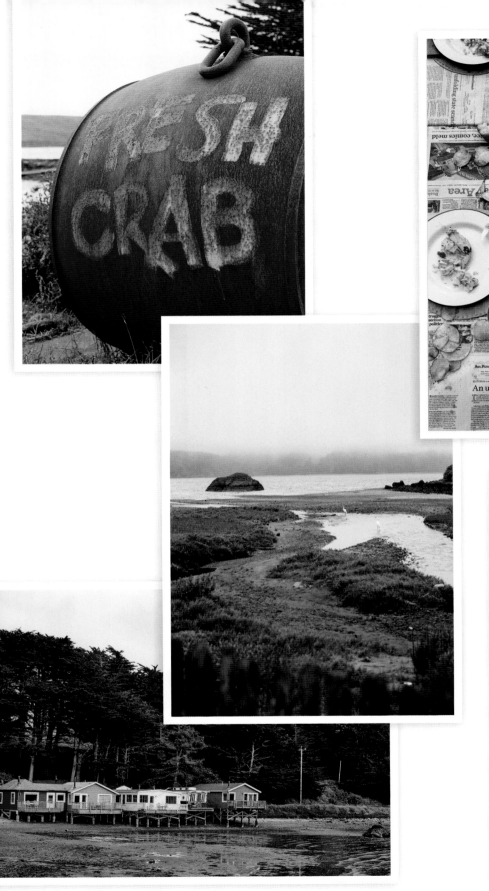

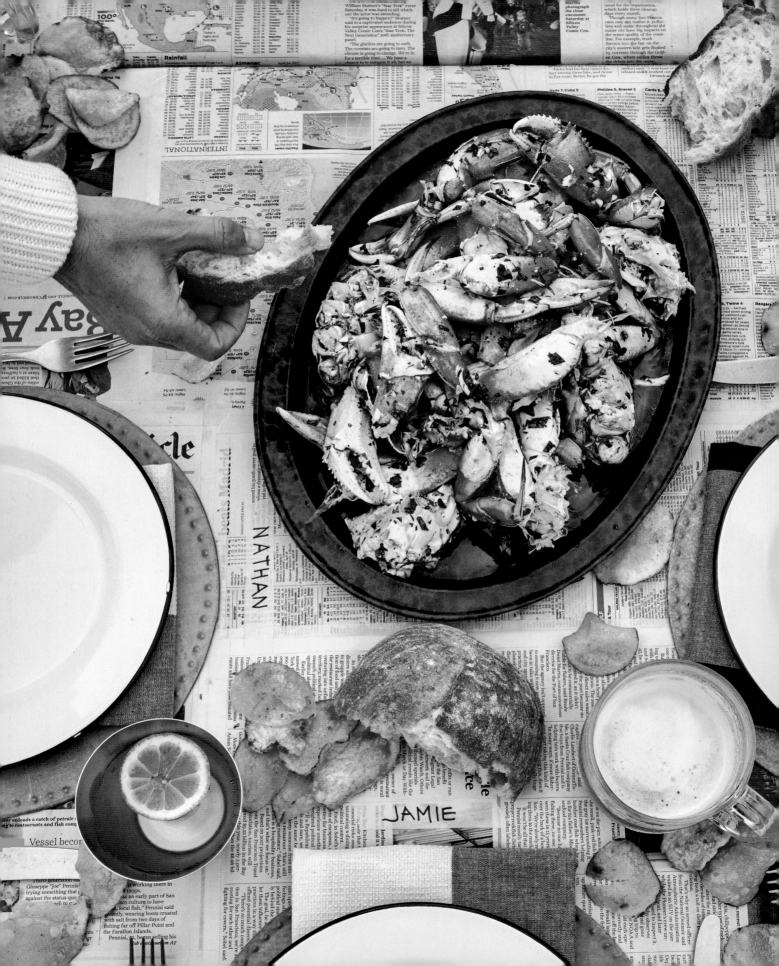

california crab

SERVES 8

My great-grandmother Marion always made this crab. We would sit in her back garden and eat practically nothing else but this and bread.
Dungeness crabs are a lot bigger, meatier than other varieties. You typically can buy them boiled so you don't need to deal with huge boiling pots.

1 CUP (240 ML) OLIVE OIL

5 CLOVES GARLIC, MINCED

½ CUP (120 ML) APPLE CIDER VINEGAR

1 TEASPOON SALT

1 TEASPOON GRANULATED SUGAR

½ TEASPOON GROUND BLACK PEPPER

½ TEASPOON HOT PEPPER SAUCE

ZEST AND JUICE OF 1 LEMON

¼ CUP (13 G) CHOPPED FRESH
FLAT-LEAF PARSLEY

4 POUNDS (1.8 KG) COOKED
AND CRACKED DUNGENESS CRAB

POTATO CHIPS, SOURDOUGH BREAD,
OR RUSTIC LOAF, FOR SERVING

Heat olive oil over medium heat and add garlic. Sauté for 2 minutes or until fragrant. Remove from heat and let cool completely. Add vinegar, salt, sugar, pepper, hot pepper sauce, lemon zest and juice, and parsley and stir well to combine. Gently fold in crab and let marinate in the refrigerator for 3 hours. Serve on a large platter alongside potato chips or bread.

corn salad

SERVES 8

This is my go-to summer salad. I also do a version with parsley and blue cheese that is a bit heavier for the colder months.

3 CUPS (435 G) CORN KERNELS (ABOUT 4 EARS)

1 LARGE RED BELL PEPPER, CHOPPED

1 LARGE TOMATO, CHOPPED

2 GREEN ONIONS, SLICED

¼ CUP (60 ML) OLIVE OIL

3 TABLESPOONS LIME JUICE

1 TEASPOON SALT

½ TEASPOON GROUND BLACK PEPPER

1 TO 2 TABLESPOONS HOT PEPPER SAUCE (OPTIONAL)

2 AVOCADOS, SLICED

⅓ CUP (50 G) CRUMBLED FETA CHEESE

2 TABLESPOONS FINELY CHOPPED FRESH CILANTRO

In a large bowl, combine corn, bell pepper, tomato, and green onions. Add olive oil, lime juice, salt, pepper, and hot pepper sauce, if using, and stir until evenly dressed.

Line a platter with sliced avocado and pile salad on top. Garnish with feta and cilantro and serve immediately.

lemon ice cream

SERVES 8 TO 10

I learned to make this ice cream in northern Italy. It is not a sorbet. I love the combination of tart flavor in a rich package. A bump up from vanilla, for sure. I like to serve the ice cream in mason jars and put on ice.

2 CUPS (480 ML) HEAVY CREAM

1 CUP (240 ML) WHOLE MILK

6 LARGE EGG YOLKS

½ CUP (100 G) GRANULATED SUGAR

¼ TEASPOON SALT

ZEST AND JUICE OF 1 LEMON

In a medium saucepan over medium heat, bring cream and milk to a simmer. In a medium bowl, whisk egg yolks, sugar, and salt. Carefully pour a small amount of hot cream mixture in a steady stream into the egg yolks, whisking constantly. Slowly add the tempered yolk mixture back into the saucepan and cook on medium-low heat, stirring constantly. Cook for 10 to 12 minutes or until the mixture thickens and coats the back of a spoon. Transfer mixture to a bowl, and let cool completely. Refrigerate for 2 hours and then process according to your ice cream maker's directions, adding lemon zest and juice in the last 5 minutes of processing.

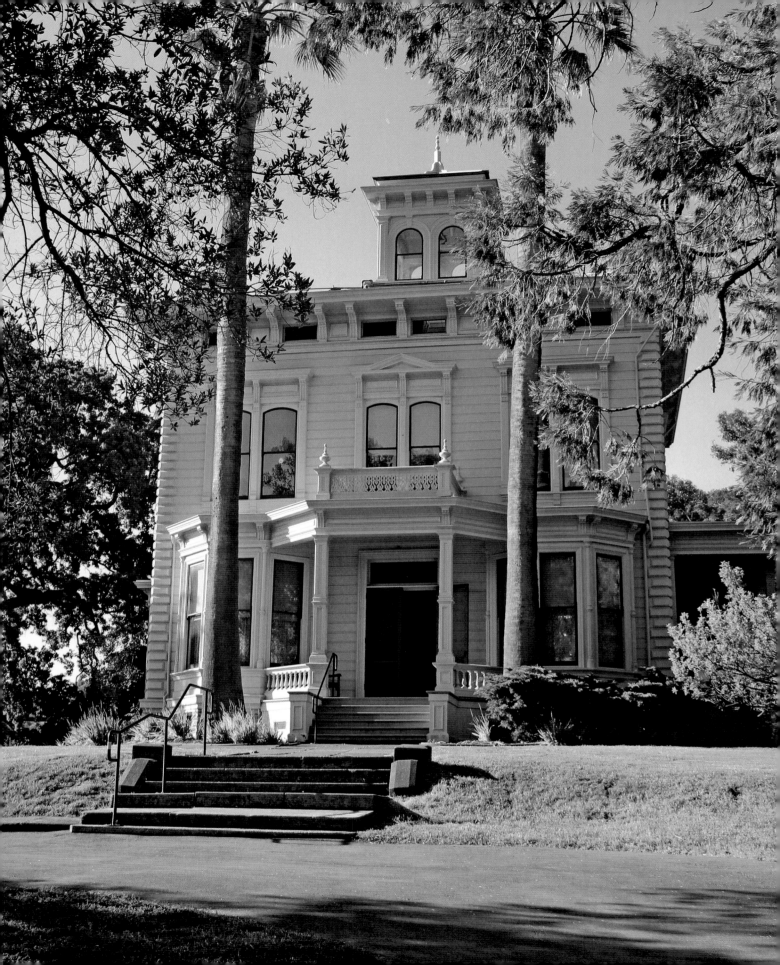

MARTINEZ

★

menu

DIRTY VODKA MARTINI

FIORI FRITTI

MARION'S SICILIAN MEATBALLS

BRUSSELS SPROUT SALAD

RED PEPPER GARLIC BREAD

FROZEN ZABAGLIONE PIE

Martinez, where I grew up, is on
the southern shore of the Carquinez Strait
in the East Bay of San Francisco.

IT'S FUNNY—EVEN THOUGH IT'S TECHNICALLY A suburb, it always felt to me like we lived in the country, surrounded by water and lots of open nature preserves. That meant plenty of backyards that fed into rolling hills, perfect for exploring, and even horses that we may or may not have ridden to the Burger King drive-through now and then. It was once a gold rush town, and much of the nineteenth-century downtown is preserved. I love the Victorian houses, the old brick bank, and the John Muir house. Yes, the godfather of our national park system chose to live *here*, thank you.

COLORFUL SICILIAN SUPPER

I have history in Martinez, as my great-grandmother Marion was the first in the family to move here from San Francisco when she married my great-grandfather.

She was my favorite person, a bold Italian-American. Her cooking and her home were a reflection of this boldness. She loved food, she loved florals, and she loved chintz.

She and Martinez were my inspiration to create this table and menu. It's like going home for me every time.

It's my updated take on her Italian-American style with a bit of Italian restaurant kitsch thrown in . . . red-and-white check tablecloth and dripping candles in Chianti bottles. I keep the best of it and add some European elements so that it feels warm and welcoming—just like her—but has a bit more of a layered design.

Round tables are great for smaller dinners. It feels cozier, and everyone can talk to one another. I set it up in the living room, ideally by the fire. (You can use a cheap folding table because no one will see the legs once the tablecloth is on.) I cover it with burlap and then layer on a smaller red-and-white check so you can see the burlap peeking through.

Blue-and-white earthenware plates break up the red-and-white and make it feel like you're in a trattoria (or at my nana's house). I use white linen napkins with a blue stripe or dish towels and arrange a water glass and a wineglass—but I serve the water in the stemware and the

Page 68: The John Muir House in my hometown. Opposite: In my Italian-American dining room, I used my Veronica wallpaper from Wallshoppe and Ralph Lauren's Mill Pond Check fabric as a tablecloth. The wicker chairs and burlap tablecloth add a calming effect to the bold pattern.

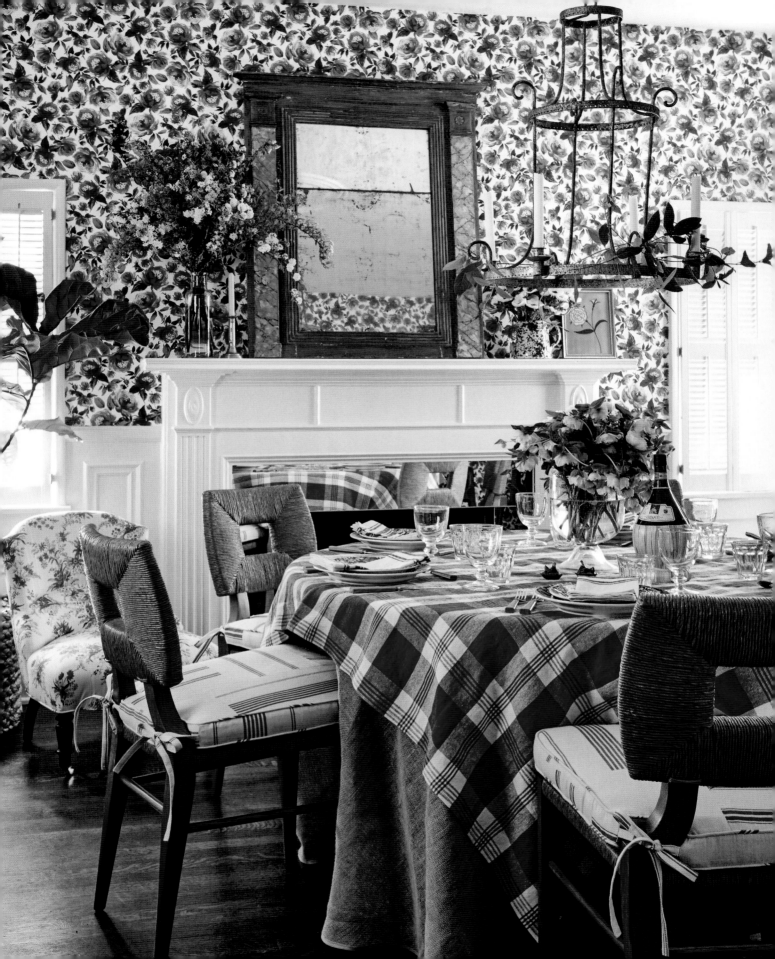

wine in the smaller glasses. (Most casual places in Italy serve wine this way.) Wooden-handled flatware adds some shape without competing with all the color and pattern.

I like to spread out the flowers here (some on the table, some on the mantel or buffet). I switch up the vessels and types of flowers but keep them all in one color, like white. Some arrangements are tall and others shorter. It reminds me of how you see flowers in European homes, pretty but totally effortless. For vases, I just pull what's around, glass cylinders, earthenware pitchers, footed bowls . . . it all works. I also wrap some ivy around the chandelier, a nod to the plastic plants you see at Italian-American restaurants.

Mare was the person who first taught me how to cook, and these meatballs were one of the first things I learned how to make. While I'm sure you can tell I love most food, this would be my last meal on earth. It's the ultimate comfort food to me. And whenever I make this meal, I'm taken back to her kitchen—mixing up the meatballs, a perfect balance of spicy and sweet.

Something I really like about this menu is that the dishes can be made in advance and I think taste better when prepared the day before. It's my cozy Italian supper with a California twist.

I love a proper cocktail to serve as soon as guests arrive. It's the perfect way to make them feel welcome and put them in a good mood. I stick with the classics and usually serve an ice-cold vodka martini with this menu. (Born during the gold rush, legend has it that the cocktail was invented here and named for the town. Though San Francisco likes to say it was first made there.)

There's nothing better with a cold drink than something crispy and hot, so I serve my fried cauliflower with cocktails.

The meatballs are Sicilian-style, filled with ground beef and pork, plus raisins and pine nuts that give them a little sweetness and texture. In California, you have to serve some fresh veggies. This Brussels sprout salad is fresh and bright alongside the red sauce and bread. Speaking of which, garlic bread is such an Italian-American staple (who doesn't love it?), and you need it to soak up every last bit of sauce.

Having an Italian-American grandmother meant that we never ate Italian food out. How could it be better than anything she made? The one exception was Fior d'Italia in San Francisco (which sadly closed recently). They had a warm zabaglione that was to die for! Eating it while sunk into one of their red leather banquettes with paintings of Vesuvius on the wall made it all the more special. When I went to re-create this dish, I wanted to tweak it so I didn't have to serve it right away. So my frozen zabaglione pie was born.

It is a twist on that classic Italian custard made with egg yolks, sugar, and a sweet wine, like Marsala. (Think of it as an Italian key lime pie.)

The first time I served it, I was nervous people wouldn't love the Marsala, but everyone gobbled it down and asked for seconds. I top it with fresh whipped cream and fresh strawberries. After dinner, we move from the table to the sofa and comfy chairs for dessert. Also, I need a place to lie on the floor after too many meatballs. ★

FAMILY STYLE

There is nothing more comforting than family-style meals. While I can enjoy a fancy dinner, I think a table or buffet filled with pots of food to dig into is the best. And family style is really California style. It's casual here. It makes for a more successful party to me. People pass things, share, and interact with the meal they're having together. And I love a pot-to-table dish. It's easier on the host and it puts people at ease, like they're in their own home. I don't have a staff, so I try to make it easier on myself whenever I can.

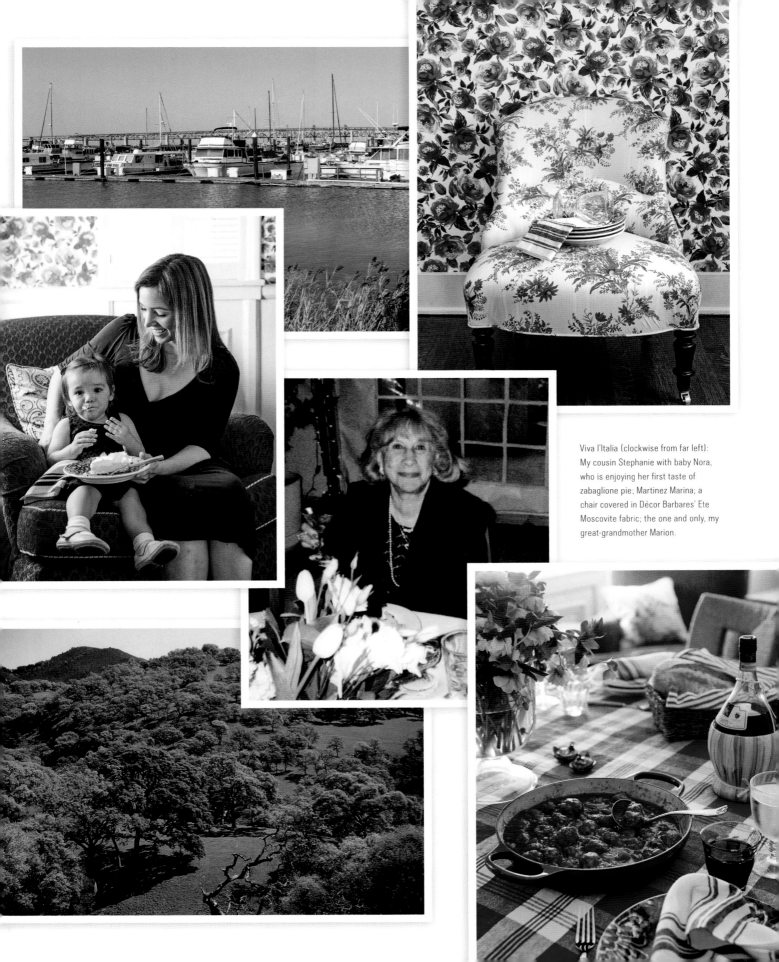

Viva l'Italia (clockwise from far left):
My cousin Stephanie with baby Nora,
who is enjoying her first taste of
zabaglione pie; Martinez Marina; a
chair covered in Décor Barbares' Ete
Moscovite fabric; the one and only, my
great-grandmother Marion.

dirty vodka martini

SERVES 1

You can't live in Martinez, the rumored
birthplace of this classic cocktail, and not make
a great martini. Pop the glasses in the freezer
for a few minutes before mixing.

ICE

2½ OUNCES (75 ML) VODKA

½ OUNCE (15 ML) DRY VERMOUTH

4 TEASPOONS OLIVE BRINE

2 TO 3 PITTED OR STUFFED GREEN OLIVES

In a cocktail shaker filled with ice, combine vodka, vermouth,
and olive brine. Shake vigorously for 1 minute. Strain into a
chilled martini glass and garnish with olives.

fiori fritti

SERVES 8

I ate this like popcorn when I was
a little kid. Like any fried food, this is
best served hot from the pan.

1 HEAD CAULIFLOWER, CUT INTO FLORETS

1 CUP (100 G) BREAD CRUMBS

½ CUP (50 G) GRATED PARMESAN CHEESE

1 TEASPOON SALT

½ TEASPOON GROUND BLACK PEPPER

3 LARGE EGGS, BEATEN

CANOLA OIL FOR DEEP-FRYING

1 LEMON, CUT INTO WEDGES

Prepare a large bowl of ice water and set aside. Bring a large
pot of water to a boil and blanch cauliflower, in batches, for
1 minute. Transfer to ice bath and continue until all florets
have been blanched and shocked. Drain well.

In a bowl, combine bread crumbs, cheese, salt, and pepper
and stir well. Transfer eggs to a shallow bowl.

Pour oil into a heavy-bottomed pot to 4 inches (10 cm) deep
and heat over medium-high heat to 350°F (175°C) on a
deep-fry thermometer. Dip florets in egg wash and then coat
in bread crumb mixture, shaking off excess. Carefully transfer
to hot oil and fry for 2 minutes or until golden brown. Drain
on paper towels and continue until all cauliflower is fried.

Serve with lemon wedges.

marion's sicilian meatballs

SERVES 8

I was taught to brown the meatballs before adding them to the sauce. Then I read
a Mario Batali cookbook where he drops the raw meatballs in the sauce instead.
I tried it (and waited to see if I was going to be struck by lightning),
and it was amazing. I never browned them again. (Sorry, Mare.) Really,
it makes sense—poaching them in the sauce makes them super tender.

for the sauce:

2 TABLESPOONS OLIVE OIL

1 CUP (110 G) CHOPPED ONION

5 CLOVES GARLIC, MINCED

1 (28-OUNCE/794-G) CAN CRUSHED TOMATOES

1 (18-OUNCE/510-G) CAN TOMATO SAUCE

1 CUP (240 ML) RED WINE

1 TABLESPOON DRIED OREGANO

4 TEASPOONS TOMATO PASTE

1 TEASPOON SALT

1 TEASPOON GRANULATED SUGAR

½ TEASPOON RED PEPPER FLAKES

for the meatballs:

2 SLICES WHITE BREAD

1 CUP (240 ML) WHOLE MILK

¼ CUP (35 G) RAISINS, CHOPPED

1 POUND (455 G) GROUND BEEF

1 POUND (455 G) GROUND PORK

½ CUP (50 G) GRATED PARMESAN CHEESE, PLUS MORE FOR SERVING

½ CUP (50 G) BREAD CRUMBS

1 LARGE EGG

¼ CUP (35 G) PINE NUTS, CHOPPED

¼ CUP (13 G) CHOPPED FRESH FLAT-LEAF PARSLEY

3 CLOVES GARLIC, MINCED

1 TABLESPOON HOT PEPPER SAUCE

1 TEASPOON SALT

1 TEASPOON GROUND BLACK PEPPER

In a large Dutch oven or pot, heat olive oil over medium heat.
Sauté onion for 5 minutes, until just soft. Add garlic and sauté
for 1 minute more. Add crushed tomatoes, tomato sauce,
wine, oregano, tomato paste, salt, sugar, and red pepper
flakes and stir. Bring to a simmer and cook, uncovered, for
1 hour, stirring occasionally.

In a small bowl, combine bread and milk and let sit for
10 minutes or until soggy. In a separate bowl, cover raisins
with warm water and soak for 15 minutes, until rehydrated.

In a large bowl, mix together beef, pork, cheese, bread
crumbs, egg, pine nuts, parsley, garlic, hot pepper sauce,
salt, and pepper. Drain raisins before adding to mixture, and
squeeze milk out of bread and add to mixture. Stir until well
combined. Roll into round balls of about two tablespoons each
and gently place in simmering sauce. Simmer for 45 minutes,
until cooked through. Serve with additional cheese.

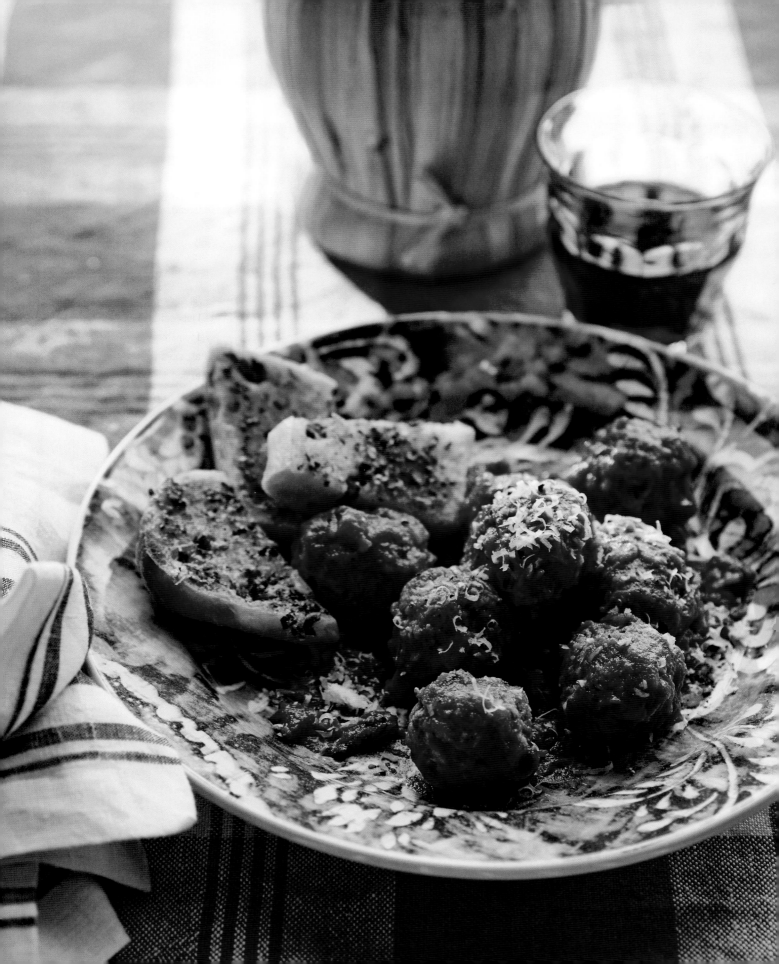

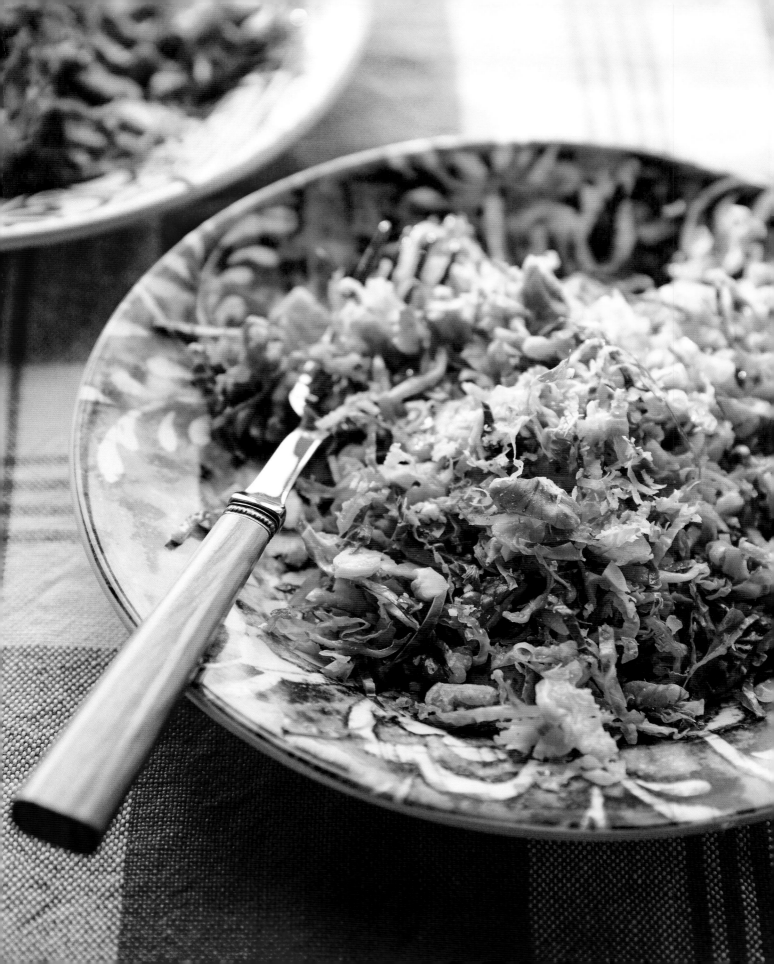

brussels sprout salad

SERVES 8

This is such a hearty salad, and it would make a great dinner all by itself. To be honest, I never loved whole Brussels sprouts. We had a few dates but nothing. Once I shredded them, everything changed, and I was in love. Tip: Trader Joe's and many other specialty stores sells bags of shredded sprouts.

3 (10-OUNCE/280-G) CONTAINERS BRUSSELS SPROUTS, TRIMMED AND SHREDDED

1 CUP (120 G) WALNUTS, TOASTED AND COARSELY CHOPPED

1 CUP (100 G) FRESHLY GRATED PARMESAN CHEESE, PLUS MORE FOR GARNISH

⅔ CUP (165 ML) OLIVE OIL

⅓ CUP (75 ML) LEMON JUICE

1 TEASPOON GROUND WHITE PEPPER

1 TEASPOON SALT

In a large bowl, toss together all ingredients until the Brussels sprouts are well coated. Let sit for 15 minutes before serving and garnish with extra cheese.

red pepper garlic bread

SERVES 8

I am not going to lie, this is basically fancy Texas toast. And you have to have the red pepper flakes. Even if you are spice-averse, it adds a depth that you need.

½ CUP (115 G) UNSALTED BUTTER, SOFTENED

½ CUP (50 G) GRATED PECORINO-ROMANO CHEESE

¼ CUP (13 G) CHOPPED FRESH FLAT-LEAF PARSLEY

2 CLOVES GARLIC, MINCED

½ TEASPOON RED PEPPER FLAKES

½ TEASPOON SALT

¼ TEASPOON GROUND BLACK PEPPER

1 LOAF FRENCH BREAD OR BAGUETTE

Preheat broiler.

In a bowl, mix together butter, cheese, parsley, garlic, red pepper flakes, salt, and pepper until well combined. Slice bread in half lengthwise and spread butter mixture evenly on both sides. Broil for 2 to 4 minutes or until golden brown and crispy. Slice and serve.

frozen zabaglione pie

SERVES 8 TO 10

I love a make-ahead pie. There are many in this book,
but this one is unexpected because of the wine. If Marsala is not
your jam, substitute it with any sweet wine you like.

for the crust:

1 CUP (120 G) GRAHAM CRACKER CRUMBS

1 TABLESPOON LIGHT BROWN SUGAR

¼ TEASPOON SALT

4 TABLESPOONS (55 G) UNSALTED BUTTER, MELTED

for the filling:

6 LARGE EGG YOLKS

¾ CUP (180 ML) SWEET MARSALA WINE

½ CUP (100 G) GRANULATED SUGAR

1 CUP (240 ML) HEAVY CREAM

1 TEASPOON VANILLA EXTRACT

STRAWBERRIES AND WHIPPED CREAM, FOR SERVING

Preheat oven to 350°F (175°C).

In a large bowl, combine graham cracker crumbs, brown sugar, and salt and stir well. Add melted butter and stir until combined. Transfer to a 9-inch (23-cm) pie plate and press into an even layer all the way up the sides. Bake for 10 minutes or until light golden. Let cool completely.

Prepare an ice bath in a large bowl and set aside. Fill a medium pot with 1–2 inches (2.5–5 cm) of water and bring to a boil. In a bowl that fits on top of the pot without water touching the bowl, whisk together the egg yolks, wine, and sugar. Vigorously whisk until it begins to thicken and becomes frothy. Whisk constantly over medium heat for 12 to 18 minutes or until mixture forms a ribbon when whisk is lifted. Transfer bowl to ice bath and whisk occasionally until completely cool.

In a large bowl, beat cream and vanilla until stiff peaks form. Fold whipped cream into cooled mixture in two batches. Transfer mixture into cooled piecrust and smooth with a spatula. Freeze for at least 4 hours or overnight.

Serve with fresh strawberries and whipped cream.

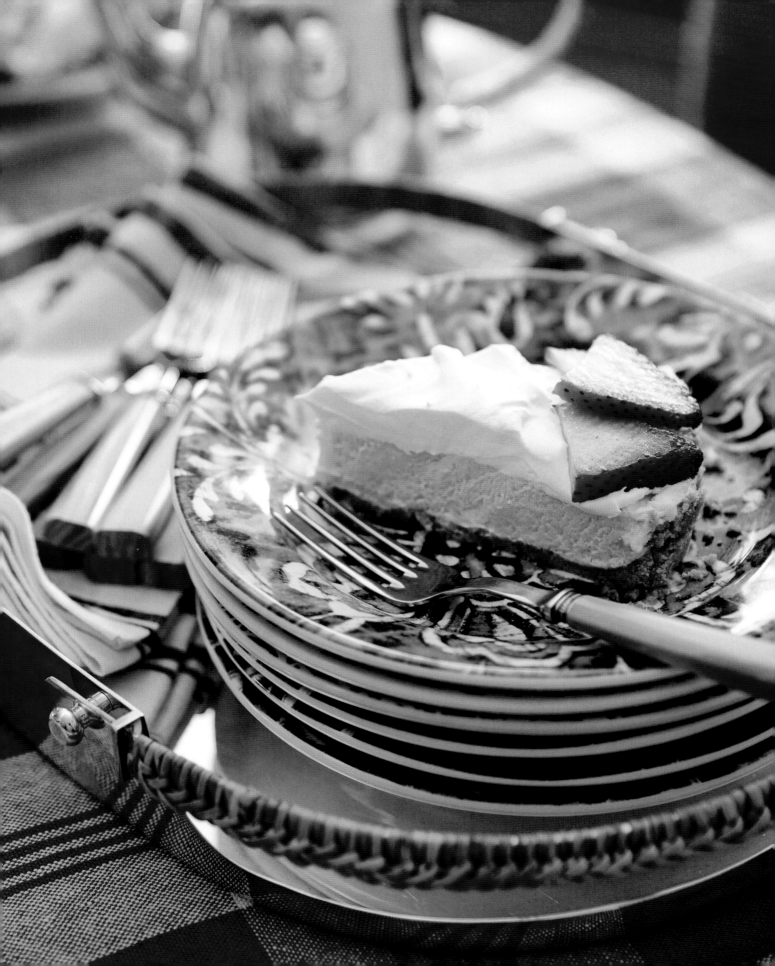

BUILD A SELF-SERVE BAR

I love a "help yourself" bar. To me, they mean everyone gets
what they want and you're not running back and
forth taking orders like a bartender. They are also more interactive
and fun, with people chatting while they help themselves.
Here's my guide to a well-stocked and smooth-running cocktail station.

THE BAR ESSENTIALS

Have these on hand for a basic bar:

VODKA

GIN

RUM (LIGHT)

BOURBON

SCOTCH

TEQUILA

VERMOUTH (DRY AND SWEET)

RED AND WHITE WINES

EXTRAS: RED VERMOUTH, COINTREAU OR TRIPLE SEC

THE MIXERS

I always buy the cute, small, single-serving bottles of soda
water, tonic, and ginger ale. I think they look much more
stylish than those huge plastic bottles, and I like the mini
soda cans too. They are less wasteful.

NONALCOHOLIC OPTIONS

I always have lemon sodas and sparkling water on hand for
guests who don't drink.

SOMETHING TO NIBBLE

Always have a snack or two on the bar as people help
themselves. This can be something as simple and easy as
nuts or chips.

NAPKINS

Make sure to have plenty of cocktail napkins on the bar, by
the snacks; some on the coffee table is also not a bad idea.

BUCKET OF ICE

Obviously essential for any bar. Extra credit for providing
crushed ice.

TRAY TIME

I always arrange things on trays. It divides the alcohol,
mixers, glassware, and garnishes. There is something about
a tray that makes a surface look organized and inviting.

GARNISH AWAY

Have plenty of lemons, limes, olives, lemon twists, mint,
and anything else guests might like in their drinks.

HIDE EXTRA SUPPLIES

I like to use an extra-long tablecloth or table skirt so that
I can quickly replenish things my guests need . . . extra
bottles of wine, napkins, nuts. This way I am not running
back and forth to the kitchen.

LOCATION!

Find a spot that is convenient for guests to access,
be it a dining room console or, as in the opposite page,
a nearby desk.

THINGS I LOVE ♥ NORTHERN CALIFORNIA

1 **MARCH** "BEST KITCHEN STORE IN SAN FRANCISCO."

2 **SPENGER'S FRESH FISH GROTTO** "CLAM STRIPS AND A MIXED LOUIE WERE MY GO-TOS AFTER A DAY OF SAILING."

3 **HEATH CERAMICS** "QUINTESSENTIAL CALIFORNIA MODERN POTTERY."

4 **FERRY BUILDING MARKETPLACE** "A TOURIST SPOT WHERE LOCALS ACTUALLY SHOP."

5 **SHED** "INCREDIBLE GOURMET FOOD SHOP AND KITCHEN STUFF."

6 **LUCCA RAVIOLI CO.** "BUY A BOX OF RAVIOLI TO TAKE HOME (ALWAYS IN MY CARRY-ON BACK TO LA)."

7 **NICK'S COVE** "COZY GETAWAY."

8 **LARKMEAD VINEYARDS** "OLDEST WINERY IN CALISTOGA, AND I LOVE THEIR REDS."

9 **HOG ISLAND OYSTER CO.** "BRING YOUR OWN PICNIC AND BUY OYSTERS THERE!"

10 **PETALUMA SEED BANK** "MY HOME GARDEN ALWAYS STARTS HERE."

11 **JOHN MUIR NATIONAL HISTORIC SITE** "THE FATHER OF OUR NATIONAL PARKS . . . ALSO FROM MY HOMETOWN."

12 **R&G LOUNGE** "SALT AND PEPPER CRAB? *YESSS*."

13 **ZUNI CAFÉ** "GOTTA GET THE CHICKEN FOR TWO."

14 **CHEZ PANISSE** "IT'S OBVIOUS, BUT I WAS LUCKY ENOUGH TO GROW UP WITH THIS GROUNDBREAKING PLACE IN MY BACKYARD."

15 **YANK SING** "DIM SUM FOR DAYS!"

16 **TADICH GRILL** "AS OLD-SCHOOL SAN FRANCISCO AS IT GETS; A FAMILY FAVORITE."

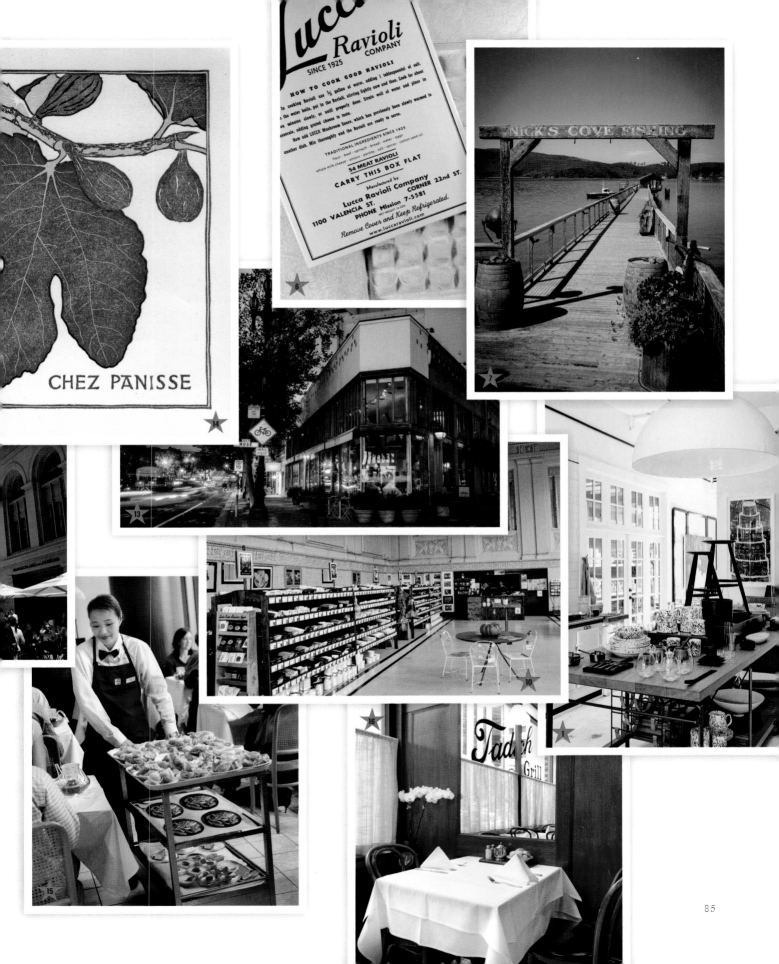

CHEZ PANISSE

14

Ravioli COMPANY
SINCE 1925

HOW TO COOK GOOD RAVIOLI

6

NICK'S COVE FISHING

13

10

1

16

Tadich Grill

15

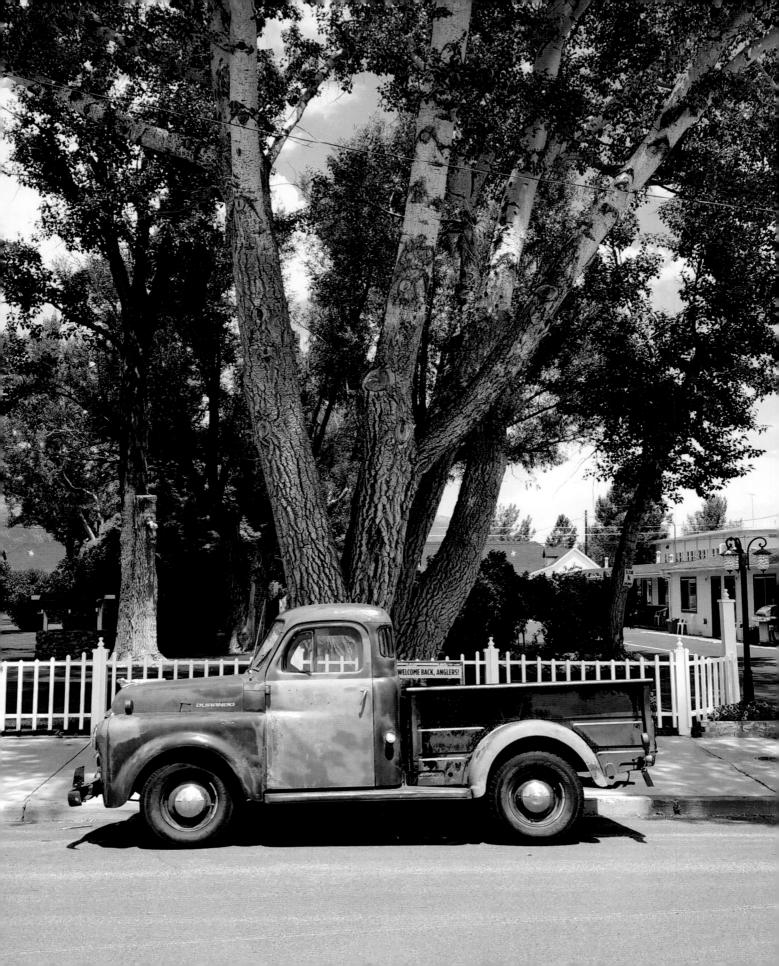

CENTRAL CALIFORNIA

★

SIERRA NEVADA

OK, so Central California is technically a subregion of Northern California, but it deserves a spotlight all its own. If you are looking at a map, it's the middle third of the state, which includes the northern part of the San Joaquin Valley, the Central Coast, and the foothills and mountains of the central Sierra Nevada.

SO YOU CAN IMAGINE THE REGION'S VARIED AND beautiful backdrops. To the west, there are beach towns like Big Sur and Monterey that have some of the most spectacular coastlines (and sunsets) anywhere. Farther inland, the Central Valley looks like something out of a John Wayne Western or a John Steinbeck novel.

People always picture desert and palm trees when they think of California, but this is cowboy country mixed with Alpine beauty. The ranches and fields lead to lush green hills, forests, and mountain peaks. Settled by trailblazers, it's still beautiful frontier land. The architecture is just as inspiring: rambling ranch houses with big porches, red-and-white barns, and pine-clad homes in the mountains.

Towns like Salinas, Markleeville, and Jackson have a raw, untouched feel and are closely tied to the land and what it provides. This is the food basket of California (and the country). I'm not one for knowing statistics, but I do know that much of the country's fruits and vegetables come from this area.

Though I grew up just outside San Francisco, I spent a lot of time here on my great-grandparents' cattle ranch just outside Stockton—a gold rush town in the Central Valley.

My first memories of home, family, food, and fun are here. If you call walking across freezing fields at five A.M. fun . . . (more on that below).

I learned early about agriculture and the cycle of food. My great-grandfather hunted and would take me along. But I quickly realized I'd rather be in the kitchen with my great-grandmother. She would teach me how to bake pies and can tomatoes just picked from her huge vegetable garden.

When I wasn't in the kitchen, my brothers and I were helping on the ranch (that's the five A.M. freezing fields), taking long hikes in the mountains, and fishing in the Carson River. Unlike other parts of California, there are true seasons here. Frosty cold mornings and evenings in the fall and dry, hot summer days filled with the smell of dried sage.

The environment and history here inform the design you see. These are places that are true Western pioneer towns. Many town centers, like Jackson and Placerville, feel frozen in time with their wooden walkways and old brick banks. The architecture in towns that hug the Sierra Nevada feels more like the Swiss Alps: white clapboard barns and simple A-frames.

Life and style are more pared back—nothing flashy or showy. It's the heartland of California.

My favorite houses to see are the original sprawling fifties ranch houses. All of the homes have faded, natural colors to blend into the background: pine greens, khakis, deep browns.

The humble, rustic way of life here inspired my love of simple, relaxed design.

Page 86: My dream wheels in Independence, California

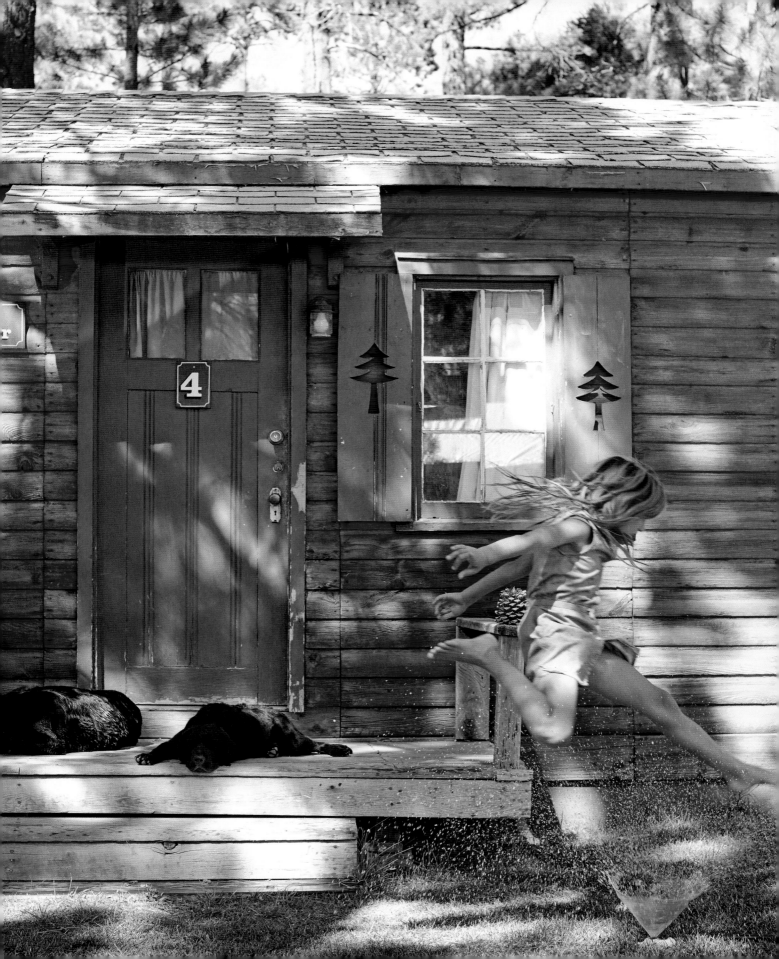

REFINED, RUSTIC STYLE

THE CENTRAL REGION PUTS THE COUNTRY IN
California. There's a beautiful simplicity to life here . . .
the homes, the people, the land. But everyone takes
great pride in their home and their family gatherings.
They're some of the most gracious hosts anywhere.

My great-grandmother Dora epitomized this. She
was a gentile English lady who ended up the wife of
a cattle rancher in the Wild West. And though she
accepted living in a tough place, she was not going to
give up the things she loved. At the helm of our family,
she took a refined-meets-rugged approach that inspired
my love for this look.

I call it Refined Rustic, which to me means classic
designs that are also cozy and comfortable. There's a
sense of history and classicism to it all: woven rugs,
faded stripes, unfussy farmhouse furniture. There's also,
of course, a bit of Western spirit: the humble straw of
a cowboy hat, the worn leather of a saddle, a copper-
edged sink.

The colors and patterns are classic Americana—
simple canvas stripes in creams and blues, some
Western motifs, and floral prints that make everyone
feel welcome.

My take is a modern one. It's about picking your
moments and using things sparingly. I'd rather see a
single authentic Navajo rug than a room covered in
southwestern patterns. It's about authentic vintage
pieces, not gift shop signs and tchotchkes.

Just remember to not overthink it. Like the people
and places here, nothing is too fancy or too precious,
and forget about fussy. ★

Remnants of the Old West (clockwise from this page): The Eastern California
Museum in an old rail car; Nacho in begging mode; the majestic Sierra Nevada;
chow time for Tucker, Louis, and Tuesday.

MY CENTRAL CALIFORNIA & SIERRA NEVADA

DAVIS
HOPE VALLEY
MARKLEEVILLE
PLACERVILLE
JACKSON
SALINAS
MONTEREY
BIG SUR
BAKERSFIELD

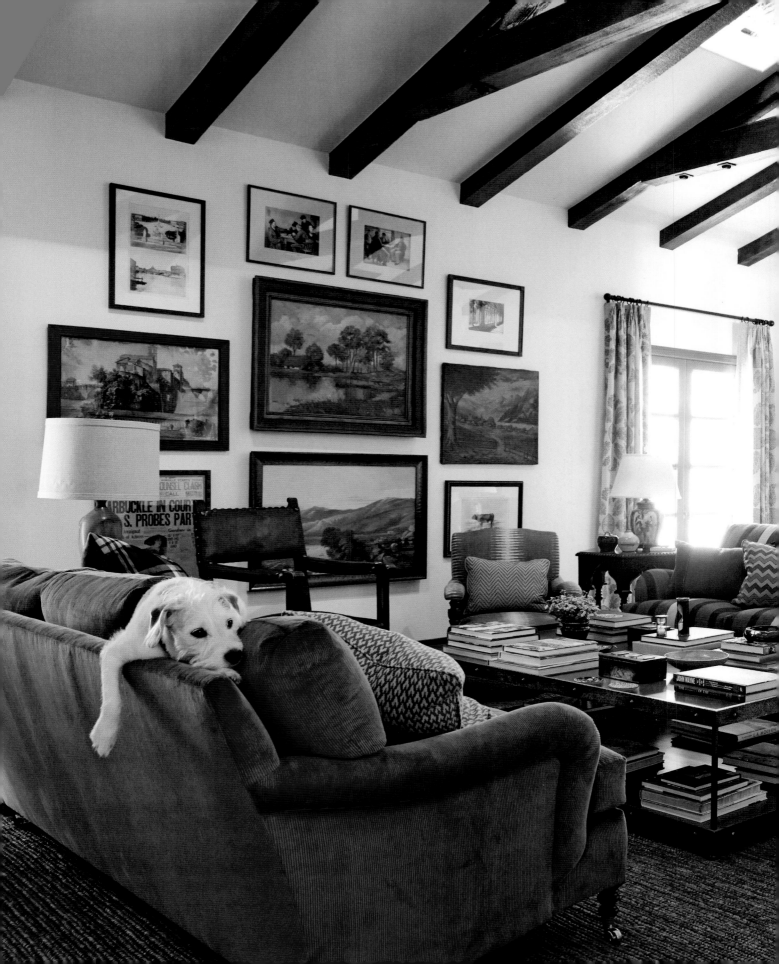

CENTRAL CALIFORNIA & SIERRA NEVADA STYLE MADE SIMPLE

PARE IT BACK

I love me some rustic style, but remember that this look can go campy or theme-y fast. To keep this from happening, anchor a space (or table) with one or two quintessential rustic notes. Try a reclaimed antler chandelier but stop before you add that wagon wheel table. Instead, place it over a simple glass or wood style. Here, it's all about editing. Always keep it classic and use actual vintage items over a gift-store reproduction. These always have more patina and depth, and they're well made.

LOOK TO NATURE

There's a reason natural elements stand the test of time in a room or on a table. They are not trendy or trite, but classic. They provide an authentic connection to what's around them. Some of my favorite ideas are slate stone floors in an entry, reclaimed wood kitchen cabinets with iron hardware, and burlap wallpaper in a bedroom. All are classic and add texture and warmth to your home.

USE WHAT YOU HAVE

It's a design lesson I've always followed. It's less about perfection and more about functionality and form. Look for timeless design that always works, like a simple bench or chair, a mason jar. They're classics for a reason. And don't be too quick to turn down your aunt's hand-me-down. A Victorian daybed can take on a new life painted black and covered in buffalo plaid. It loses some severity and feels modern and fun.

A Masculine Mix: Earthy colors with textured fabrics (corduroy and blanket weaves) infuse the room with a cowboy spirit for today.

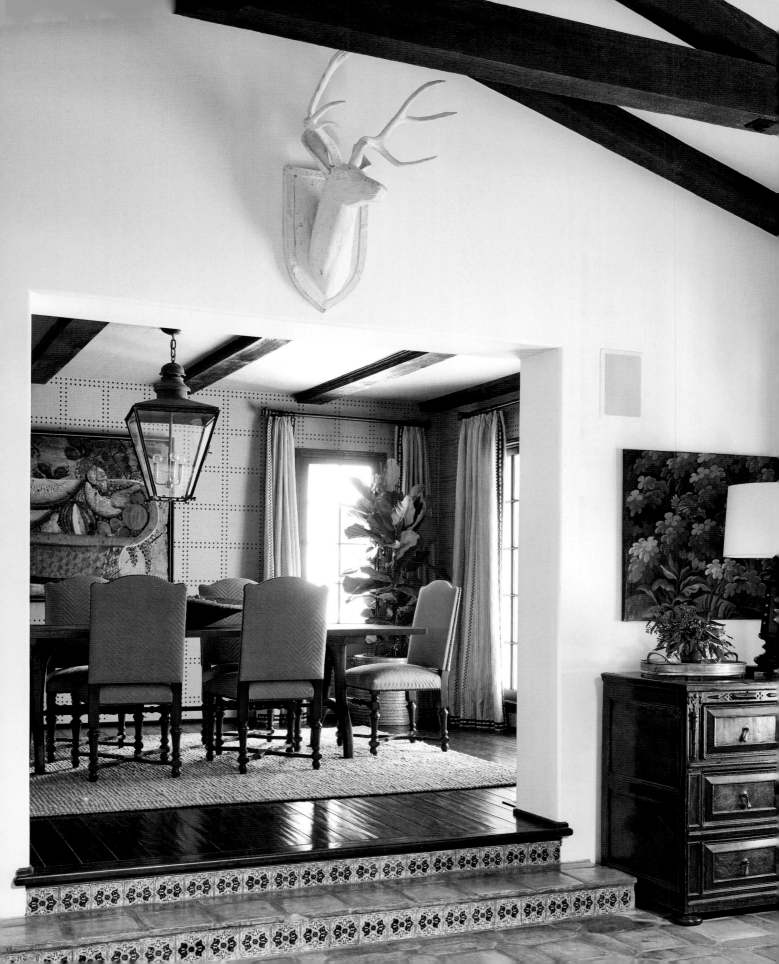

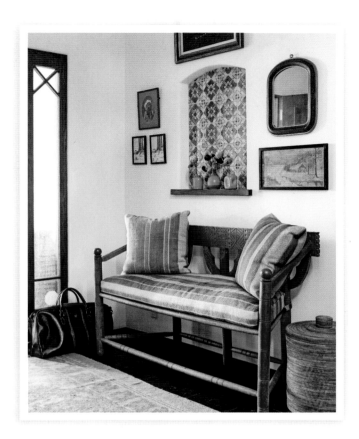

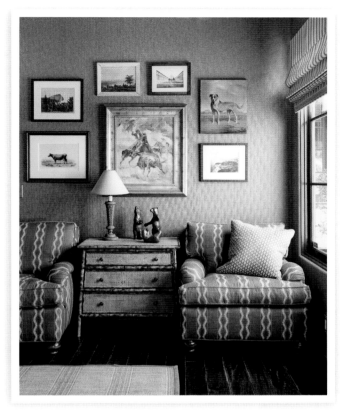

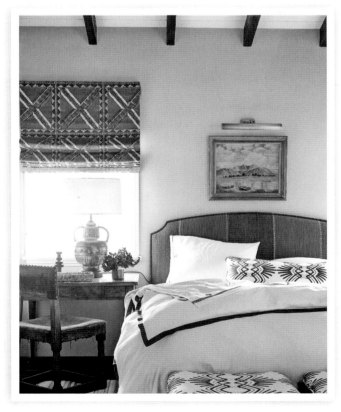

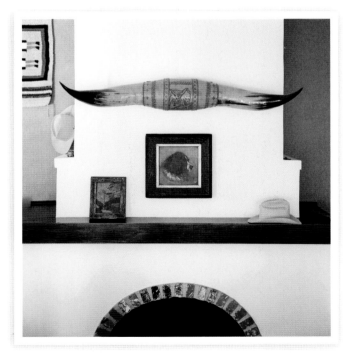

This page and opposite: Throughout this entire house, I really let the Spanish architecture lead the design. The simplicity of the white walls and dark wood beams create a framework that allows the antique pieces, art, and fabrics—from homespun to mod stripes—to shine.

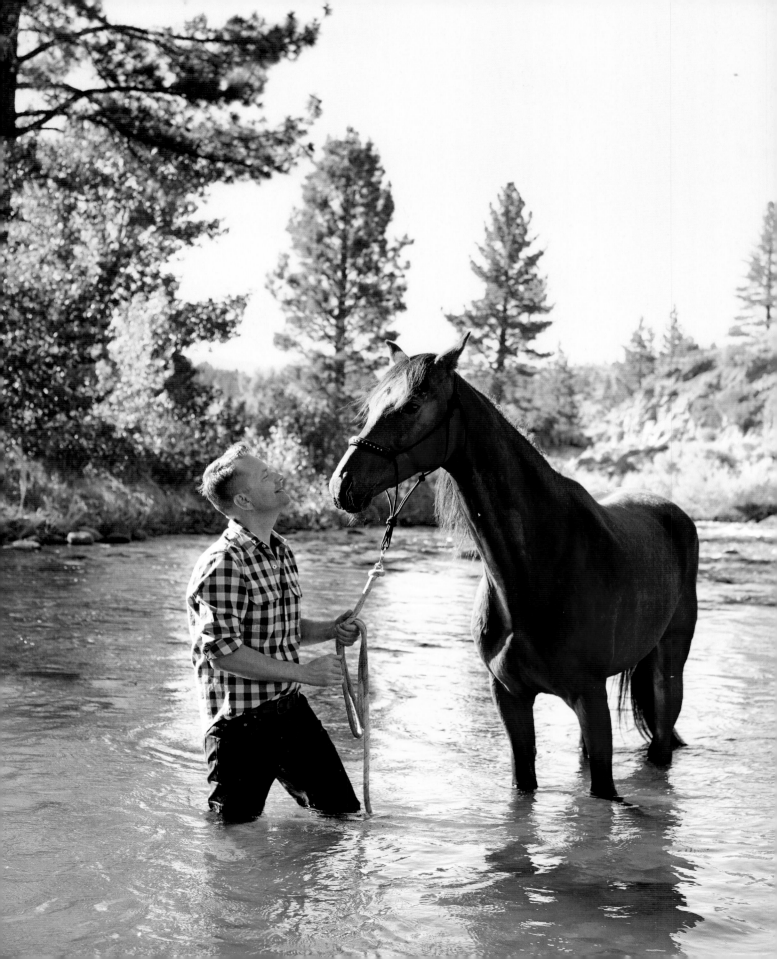

MARKLEEVILLE

menu

RANCH CHILI CON CARNE

JALAPEÑO CORN BREAD

TROMANHAUSER POTATO SALAD

MIXED BERRY COBBLER

Markleeville is an original California gold rush town in the middle of the Sierra Nevada. We'd always pass through its six square miles on our way to Lake Tahoe. It was a magical place to me as a little kid, a perfect mix of the Old West—with swinging saloon doors and wooden walkways that creak under cowboy boots—and lush, grassy Alpine valley areas.

JUST AS BEAUTIFUL IN THE SUMMER AS IT IS IN THE winter, it's a place I would go to year-round to camp, fish, and hunt.

CAMPFIRE CROWD PLEASER

This table and menu is my way of going right back to that town, that era (but with less chance of a saloon brawl). I also believe the closer you are to nature, the less you need. I grew up fishing, hiking, hunting, and camping with my family. Even though we were in a tent, with no running water, we always ate well and had a blast.

I think that having a childhood spent almost entirely outdoors influences how I cook and entertain today. My laid-back, easy approach is not just a response to being lazy!

And this is as laid-back and easy as it gets: I think of it as Cowboy Country Fantasy. The menu and setting channel Old West style, camping under the stars and paring things down to the basics.

But you don't need to be in the Wild West to enjoy it. This menu is great for a backyard barbecue, for Super Bowl parties, and of course for camping. It feeds a big crowd, it's totally portable, and each dish tastes better when made the day before. So you can prep it all in advance, warm it up, and you're done. All that's left to do that day is set up a chili bar so people can load up with cheddar, chips, jalapeños, etc.

Since everyone will be gathered around the campfire (or television) to eat, there's no table to sit at, so I use one as a work area/buffet. A folding table is fine (remember, we are not fancy here), but if you want, you can throw a simple cloth or runner over it. I do like to hang something just behind the table for fun, like a vintage flag or blanket.

I stack utensils, napkins, and tin plates and bowls at the prep station. I love camp tinware—it's so pretty, practical, and sturdy. And it weighs nothing. (See No More Paper Plates! on page 101.)

For flowers, I just use a few wild sprigs found around where we are camping and arrange them in a sturdy jug or camp coffeepot.

I lay out bowls of spices and dried Anaheim chiles, which are ingredients but have the benefit of looking beautiful too. After all, the cowboys didn't have much in the way of table decor.

Page 96: The only animal I know who loves to swim more than my labs is Dallas. Opposite: The camping kitchen is ready to feed a hungry corral.

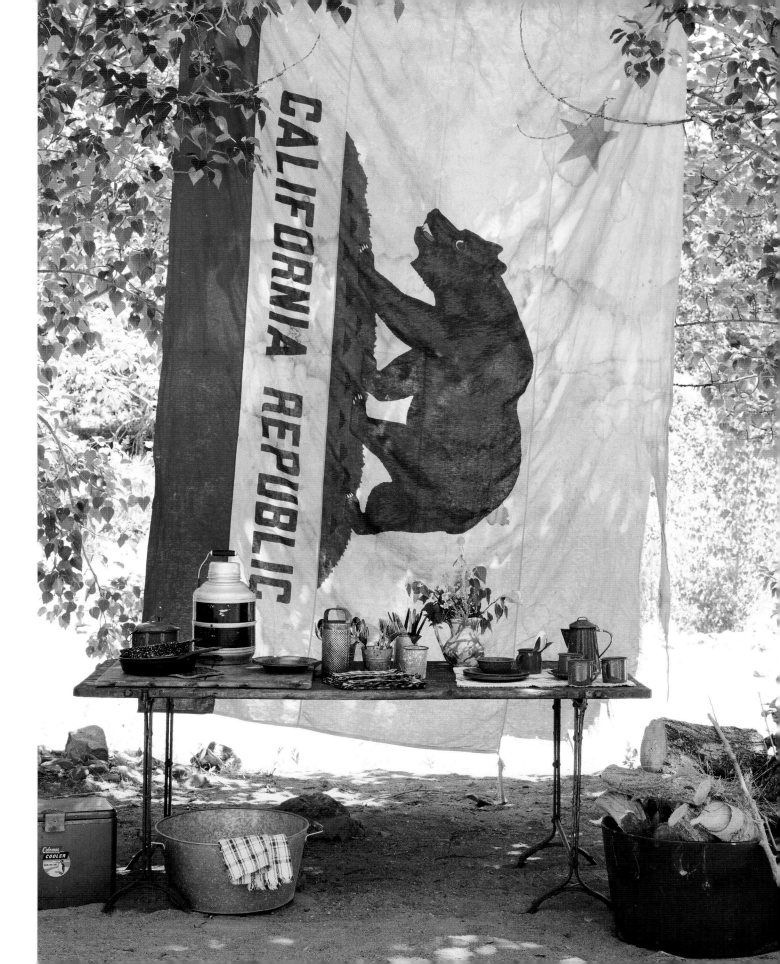

Chili is such a personal thing. Everyone has his or her preferences . . . like to bean or not to bean? Mine is true to the original, but I couldn't resist making a few small tweaks. Some things have not changed, like using steak instead of ground beef. And some twists are new, like adding coffee (trust me). To me, you can't have chili without corn bread. This is another ranch classic, but I switch it up each time I make it, mixing in a little cheddar sometimes or using Anaheim chiles. I love how the sweetness of the corn balances the heat of the peppers.

The potato salad was a staple at the ranch; there was always a bowl of this in the fridge. My twist is to use pickle juice instead of regular vinegar. It's a great way to use what's left in the jar.

Blackberries and raspberries grew all over the ranch, so this cobbler was often on the table. Serve it with vanilla ice cream and, I mean, how can you go wrong? ★

Opposite: Anaheim chiles and spices are ready for their star moment as chili con carne.
Right: Pre-cobbler berries

NO MORE PAPER PLATES!

Can I just take a moment to make a plea? No more paper plates, please. I love convenience and simplicity, but I think they're a total waste. And it's not just a style thing. They're not eco-friendly, and I really believe that food just doesn't taste as good on them. Instead, I use camp tinware or anything that's lightweight and stackable. You'll save money, and the food will be more delicious. Promise.

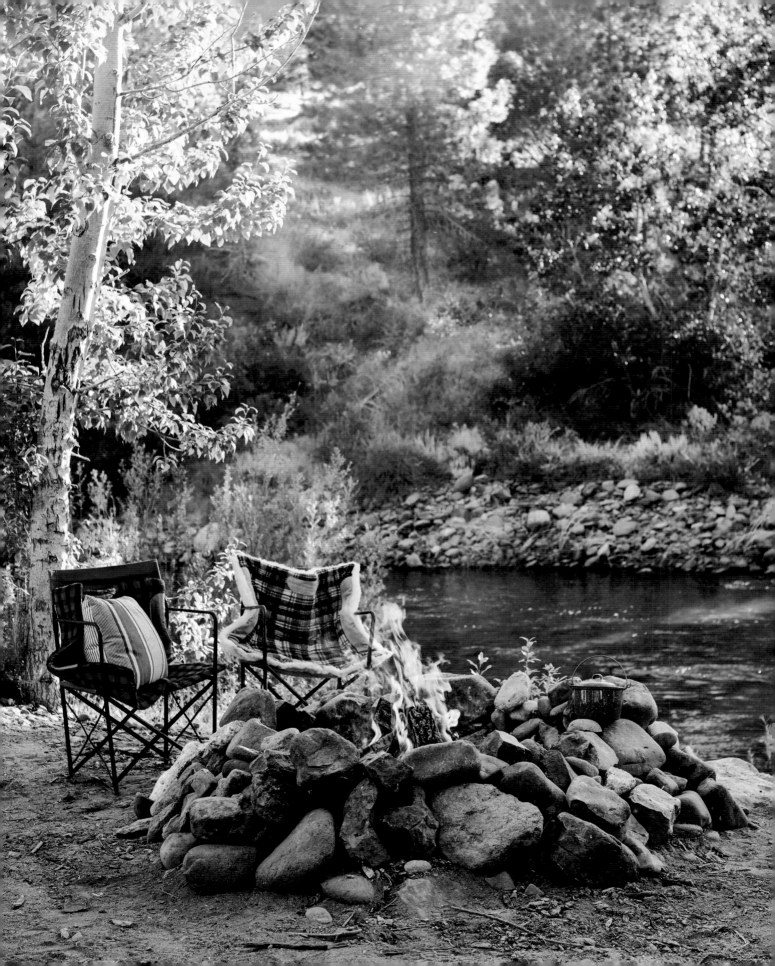

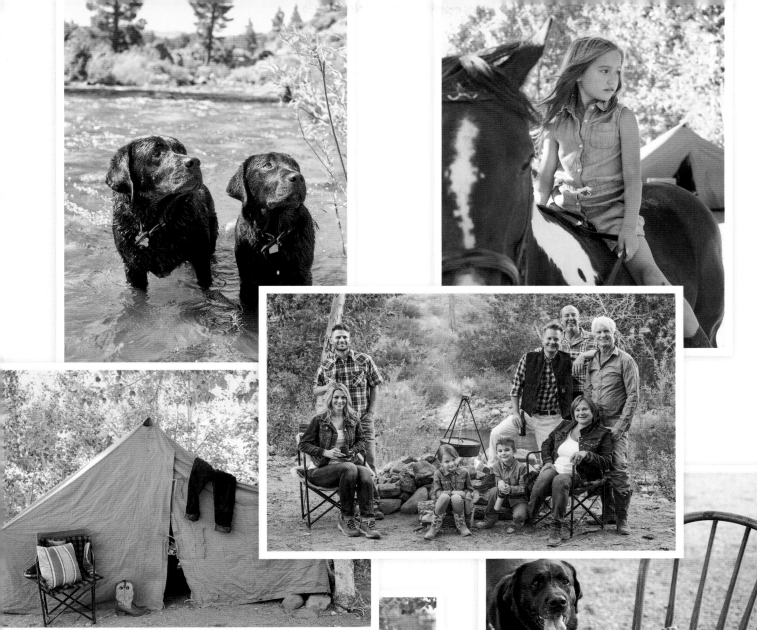

Opposite: Campfire chic. This page (clockwise from top left): My water dogs in the Carson River; family cookout; surprise, surprise, Nacho begging again; getting the s'mores ready with Minnie, Johnny, and Tuesday.

ranch chili con carne

SERVES 6 TO 8

This was the standard recipe on the ranch. But if you are curious
about making it your own, please go ahead. Change it up or add to it! Just please make it.

3 POUNDS (1.4 KG) BEEF ROAST, CUT INTO 1-INCH (2.5-CM) CUBES

1 TEASPOON SALT

1 TEASPOON GROUND BLACK PEPPER

3 TABLESPOONS CHILI POWDER, DIVIDED

1 POUND (455 G) BACON, CHOPPED

1 YELLOW ONION, FINELY CHOPPED

5 CLOVES GARLIC, MINCED

2 TABLESPOONS CUMIN SEEDS

1 TABLESPOON DRIED OREGANO

1 TEASPOON SWEET PAPRIKA

1 TEASPOON DRIED THYME

1 TEASPOON GROUND CUMIN

1 BOTTLE MEXICAN BEER

1 (28-OUNCE/795-G) CAN TOMATO SAUCE

1 CUP (240 ML) BEEF STOCK

4 DRIED ANAHEIM CHILES, REHYDRATED IN
3 CUPS (720 ML) BOILING WATER AND PUREED

1 TABLESPOON INSTANT ESPRESSO

SOUR CREAM, SHREDDED CHEDDAR CHEESE,
CHOPPED RED ONION, FOR SERVING (OPTIONAL)

In a large bowl, toss beef with salt, pepper, and 2 tablespoons of the chili powder and set aside. Sauté bacon in a large Dutch oven, stirring often, for 12 minutes or until crispy. Remove with a slotted spoon to drain on paper towels.

Brown beef in bacon fat on all sides for 8 to 10 minutes. Remove beef from pot and set aside. Sauté onion and garlic in same pot for 5 minutes or until just translucent. Add remaining chili powder, cumin seeds, oregano, paprika, thyme, and ground cumin and sauté for 3 minutes to toast. Deglaze with beer and bring to a boil. Add tomato sauce, beef stock, pureed chiles, and espresso and stir. Add reserved beef and bacon and bring to a boil. Reduce to a simmer and cook for at least 1 hour.

Serve with sour cream, shredded cheese, and chopped red onion, if desired.

jalapeño corn bread

SERVES 12

Obviously, cornbread to is to chili as peanut butter is to jelly.
And it's even better with honey drizzled over it.

2 CUPS (255 G) ALL-PURPOSE FLOUR

1½ CUPS (185 G) CORNMEAL

⅔ CUP (135 G) GRANULATED SUGAR

1 TABLESPOON BAKING POWDER

1 TEASPOON SALT

2½ CUPS (600 ML) WHOLE MILK

½ CUP (120 ML) VEGETABLE OIL

2 LARGE EGGS, BEATEN

½ CUP (75 G) SLICED JALAPEÑO CHILES

Preheat oven to 400°F (205°C). Grease a 9-inch (23-cm) square baking pan and line with parchment paper.

In a large bowl, whisk together flour, cornmeal, sugar, baking powder, and salt. In a medium bowl, combine milk, oil, and eggs. Mix wet and dry ingredients together until just moist. Fold in jalapeños and pour batter into greased pan.

Bake for 1 hour, until a toothpick inserted in the center comes out clean. Let cool before slicing.

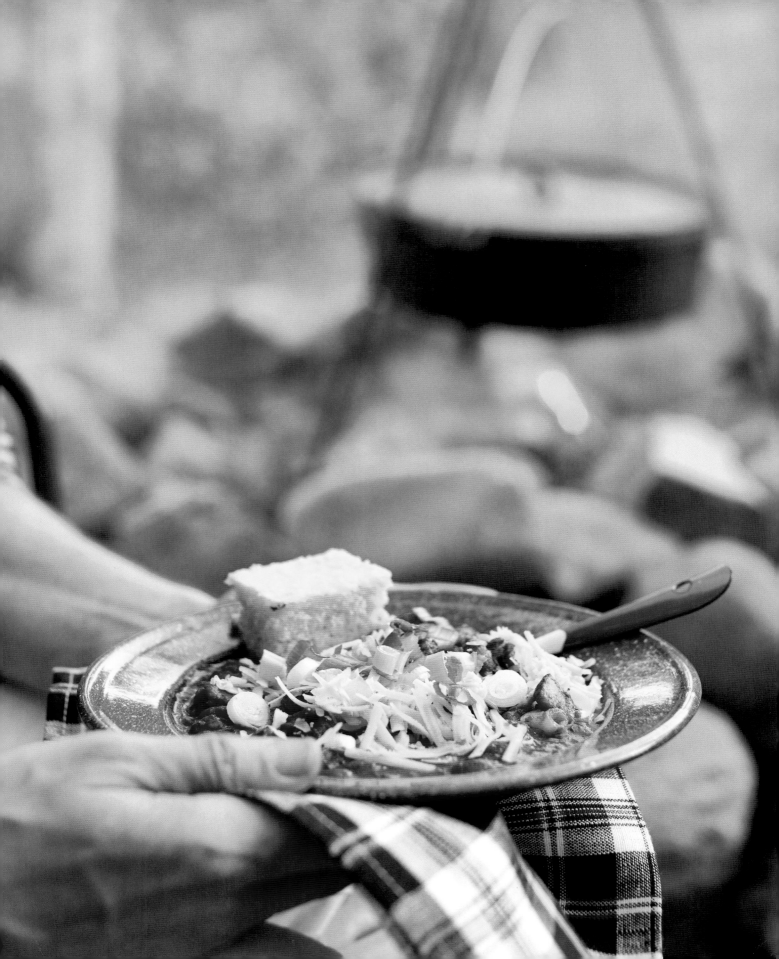

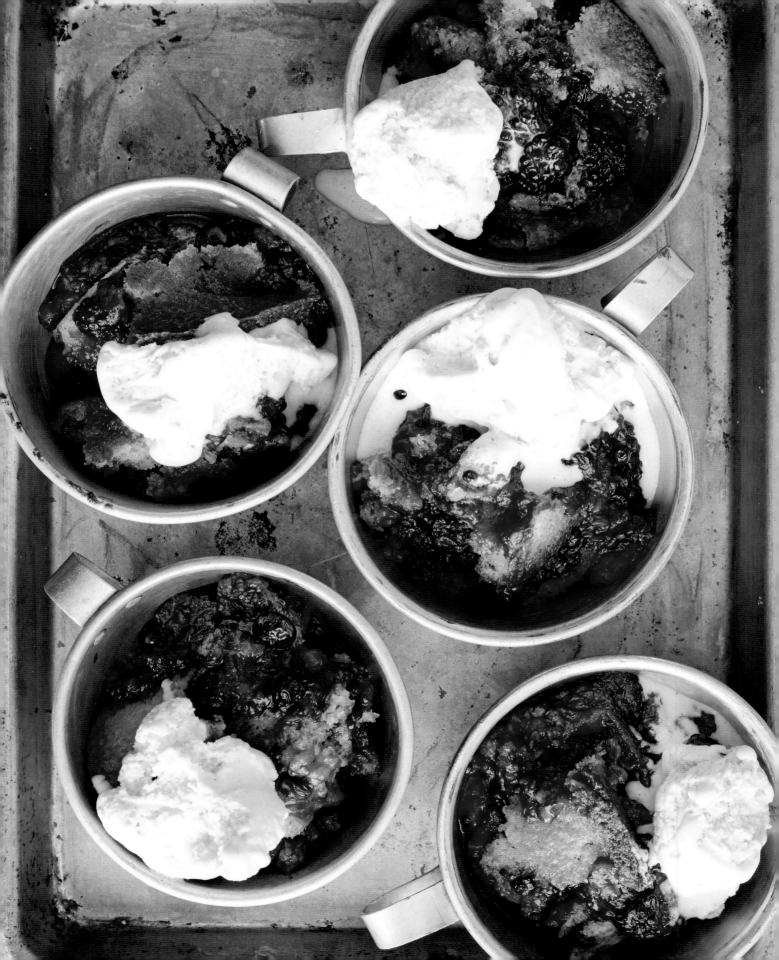

tromanhauser potato salad

SERVES 6

I use baby yellow potatoes for this recipe, but feel free to use the red-skin
variety if you like. Also, you can substitute Dijon mustard for the whole grain. I just
love the pops of the mustard seeds when you bite into the salad.

2 POUNDS (910 G) BABY YELLOW POTATOES

½ RED ONION, FINELY CHOPPED

3 STALKS CELERY, FINELY CHOPPED

½ CUP (70 G) DILL PICKLES, CHOPPED

½ CUP (120 ML) MAYONNAISE

¼ CUP (13 G) CHOPPED FRESH FLAT-LEAF PARSLEY

2 TABLESPOONS WHOLE-GRAIN MUSTARD

1 TABLESPOON PICKLE JUICE

½ TEASPOON SALT

½ TEASPOON GROUND BLACK PEPPER

½ TEASPOON CELERY SALT

½ TEASPOON HOT PEPPER SAUCE

Bring a large pot of water to a boil over high heat. Cook potatoes for 15 to 20 minutes or until tender when pierced with a fork. Drain and let cool.

In a large bowl, combine potatoes with onion, celery, pickles, mayonnaise, parsley, mustard, pickle juice, salt, pepper, celery salt, and hot pepper sauce and toss gently to coat. Serve immediately or refrigerate for up to 4 hours.

mixed berry cobbler

SERVES 8 TO 12

You can use virtually any fruit in a cobbler and it will be OK. I've done this recipe
with nectarines, peaches, and all kinds of berries. But the mix of
blueberries, blackberries, and raspberries here is what makes it the ultimate version to me.

2 CUPS (285 G) BLACKBERRIES

1 CUP (125 G) RASPBERRIES

1 CUP (145 G) BLUEBERRIES

1 CUP (200 G) PLUS 2 TABLESPOONS
GRANULATED SUGAR, DIVIDED

ZEST AND JUICE OF 1 LEMON

1 CUP (125 G) ALL-PURPOSE FLOUR

2 TEASPOONS BAKING POWDER

½ TEASPOON SALT

1 CUP (240 ML) WHOLE MILK

½ CUP (115 G) UNSALTED BUTTER, MELTED

1 TEASPOON VANILLA EXTRACT

VANILLA ICE CREAM, FOR SERVING

Preheat oven to 400°F (205°C).

In a large bowl, combine berries with 2 tablespoons of the sugar and the lemon zest and juice and lightly mash to release juices.

In a separate bowl, whisk together flour, baking powder, salt, and remaining sugar. Add milk, butter, and vanilla and mix well. Heat a 9-inch (23-cm) cast-iron skillet in the oven for 5 minutes. Carefully pour batter into skillet and top with berries and their juices in the center. Bake for 1 hour, until top is golden brown and a toothpick inserted in the center comes out clean. Let cool for 5 minutes before serving with ice cream.

HOPE VALLEY

★

menu

PESTO-CRUSTED LAMB CHOPS

SIDNA'S PEA SALAD

SMASHED RED POTATOES WITH ASIAGO

PIMM'S CUP

LEMON BUNDT CAKE

Just south of Lake Tahoe, this picturesque region
has amazing trout fishing and miles of great horse trails.
In the winter, it's filled with people snowshoeing
and cross-country skiing. There's so much
to do, you forget there's practically no cell service.

IT LOOKS LIKE A SWISS ALPINE FANTASY WITH ROLLING hills, little wooden chalets, and fields of wildflowers (which I loved to press when I was little). It's an outdoor wonderland where people go to run, ski, and cast off. I love this little slice of northern Europe in the heart of California.

LADY'S GARDEN LUNCH

These photos were taken at my mom's (aka Lady's) house. The dishes and the English-meets-Western design here are an ode to the magic of living outdoors. My happiest memories here were in early spring when the weather turned warm and our world turned outward . . . especially our meals.

I love an alfresco lunch. Who doesn't want to eat outside when the weather is nice? This party was definitely inspired by my other great-grandmother, Dora, who was English. When I was little, I used to think everything she did was magical. Her tables always had an *Alice in Wonderland* feel to them: the colorful china, lace napkins, and cut-crystal glasses.

My take is, surprise, a bit more casual. I keep the farmhouse table and pull up a jumble of chairs that definitely don't match. The tablecloth is a length of inexpensive striped linen I got at a fabric store and trimmed with scissors (I love the way the raw edges look). I mix some vintage white china with newer white plates.

The glasses are a combination of my grandmother's cut glass and other stemware I found at junk shops. Instead of lace everywhere, I scatter a few doilies along the table and on the drinks tray. You can re-create it using what you have around. Don't worry about it looking mismatched. That's the charm of it.

This menu is a blend of old and new too. Lamb chops were always a treat on the ranch (it was usually steak or burgers). And I always associate them with spring. They're marinated in my mom's parsley pesto (it was always growing wild in the garden).

To me, this pesto is a grown-up version of mint jelly, which I used to pour over my lamb. There is no better accompaniment to the lamb than these smashed potatoes. The Asiago cheese gives them the salt factor you want, and the crispy shallots add some crunch to the smooth potatoes.

A family friend always made this pea salad, and I love the passé mix of peas with watercress, water chestnuts, sour cream, and Spanish peanuts.

I always serve my lemon Bundt cake with lots of fresh berries, drizzle sauce, and whipped cream for guests to build their own desserts. The Pimm's cup is another nod to my English great-grandmother. ★

Opposite: This is truly a vintage mix. I love how the classics stand the test of time.

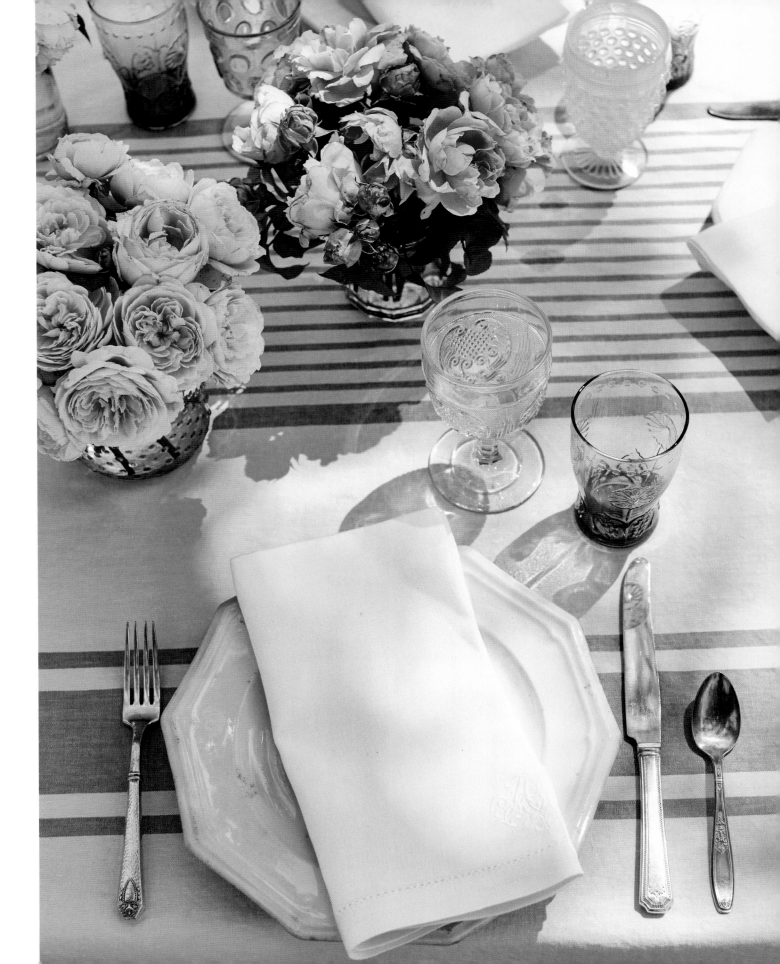

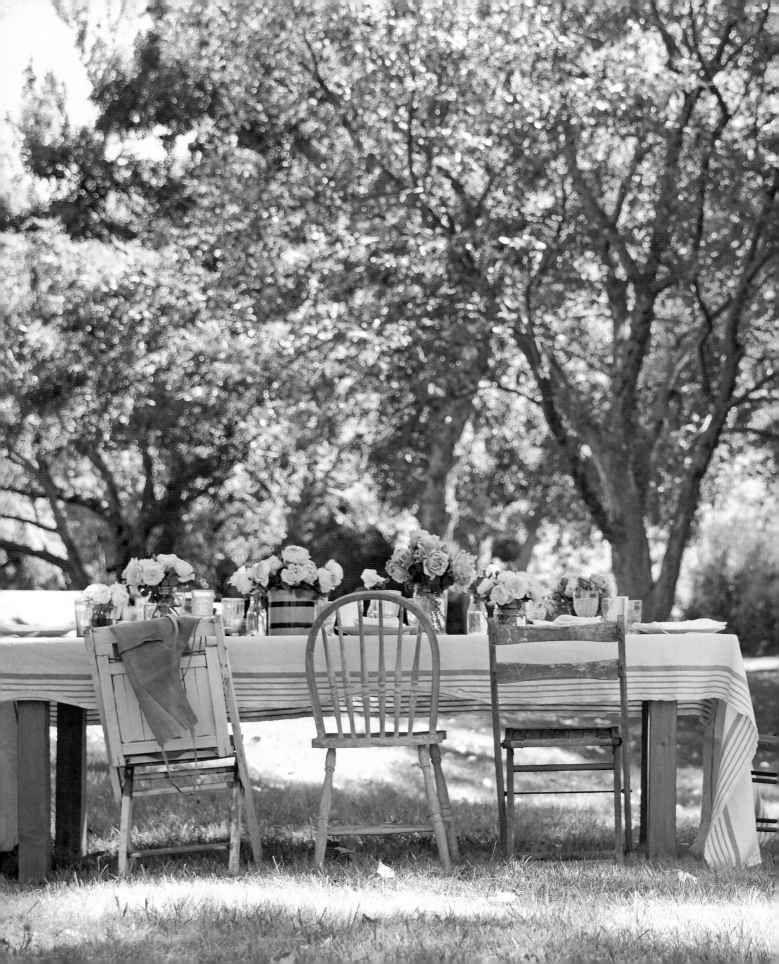

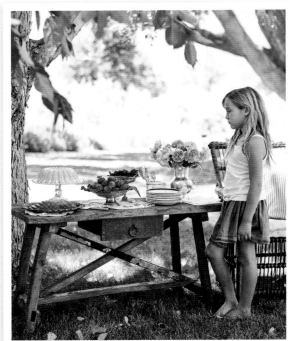

Lovely Day (clockwise from top left): Tuesday scoping out the dessert buffet; Mom serving up lemon deliciousness; Matthew and Dallas taking a spin; vintage quilts about to become extra seating; everyone gathers on the banks of the Carson River.

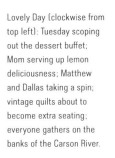

TIPS FOR ENTERTAINING OUTDOORS

There's no difference between setting up a party inside or outside. My same
philosophy applies. Good planning and preparation is half the battle.
A little organization beforehand means you can enjoy the fun as much as your guests.

DO A WALK-THROUGH

I pretend I'm a guest and walk through the space to figure out where to place the bar, the food, the dessert. It also helps me think about the basics . . . where am I going to sit? Is there a place to put my drink?

CREATE A SENSE OF SPACE

Making an outdoor "room" is easier than you think. It can be a seating area created with a blanket and cushions on the grass or a complete outdoor lounge with furniture, rugs, and lighting. No matter how understated or over the top, people will feel more welcome and relaxed.

SPREAD OUT

Just like you would indoors, create stations to keep people moving and to avoid having a crowd at one end of the party. Set up distinct areas for the bar, the buffet, and the dessert table.

HEATPROOF YOUR CENTERPIECE

If it's a sweltering day, delicate flowers are only going to wilt and die. Instead, put out something heartier that loves the sun, like lavender or olive branches.

CAST A SPELL

You don't need a lighting designer to make your party look magical. It's amazing what some inexpensive string lights and five or six hurricane lanterns can do to a space.

LOOK AROUND

There may be lots of great natural foliage already on the scene. Branches, greenery, fruit, or succulent plants can be pulled in from the perimeter quickly and easily. Not to mention they're free!

PASS ON PLASTIC

Alfresco dining does not have to equal disposable dinnerware. Use glass and silver for fancier affairs or tinware for a cookout. It just makes it all feel that much more special and considered.

CALL FOR BACKUP

Just like in my bar, I keep extras of everything I might run out of (cooler of ice, extra cutlery) tucked under a table or just out of sight. You'll spend more time with friends and less time running back and forth from the house.

EXPECT THE UNEXPECTED

I keep a basket nearby with umbrellas (for rain or extra-hot days), sunscreen, bug spray. For nighttime parties, have extra throws, citronella candles, and flashlights (someone always loses their keys in the grass).

LIGHT THE WAY

Don't stop at lighting the table and bar. Make sure guests can find their way to and from the house and their cars after dark. You can use votive candles in paper bags and paper lanterns or battery-operated lights.

pesto-crusted lamb chops

SERVES 8

These have such a flavorful bite thanks to the pesto
coating. For extra crunch, place them under the broiler
for a few minutes. But remember to watch them.
They will burn quickly.

for the pesto:

½ CUP (25 G) FRESH FLAT-LEAF PARSLEY LEAVES

½ CUP (20 G) FRESH BASIL LEAVES, TORN

¼ CUP (25 G) TOASTED WALNUTS

¼ CUP (25 G) GRATED PARMESAN CHEESE

2 CLOVES GARLIC, SMASHED

½ TEASPOON SALT

½ TEASPOON GROUND BLACK PEPPER

½ CUP (120 ML) OLIVE OIL

for the lamb:

2 TABLESPOONS OLIVE OIL

2 FRENCHED RACKS OF LAMB (1½ POUNDS/680 G EACH),
AT ROOM TEMPERATURE

1 TEASPOON SALT

1 TEASPOON PEPPER

1 CUP (100 G) BREAD CRUMBS

Preheat oven to 425°F (220°C).

To make the pesto: In a food processor, pulse parsley, basil,
walnuts, cheese, garlic, salt, and pepper until coarsely chopped.
With the machine running, slowly drizzle olive oil into the mixture
and process until finely chopped but with some chunks still visible.
Set aside.

To make the lamb: Heat a large skillet over high heat and add
olive oil. Season the racks of lamb with salt and pepper and sear
in hot pan for 2 minutes per side. Transfer to a greased baking dish
or sheet pan and let cool for a few minutes. Brush the racks all
over with pesto, coating evenly, and then coat with bread crumbs
by pressing them firmly onto the meat.

Roast lamb for 12 to 15 minutes, or until internal temperature
reaches 145°F (63°C) for medium-rare. Let rest for 5 minutes
before carving.

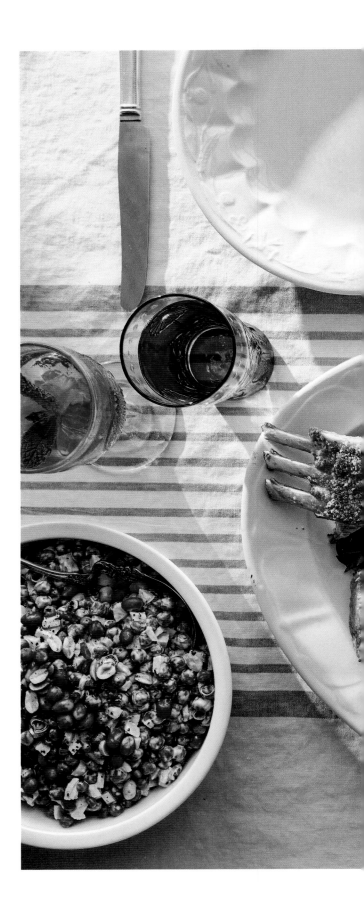

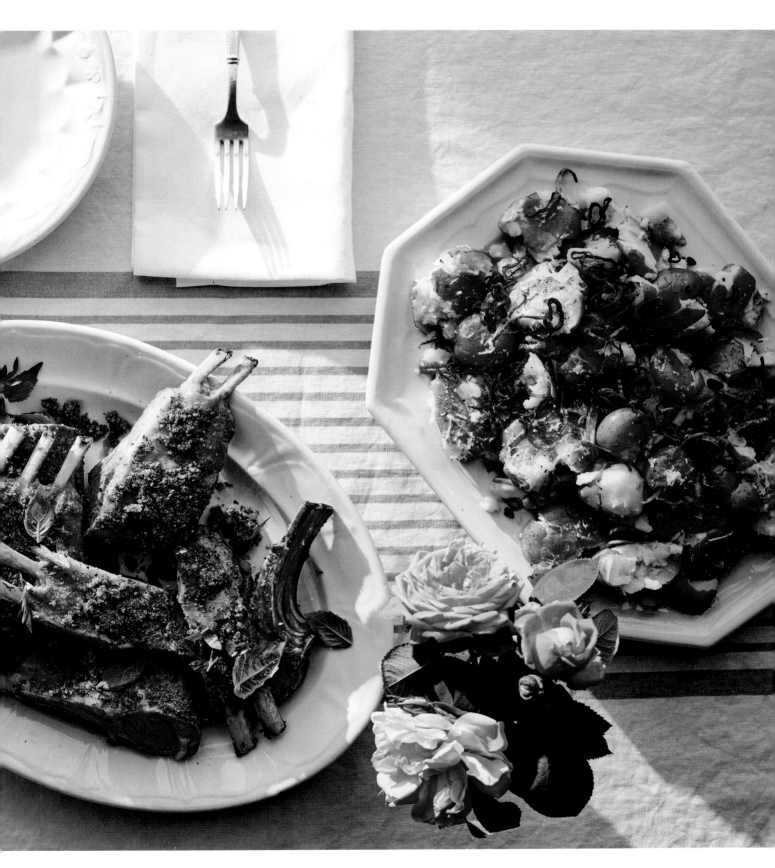

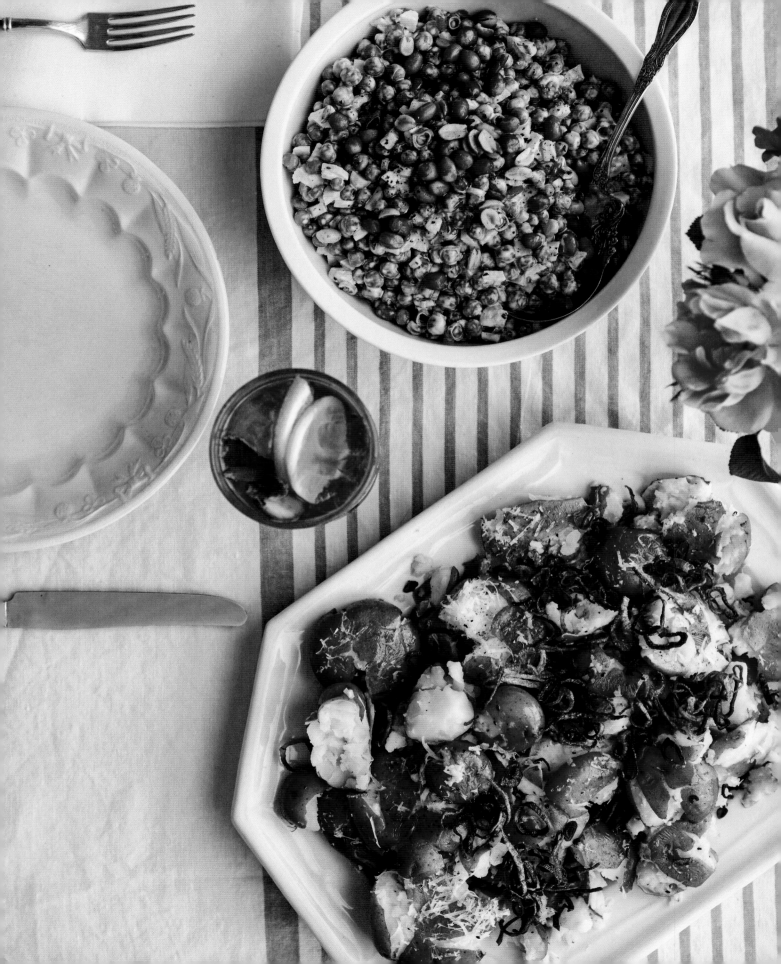

sidna's
pea salad

SERVES 8

I am single-handedly trying to keep these
old-lady lunch dishes alive. The original recipe is bacon
optional, but for me, bacon is never optional.

½ CUP (120 ML) MAYONNAISE

½ CUP (120 ML) SOUR CREAM

1 TABLESPOON HOT PEPPER SAUCE

1 TEASPOON LEMON JUICE

1 TEASPOON SALT

1 TEASPOON GROUND BLACK PEPPER

3 (10-OUNCE/280-G) BAGS FROZEN PEAS,
THAWED AND DRAINED

3 GREEN ONIONS, SLICED

1 (8-OUNCE/225-G) CAN WATER CHESTNUTS,
DRAINED AND CHOPPED

½ CUP (75 G) SPANISH PEANUTS

4 STRIPS COOKED BACON, CRUMBLED (OPTIONAL)

In a large bowl, whisk together mayonnaise, sour cream, hot
pepper sauce, lemon juice, salt, and pepper until combined.
Add peas, green onions, and water chestnuts and mix well.
Garnish with peanuts and crumbled bacon, if desired.

smashed red potatoes
with asiago

SERVES 6

Most people are purists about mashed potatoes.
I can get behind a classic yellow potato, but I love
red skin for this. It is a bit unexpected,
especially with the addition of the creamy Asiago.
The perfect complement to the lamb chops.

3 POUNDS (1.4 KG) MEDIUM RED POTATOES,
SCRUBBED

¼ CUP (60 ML) OLIVE OIL

4 SHALLOTS, PEELED AND THINLY SLICED

½ CUP (115 G) UNSALTED BUTTER, MELTED

1½ CUPS (128 G) GRATED ASIAGO CHEESE

2 CLOVES GARLIC, MINCED

1 TEASPOON SALT

1 TEASPOON GROUND BLACK PEPPER

Preheat broiler.

Bring a large pot of water to a boil and cook potatoes for
20 minutes or until just tender when pierced with a fork.
Drain well.

While potatoes are cooking, make crispy shallots: Combine
olive oil and shallots in a sauté pan and bring to a simmer
over medium heat. Cook for 15 to 20 minutes, stirring
frequently, until shallots turn golden brown. Transfer with
a slotted spoon to a paper towel to drain and let cool.

Transfer potatoes to a rimmed baking sheet in a single layer.
Smash each potato with a large spatula or small skillet until
about ½ to ¾ inch (12 mm to 2 cm) thick. Drizzle all over
with melted butter and sprinkle with cheese, garlic, salt, and
pepper. Broil for 4 to 8 minutes or until cheese is melted.
Transfer to a serving platter and garnish with crispy shallots.

pimm's cup

SERVES 6 TO 8

Pimm's is an English liqueur that is derived from gin and has a fresh, herbaceous taste. It's perfect for an outdoor garden party. I love this drink and I always go BIG on the garnish. To me, this drink is like a salad and cocktail in one.

1½ CUPS (360 ML) PIMM'S NO. 1

1½ CUPS (360 ML) GINGER BEER

½ CUP (120 ML) FRESH GRAPEFRUIT JUICE

1 LEMON, SLICED

1 SMALL GRAPEFRUIT, SLICED

2 PERSIAN CUCUMBERS, CUT INTO SPEARS

MINT, FOR GARNISH

In a large pitcher, combine Pimm's No. 1, ginger beer, grapefruit juice, lemon slices, and grapefruit slices and stir well. Add ice and let chill for 10 minutes. Garnish each serving with a cucumber spear and a sprig of mint.

lemon bundt cake

SERVES 12 TO 16

This is an old recipe from my grandmother Mare. It is one those dishes that friends always request. When I ask, "Can I bring anything?" They reply, "Yes, bring the lemon Bundt."

1 CUP (225 G) UNSALTED BUTTER, AT ROOM TEMPERATURE

2⅓ CUPS (470 G) GRANULATED SUGAR

6 LARGE EGGS

¾ CUP (180 ML) PLUS 5 TABLESPOONS (75 ML) LEMON JUICE (ABOUT 6 LEMONS), DIVIDED

3 TABLESPOONS FRESHLY GRATED LEMON ZEST

3 CUPS (385 G) ALL-PURPOSE FLOUR

1 TEASPOON BAKING SODA

1 TEASPOON SALT

1 CUP (240 ML) SOUR CREAM

2 CUPS (250 G) CONFECTIONERS' SUGAR, SIFTED

Preheat oven to 350°F (175°C) and thoroughly grease a nonstick 12-cup (2.8-L) Bundt pan.

With an electric mixer, cream together butter and granulated sugar for 3 minutes or until fluffy. Add eggs one at a time, beating well after each addition. Mix in ¾ cup (180 ml) of the lemon juice and the lemon zest.

In a large bowl, stir together flour, baking soda, and salt. Alternately add flour mixture and sour cream to the butter mixture, starting and ending with flour, and mix until just combined.

Pour batter into prepared pan and smooth top. Bake for 55 to 60 minutes or until a toothpick inserted into the middle comes out clean. Let cool on a wire rack for 12 minutes. Invert to remove from pan, and cool completely on rack before glazing.

In a small bowl, whisk together the remaining 5 tablespoons (75 ml) of lemon juice and the confectioners' sugar until smooth. Drizzle over cooled cake and let sit for 15 minutes before serving.

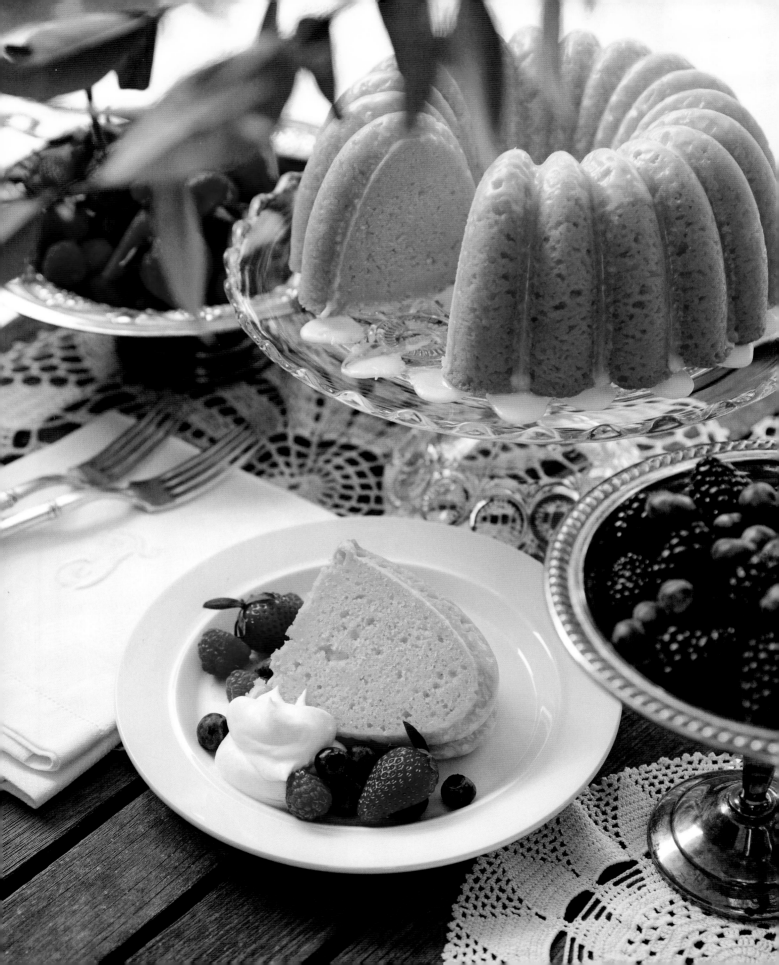

CASTROVILLE

menu

CAULIFLOWER SOUP

CHICKEN WITH ARTICHOKES AND LEMON

GORGONZOLA AND ROASTED
TOMATO POLENTA

PRUNE CAKE WITH
COFFEE CREAM CHEESE FROSTING

Though Castroville has a population of less than ten thousand, that doesn't stop it from being a major agricultural hub. The small town, located just a few miles inland of Monterey Bay, is the "Artichoke Center of the World." Each May, they have a festival to prove it.

DRIVING THROUGH THE AREA AS A KID, I WOULD SEE endless stretches of green fields. With most people visiting cities like San Francisco and Los Angeles, it's easy to forget that so much of California is farm country. You've got this agricultural hub aligning with a beautiful coastline. That's the magic of California for you.

FARMHOUSE KITCHEN DINNER

As you'd expect, the people here are the salt of the earth. I have always found such beauty in a pared-back country lifestyle. I wanted to create a menu and table that celebrated this often-overlooked region of California. The setting and menu for this kitchen supper are easy, fresh, and lovely.

The table is as natural as the dishes on it. When you have supper in the kitchen, you aren't going for a huge, elaborate table anyway. I start with an indigo fabric (it's really a Japanese tie-dye), but any dark blue would work. It reminds me of denim and looks great with the muted pottery plates on top.

I love a mixed glassware situation. Here, I pair green tumblers with some dimpled copper cups. To keep it from going too crafty, I use midcentury chairs that have clean lines. The final effect is a modern, artisanal farmhouse look that feels so California to me. In almost every home here (farm or otherwise), there's a bit of homespun, handmade style that shines through.

I always make a cauliflower soup to start that is delicious hot or cold. It doesn't even need cream because when the cauliflower is blended, it has a velvety texture on its own. I serve it in a tureen in the middle of the table so everybody can help themselves.

You can't have a California farmhouse dinner without artichokes. It's that quintessential vegetable that everyone who grew up here remembers eating in every way: fried, sautéed, steamed. This dish, like everything on the menu, is served family style. I bring the pan straight to the table. (But you can plate it if you want.)

Polenta is often served with something like short ribs piled on top, but I like it as a side: I put some on a butcher's block, add a layer of cheese, and then pour the rest of the polenta on top. The cheese melts and oozes into every bit of it. Then I sprinkle with roasted tomatoes.

Prune cake . . . it sounds gross, I know. But I promise you, this is so moist and delicious, and doesn't have at all a prune-y taste. It's like banana bread, and we all know how good that is. ★

Page 122: Did I ever tell you I love artichokes? Opposite: This is quite possibly my favorite kitchen that I ever designed. Following pages: It has always struck me how similar farmhouse furniture is to midcentury designs. That's why I love to mix them together and often do. It really works.

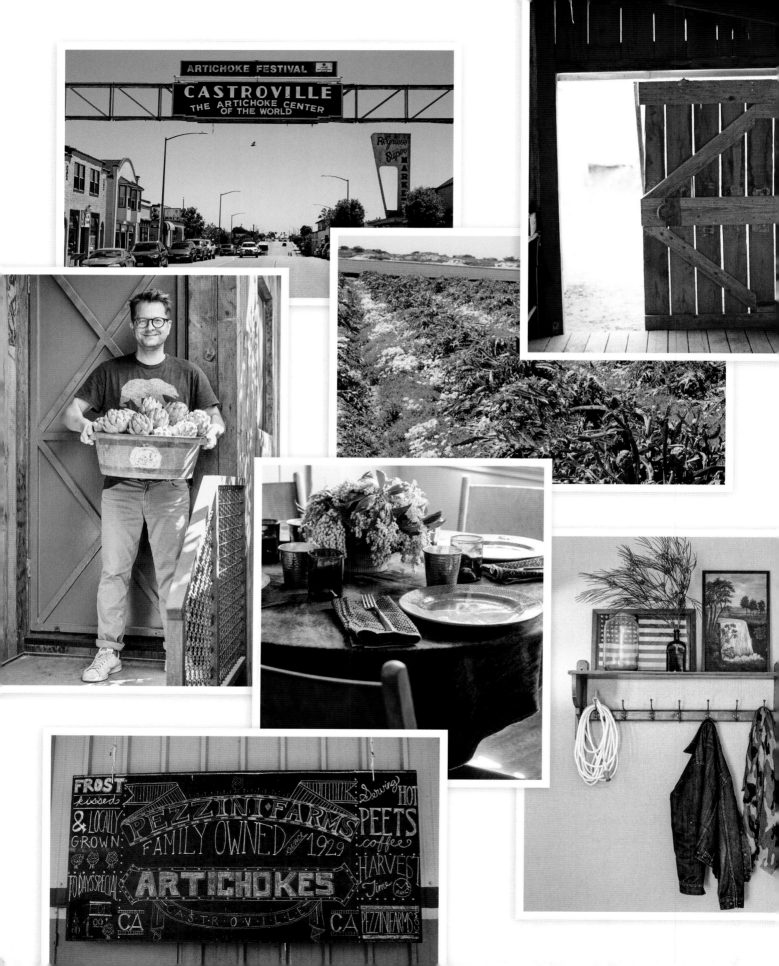

cauliflower soup

SERVES 6

This soup is delicious hot or cold. Swear. The other thing
that's slightly unbelievable is that is has absolutely
no cream. People in LA always think I am lying about it.

3 TABLESPOONS OLIVE OIL, DIVIDED,
PLUS MORE FOR GARNISH

3 LARGE LEEKS, CLEANED AND SLICED,
1 CUP (90 G) RESERVED

1 MEDIUM HEAD CAULIFLOWER, CUT INTO FLORETS

2 CLOVES GARLIC, MINCED

5 CUPS (1.2 L) CHICKEN BROTH

2 TEASPOONS SALT

1 TEASPOON GROUND BLACK PEPPER

In a large pot, heat 2 tablespoons of the olive oil over medium-high heat. Add leeks (minus reserved 1 cup [90 g]) and sweat for 5 minutes or until beginning to become translucent. Add cauliflower and garlic and cook for 8 minutes more, until beginning to soften. Add chicken broth and bring to a boil. Reduce to a simmer and cook for 20 to 25 minutes, until cauliflower is tender. Add salt and pepper and blend until smooth—in batches in a high-powered blender or with a handheld immersion blender—thinning with water to reach desired consistency. Keep warm.

In a medium skillet, heat remaining 1 tablespoon olive oil over high heat. Add reserved leeks and sauté for 10 minutes or until beginning to get brown and crispy.

Serve soup topped with crispy leeks and a drizzle of olive oil.

chicken with artichokes and lemon

SERVES 8

Artichokes are a California staple. People sometimes think
of them only as steamed in a fancy restaurant,
but they're a great ingredient to use in lots of dishes.
They work really well with chicken and lemon.

8 SKIN-ON, BONE-IN CHICKEN THIGHS

6 CLOVES GARLIC, MINCED

1 TABLESPOON FRESH ROSEMARY, CHOPPED

1 TABLESPOON OLIVE OIL

1 TEASPOON SALT

½ TEASPOON GROUND BLACK PEPPER

½ TEASPOON RED PEPPER FLAKES

2 MEYER LEMONS, CUT INTO WEDGES

2 CUPS (335 G) FRESH BABY ARTICHOKE HEARTS,
CUT IN HALF AND TOUGH OUTER LEAVES REMOVED

1 CUP (240 ML) CHICKEN BROTH

1 TABLESPOON CAPERS, DRAINED

Preheat oven to 400°F (205°C).

Pat chicken dry with paper towels and place in a large baking
dish in a single layer, skin side up. Sprinkle with garlic,
rosemary, olive oil, salt, pepper, and red pepper flakes. Tuck
the lemon wedges and artichoke hearts all around the thighs
and let sit for 10 minutes to marinate.

Roast uncovered for 20 minutes or until the skin begins to
brown lightly. Add broth and capers, cover, and bake for 1 hour
or until chicken is cooked and reaches internal temperature of
165°F (75°C).

Remove the chicken and lemons and pour pan juices into
a small saucepan. Bring to a boil, lower heat, and simmer for
12 minutes, until reduced by half. Serve chicken with sauce.

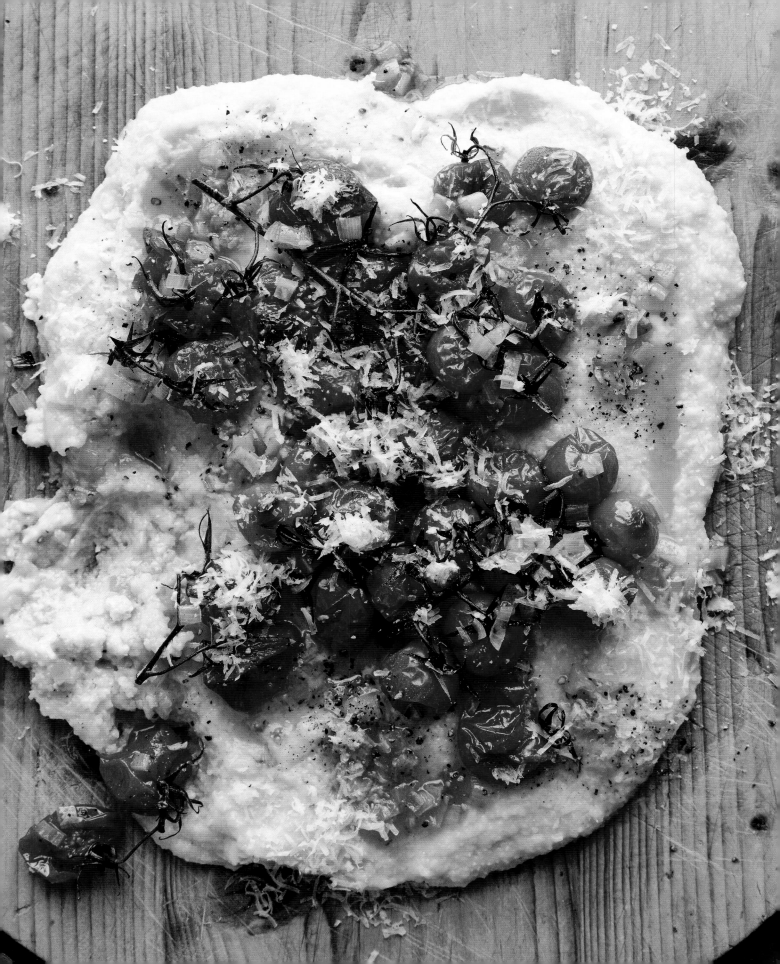

gorgonzola and roasted tomato polenta

SERVES 8 TO 10

Polenta is an easy option when entertaining. I often make this when there are non-meat eaters on the guest list, as they are happy to have this alone. I always serve it on a butcher's block.

2 TEASPOONS SALT, DIVIDED

1 CUP (120 G) POLENTA

4 TABLESPOONS (55 G) UNSALTED BUTTER

2 CUPS (290 G) CHERRY TOMATOES

2 SHALLOTS, PEELED AND CHOPPED

1 TABLESPOON OLIVE OIL

½ TEASPOON GROUND BLACK PEPPER

1 CUP (227 G) CUBED GORGONZOLA DOLCE CHEESE

¼ CUP (25 G) GRATED PARMESAN CHEESE

Preheat oven to 425°F (220°C).

In a medium saucepan, bring 5 cups (1.2 L) water to a boil over high heat. Add 1 teaspoon of the salt. Slowly add polenta and stir well. Reduce to low and cook for 45 minutes, stirring every 10 minutes. If polenta becomes too thick, thin with ¼ cup (60 ml) water to keep soft enough to stir. Add butter and stir until melted. Keep warm.

On a rimmed baking sheet, combine tomatoes, shallots, olive oil, remaining 1 teaspoon salt, and pepper. Roast for 12 minutes or until tomatoes are beginning to shrivel and release their juices.

To serve, pour half the hot polenta on a large butcher's block. Sprinkle with Gorgonzola Dolce and then cover with remaining polenta. Pour roasted tomato mixture with juices on top and sprinkle with Parmesan. Serve immediately.

prune cake with
coffee cream cheese frosting

SERVES 9

This is my great-grandmother's recipe and was actually an accident. She ran out
of something and used prunes instead. I normally don't tell people it's a
prune cake as they make the same face I did when I was little. But the prunes are
chopped so finely, no one ever notices. They make the cake extra moist and yummy.

for the cake:

1 CUP (200 G) GRANULATED SUGAR

⅔ CUP (165 ML) VEGETABLE OIL

½ CUP (120 ML) WHOLE MILK

2 LARGE EGGS

2 CUPS (255 G) ALL-PURPOSE FLOUR

1 TEASPOON BAKING SODA

1 TEASPOON GROUND CINNAMON

½ TEASPOON GROUND CLOVES

½ TEASPOON ALLSPICE

¼ TEASPOON SALT

2 CUPS (200 G) WALNUTS, COARSELY CHOPPED

1 CUP (130 G) PRUNES, CHOPPED

for the frosting:

½ CUP (115 G) UNSALTED BUTTER, SOFTENED

1 (8-OUNCE/225-G) PACKAGE CREAM CHEESE, SOFTENED

1 CUP (125 G) CONFECTIONERS' SUGAR

2 TABLESPOONS STRONG COFFEE

Preheat oven to 350°F (175°C). Grease a loaf pan and line with
parchment paper.

In the bowl of a stand mixer, whisk together sugar, oil, and milk.
Add eggs one at a time, beating well after each addition. In
a medium bowl, combine flour, baking soda, cinnamon, cloves,
allspice, and salt. Add dry ingredients to wet ingredients in
two additions, mixing well. Fold in nuts and prunes and stir
until well distributed. Pour into prepared loaf pan and bake for
45 minutes or until a toothpick inserted in the center comes
out clean. Let cool.

In the bowl of a stand mixer, beat together butter and cream
cheese until smooth. Add confectioners' sugar and coffee and
beat well. Frost cooled cake and slice to serve.

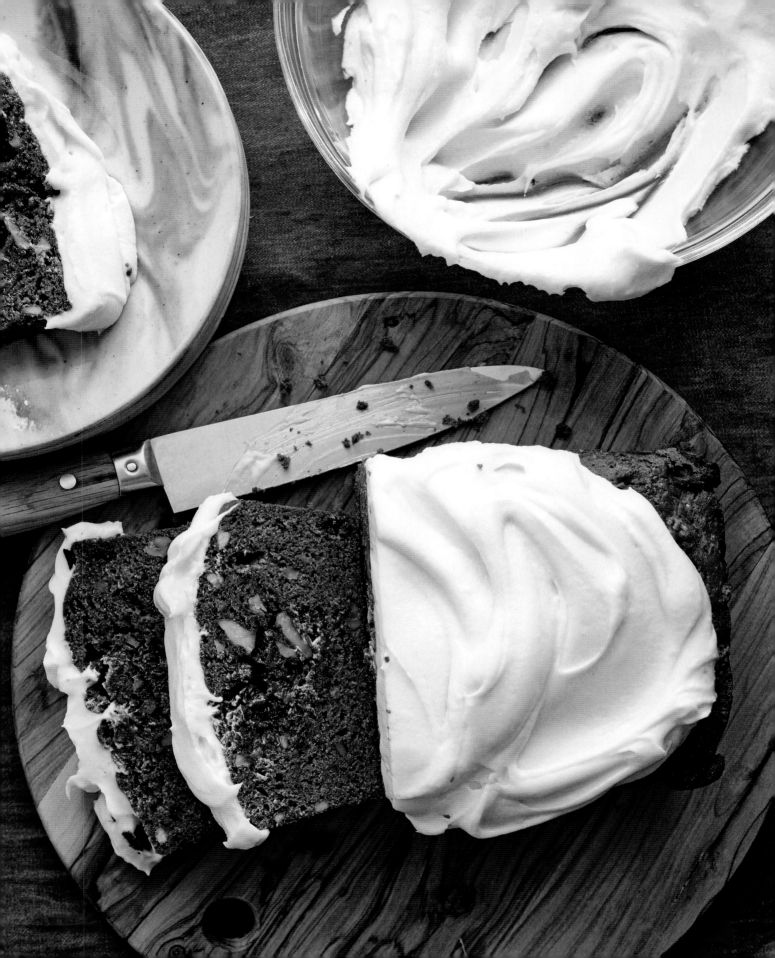

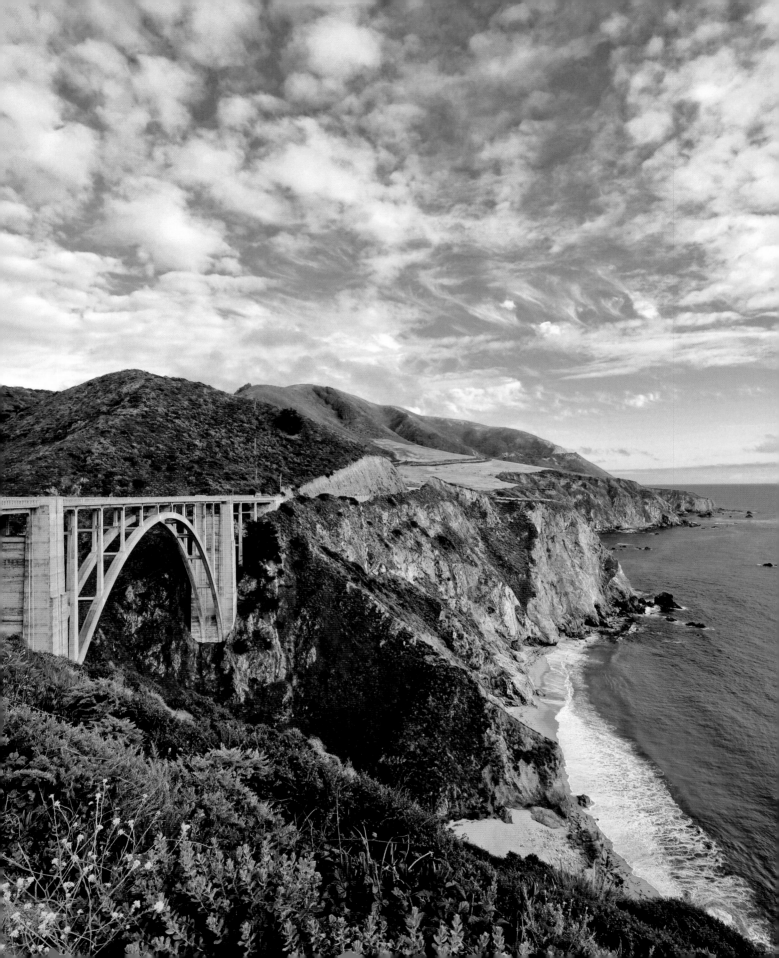

BIG SUR

★

menu

PEANUT RAMEN-NOODLE SALAD

SWEET AND SPICY WINGS

MATCHA RICE KRISPIES® TREATS

LIMEADE

Three and a half hours south of San Francisco,
Big Sur is a town that hugs the coastline and has *the* most
spectacular views—it's a place like nowhere else.
Whenever you go there, you feel like you are on another planet.

THE LIGHT, THE AIR . . . IT'S LIKE ITS OWN LITTLE
universe tucked into a pocket of California. That's why
people come from all around the world to soak in the
dramatic cliffs, admire the spectacular sunsets, and hike
through the forests of redwoods. There's also the free-
spirited culture there that has drawn writers and artists
to places like the Esalen Institute, a retreat center that
has hot springs with the best views in town.

ASIAN-STYLE PICNIC

Big Sur is the best place for a picnic when driving the
original Route 1, or the PCH (Pacific Coast Highway).
For me, packing a picnic is more about preparation than
any fancy setup. But I keep a tailgating bag at the ready
for those impromptu roadside meals.

My dad would drive us to Big Sur each winter to see
the elephant seals on the beaches.

A huge colony would come to breed and give birth. I
remember taking the day off from school, driving down
the coast, and sitting on a cliff with our picnic lunch. We
were probably more excited about cutting school than
the seals, and I was (and am still) always game for great
picnic food. Then it was a sandwich and potato chips.

Now when packing for a day trip, I raise the bar a bit
with the dishes and the presentation.

Sweet and spicy wings are perfect for a picnic
because they are equally delicious hot or cold. They have
such a good tang, and the peanuts add great crunch.
The cilantro brings a nice herbal hit as well. They're the
kind of thing you want to eat like popcorn, and you can
because you serve them in handy Chinese takeout food
boxes. Just don't forget the napkins.

The peanut ramen-noodle salad is another great
one to make for a picnic or tailgate because you don't
need plates or even serving utensils! I make it the day
before and pack it in individual servings in the takeout
containers and throw in some chopsticks. Preportioned
and no cleanup.

I've always loved Rice Krispies® Treats, but I was
looking for a way to jzeush them up. So now I dip
them in a mixture of melted white chocolate and
matcha powder. Matcha is a Chinese green tea that
has a fresh, almost grassy flavor with a sweet finish.
It's being used more and more as a dessert ingredient
in ice cream and macarons. But I thought it was time
for it to meet the marshmallow treat. Even matcha
nonbelievers will eat two (or more). ★

Opposite: Tailgating with a view just north of the Bixby Bridge.

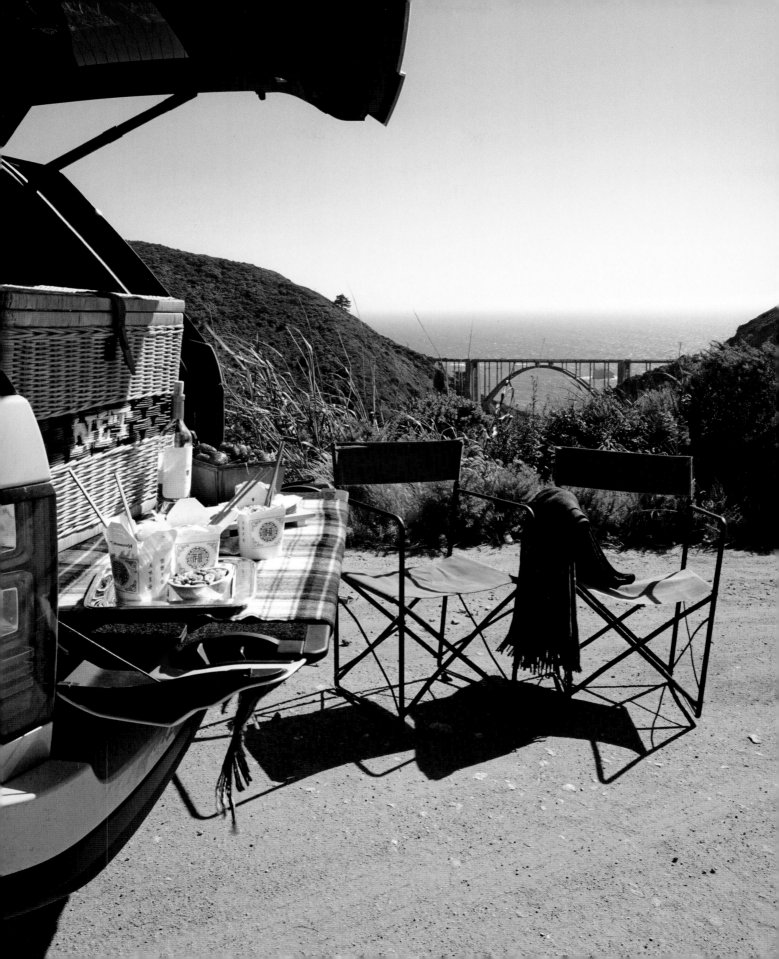

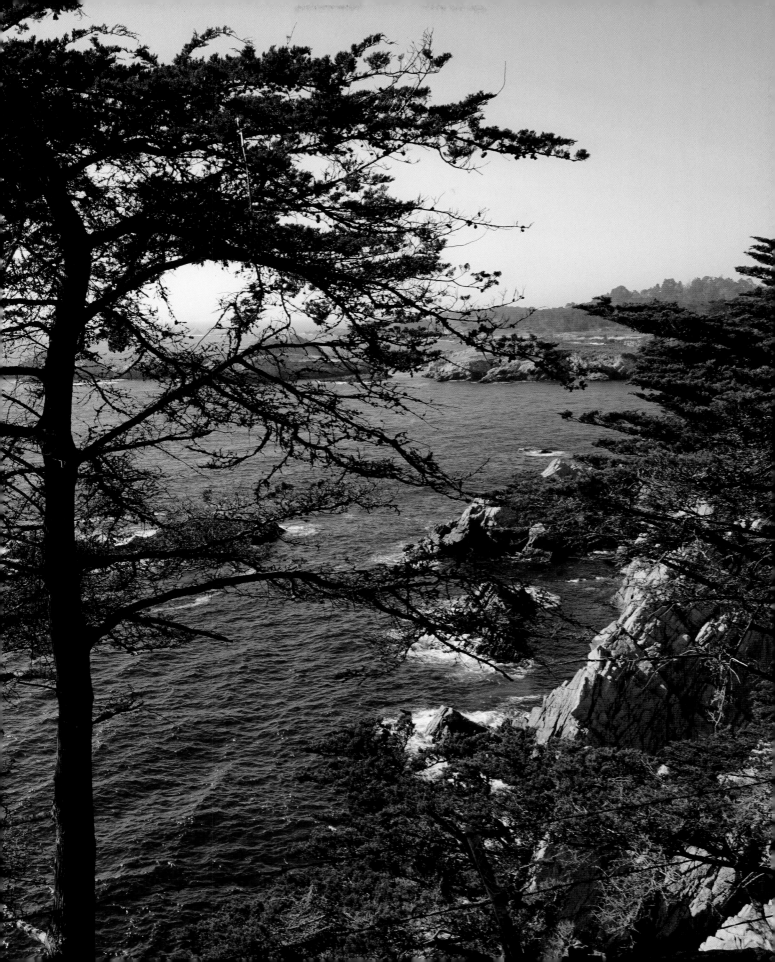

peanut ramen-noodle salad

SERVES 10

A cabbage-based salad is genius for a picnic, barbecue, or potluck because its heartiness means it will not wilt or get soggy like other lettuces. Add grilled or roasted chicken and it makes a great main dish.

for the dressing:

¼ CUP (60 ML) OLIVE OIL

3 TABLESPOONS CREAMY PEANUT BUTTER

1 TABLESPOON LIME JUICE

2 TEASPOONS CHILI GARLIC SAUCE

2 TEASPOONS GRATED, PEELED FRESH GINGER

2 TEASPOONS LIGHT BROWN SUGAR

3 CLOVES GARLIC, MINCED

for the salad:

2 (3-OUNCE/85-G) PACKAGES CHICKEN-FLAVORED RAMEN NOODLES

2 CUPS (140 G) THINLY SLICED SAVOY CABBAGE

2 CUPS (190 G) THINLY SLICED GREEN CABBAGE

1 ROTISSERIE CHICKEN, SHREDDED

3 MEDIUM CARROTS, PEELED AND SHREDDED

3 GREEN ONIONS, SLICED

1 SMALL RED BELL PEPPER, JULIENNED

4 RED RADISHES, THINLY SLICED

3 TABLESPOONS CHOPPED FRESH CILANTRO

1 TABLESPOON MINCED JALAPEÑO CHILE

In a small bowl, whisk together dressing ingredients and set aside.

Cook noodles according to package directions. Drain and cool noodles completely. Mix flavor packets with 6 tablespoons (90 ml) water and add to dressing. In a large bowl, combine noodles, cabbage, chicken, carrots, green onions, bell pepper, radishes, cilantro, and jalapeño and toss. Add dressing and mix until coated.

Serve immediately or refrigerate for up to 2 hours.

sweet and spicy wings

SERVES 6

My friend Jamie and I have been making these wings since college. It's everything you want in an Asian wing: sweet, spicy, and crunchy, and it has a fresh bite from the cilantro. These work for any occasion, picnics, or Super Bowl and Oscar parties.

½ CUP (120 ML) PLUS 2 TABLESPOONS SOY SAUCE, DIVIDED

¼ CUP (60 ML) SESAME OIL

¼ CUP (10 G) FRESH CILANTRO, CHOPPED,
PLUS MORE FOR GARNISH

¼ CUP (15 G) SLICED GREEN ONIONS,
PLUS MORE FOR GARNISH

3 TABLESPOONS MINCED GINGER

2 POUNDS CHICKEN WINGS

1 CUP (240 ML) RICE VINEGAR

¾ CUP (180 ML) HONEY

2 TABLESPOONS SAMBAL OELEK OR CHILI GARLIC SAUCE

1 TABLESPOON SRIRACHA

3 CLOVES GARLIC, MINCED

2 CUPS (410G) COOKED WHITE RICE

¼ CUP (35 G) SALTED ROASTED PEANUTS, CHOPPED

In a large bowl, combine ½ cup (120 ml) of the soy sauce, sesame oil, cilantro, green onions, and ginger and stir. Add chicken wings and toss to coat. Cover and marinate in the refrigerator for at least 2 hours, up to overnight.

Preheat oven to 400°F (205°C). Remove wings from sauce and place on a greased baking sheet. Bake for 25 to 30 minutes or until golden and crispy.

While wings are baking, in a saucepan, combine remaining 2 tablespoons soy sauce, rice vinegar, honey, sambal oelek or chili garlic sauce, sriracha, and garlic. Bring to a boil, reduce heat, and simmer for 40 minutes, until thickened and syrupy.

Transfer baked wings and sauce to a large bowl and toss to coat. Serve immediately over rice, garnished with cilantro, green onions, and peanuts.

matcha rice krispies® treats

SERVES 9

A grown-up twist on a childhood classic.
You can swap out the matcha for coffee, if you like.
No matter what you add, it's delicious.

3 TABLESPOONS UNSALTED BUTTER

5 CUPS (300 G) MARSHMALLOWS

4 CUPS (110 G) RICE KRISPIES® CEREAL

8 OUNCES (225 G) WHITE CHOCOLATE CHIPS

1 TABLESPOON CULINARY-GRADE MATCHA POWDER

Grease an 8-inch (20-cm) square pan with cooking spray and line with parchment paper.

In a large pot, melt butter over medium-low heat. Add marshmallows and stir until melted. Turn off the heat and stir in cereal until well mixed. Transfer to prepared pan and press into an even layer. Refrigerate for 1 hour or until firm.

Cut into 9 squares and remove from pan.

Over a double boiler, slowly melt white chocolate, stirring often. Once completely melted, add matcha powder and stir until combined. Carefully dip half of each Rice Krispies® square in melted chocolate and place on waxed paper to harden.

limeade

SERVES 12

1 CUP (200 G) GRANULATED SUGAR

2 CUPS (480 ML) FRESH LIME JUICE

1 LITER CLUB SODA

VODKA AND BITTERS, IF DESIRED

In a small saucepan, combine sugar and 1 cup (240 ml) water. Bring to a boil and simmer just until sugar has dissolved. Cool completely.

In a large pitcher with ice, combine simple syrup with lime juice and club soda and stir.

If desired, add 1½ ounces (45 ml) of vodka and a dash of bitters to each serving.

THINGS I LOVE ♥ CENTRAL CALIFORNIA & SIERRA NEVADA

1 **SORENSEN'S RESORT** "A CHARMING ALPINE VILLAGE IN THE WILD WEST."

2 **GROVER HOT SPRINGS** "A PERFECT POST-SKI SPOT IN THE SIERRA NEVADA, DATING BACK TO THE GOLD RUSH."

3 **POOR RED'S BAR-B-Q** "STOP FOR BARBECUE ON YOUR DRIVE FROM SAN FRANCISCO."

4 **EL TORO BRAVO** "IN COLLEGE, MY FRIEND JAMIE AND I USED TO BUY BURRITOS IN BULK AND KEEP THEM IN OUR FREEZER."

5 **KIT CARSON LODGE** "YOU'LL BE TRANSPORTED TO THE OLD WEST."

6 **POST RANCH INN** "ONE OF MY FAVORITE HOTELS IN THE WORLD."

7 **NEPENTHE RESTAURANT** "GO FOR THE SUNSET."

8 **PEZZINI FARMS** "ARTICHOKES STRAIGHT FROM THE FIELDS."

9 **THE MAJESTIC YOSEMITE (FORMERLY AHWAHNEE HOTEL)** "THE OLDEST LODGE—INCREDIBLE."

10 **NATIONAL HOTEL, JACKSON** "A GOLD RUSH GEM—AND A GREAT PLACE TO STOP ON THE WAY TO TAHOE."

11 **SEQUOIA HIGH SIERRA CAMP** "ONE OF MY FAVORITE PLACES TO 'CAMP' IN CALIFORNIA."

12 **RED'S DONUTS** "CAN'T DRIVE THROUGH MONTEREY WITHOUT A STOP AT RED'S."

13 **HEARST CASTLE** "I'VE BEEN IN LOVE WITH HEARST CASTLE SINCE I WAS A KID...ONE OF THE MOST MAGICAL SPOTS IN CALIFORNIA."

14 **SUNBUGGY** "I'M A THRILL SEEKER AND A BEACH LOVER...MY WORLDS COLLIDE AT SUNBUGGY."

15 **SAN SIMEON'S PIEDRAS BLANCAS ROOKERY** "ONE OF THE BEST PLACES TO SEAL WATCH!"

SOUTHERN ★ CALIFORNIA

Southern California and Northern California
are really so different, visually and culturally.
I always say it's a good thing there is a Central buffer
between them to keep the family together.

JUST LIKE NORTHERN AND CENTRAL CALIFORNIA, THE
southern region, which runs from Ventura down to San
Diego, is very much influenced by the weather, landscape,
and people. First, it's sunny and temperate year-round,
which greatly influences how people live as well as their
sense of style. This is where indoor-outdoor living started.
Here, blurring the lines of where your living spaces begin
and end ultimately makes a home relaxed and open.

The architecture varies here more than anywhere
I have seen. Drive around and you'll see a midcentury
home next to a 1930s Spanish, then a Tudor style directly
across from a classic Craftsman.

That's what is so amazing about California—there's a
little bit of everything here. I really started to understand
that when I came to SoCal the first time.

When I was a teenager, my parents bought a house in
Laguna Beach. That changed everything for me. There
was a freedom, a feeling, here that made me want to get
to the beach as soon as possible.

San Francisco, I love you, but bye-bye fog!

Laguna is one of those quintessential Southern
California beach towns where you can walk
everywhere. It was so fun meeting all the local kids and
seeing what they were wearing. I loved going to the
surf shops and buying stuff and bringing it back home
to show off proudly.

It was this time in Laguna as a teen that convinced
me this was where I belonged. Like I've said, pretty
much all of California is laid-back, but SoCal takes the
cake. You can basically live in a bathing suit and no
shoes in some places. And I have.

Everything was new and exotic to me here. My
aunt and uncle lived in a 1920s Spanish house in La
Jolla in northern San Diego, and their home and the
town around it felt like another world to me. We'd
walk to the beach passing perfect square houses with
tiled courtyards in the middle, each of which had an
old fountain surrounded by ferns.

Opposite: Eric and me at Malibu Pier—one of our favorite spots.

The lifestyle here was beyond relaxed. We'd throw on our bathing suits and flip-flops, walk to the beach (stopping to pick up a bucket of fried chicken, of course), and spend the entire day swimming, surfing, and playing volleyball.

Indoor-outdoor living is what it's all about here. There are porticos and big outdoor rooms and courtyards. I mean, we had a deck or patio and pool in Northern California, but these huge, expansive spaces felt like they turned the home inside out.

The entertaining is different too. My aunt in La Jolla loved to have people over all the time, but she never stressed. Usually because it was another bucket of fried chicken along with some side salads and always, always quesadillas and guacamole on the patio. This was *the* snack at my aunt's house.

Obviously, the weather is a big factor. People spend so much time outdoors and it's just nice to eat outside. And entertaining alfresco is always more casual. When people talk about California entertaining, it's this just-back-from-the-beach, barefoot brand of hosting.

Another big thing that influences how people decorate and entertain here is that this is very much an "at home" place. Yes, people go out to restaurants and do other things, but most get-togethers here happen in the home. So your house is this great, relaxed space that's ready to receive guests anytime. If you had to have a formal setting to entertain, you'd never invite anyone.

I love that culture. It's the complete circle I've talked about in this book. Have a welcoming house, put together a nice table, and serve delicious food. It's as simple as that. Moving to Southern California really helped me put it all together. It's the reason I put a garden and a kitchen in my shop. I treated it like a home.

This ease and freedom to do what you like has created a lifestyle that has influenced fashion, decor, entertaining, and food. Slow down, relax, kick off your shoes, and just enjoy.

Opposite (clockwise from bottom left): The beautiful Mission San Juan Capistrano; old-school lifeguard tower in Laguna Beach; surf break in Newport Beach; making homemade jam in Ojai; Nacho pondering a boat purchase at Ranch at the Pier; a post-rain super bloom of poppies.

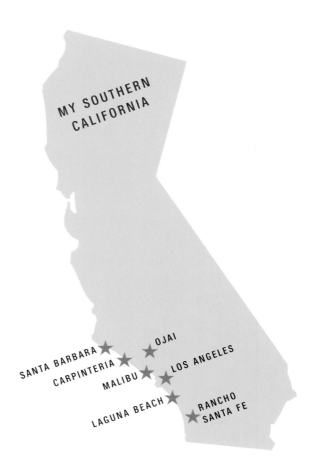

MY SOUTHERN CALIFORNIA

SANTA BARBARA ★
CARPINTERIA ★
OJAI ★
MALIBU ★
LOS ANGELES ★
LAGUNA BEACH ★
RANCHO SANTA FE ★

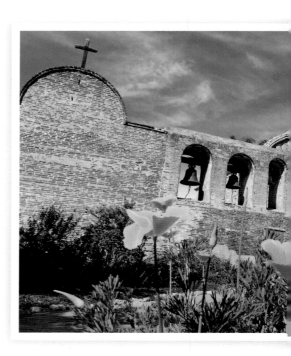

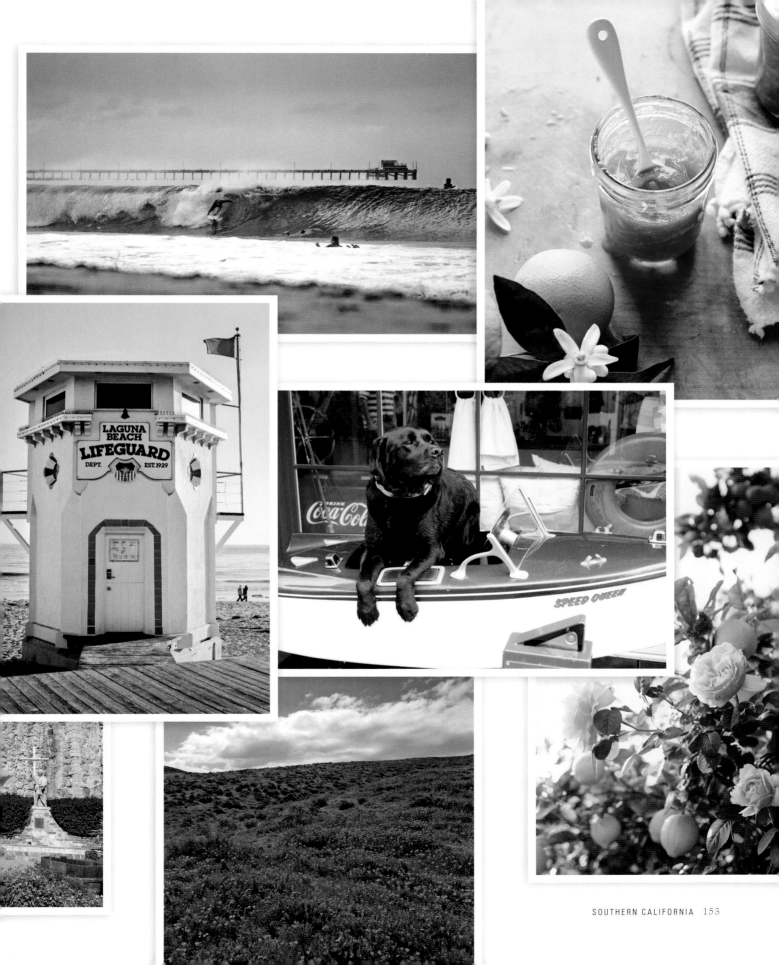

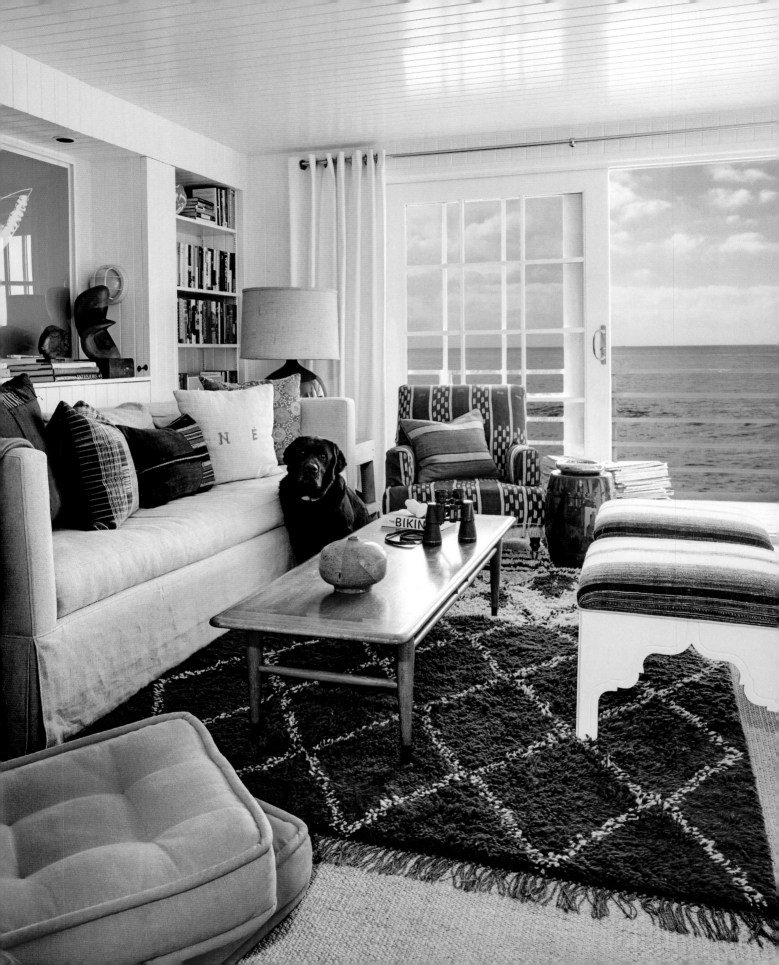

FREE-SPIRITED STYLE

AS I SAID, THERE'S A STYLISTIC FREEDOM HERE that's like no other place. Maybe it's because of California's pioneering past or the influence of Hollywood—a culture built on the idea of make-believe.

You can do and be whatever you want here. People on the East Coast or even in Northern California are a bit more practical. Southern California is built on fantasy.

So people think nothing of creating their dream, even if that means tearing down an existing home and rebuilding it to their own taste. For better or for worse. You get some real doozies, but there are also amazing rebirths. It's the spirit of reinvention.

Look at Dawnridge, the Beverly Hills estate created by legendary designer Tony Duquette. It's over-the-top outrageous but seems to fit in just fine.

If you want to do something out here, no one's going to tell you that you can't. That's why people are more willing to go for it with color too. Maybe it's the perpetual sunshine making people happy, but they want to be exuberant with both color and pattern.

This blend of bold choices and relaxed living make being a designer so fun here. I've always been a color guy, but I found myself making more daring choices more frequently now that I live here.

Of course, with indoor-outdoor living as the norm, it's had a huge impact on style everywhere. Doors are flung open, and there's little difference between the designs on either side.

Whether or not you actually live on the beach, its impact is felt everywhere in Southern California. And there isn't just one beach look. Drive from Santa

Barbara all the way down to San Diego and you'll find one adorable beach town after another. From Redondo Beach to Huntington Beach, Laguna Beach to Del Mar, Escondido to La Jolla.

Each of these places has its own twist on Southern California living. So wherever you are, it feels like nowhere else. Some are more high-end, and some have more of a surfer-town vibe, but they do share some common designs—crisp white rules, there's nothing heavier than a canvas fabric, and furniture is loose and natural.

Just like life here. ★

Opposite: I often use vintage fabrics (here on the chair and stools) to upholster pieces in a beach house. They instantly create a relaxed, perfectly worn-in look. Above right: I love a good art stack. That is a photograph by William Abranowicz and a drawing propped casually against a wall. It gives art a whole new look.

SOUTHERN CALIFORNIA STYLE MADE SIMPLE

THINK INDOOR-OUTDOOR

I pull a dining table out to the beach or the yard and design rooms with outdoor pieces like wicker chairs and stone urns. Other tricks I use are placing a big tree in a corner of a room or adding a rug to define an outdoor patio or porch. The easy and quick way to get the look is to use pieces made from rush, rattan, bamboo, or reclaimed wood.

LIGHTEN IT UP

Try any cotton, canvas, or linen fabric for upholstery or curtains to get a look that is so Southern California. They instantly make a room welcoming. Everyone feels they can come in and plop down anywhere. They also maximize light. I love the idea of lightening up floors with white paint or ceilings with a pale blue. I'll let you in on another secret: My go-to beach white is Benjamin Moore Super White.

TURN UP THE COLOR

Maybe it's the western light, but people here embrace bright color. Even a totally traditional home can sport a poppy orange or grass green. For paint, try covering an entire wall, trim and all. It sounds super loud, but it actually recedes more than if you use a bright blue and have stark white trim around it. I also love incorporating color via removable wallpaper. You can literally have it up for a year, a month, or a week. If you're more afraid of color, do an accent chair or some pillows. My only guideline with color is this: If I don't see the color in nature, I don't use it.

Top right: I like a tablescape that doesn't feel too precious. Found things can be just as lovely as antiques. Here, palm leaves and shells gathered on a walk mix with a favorite watercolor by Lulu DK. Right: This very '80s painting gets a new life in a simple, modern frame. Opposite: You can layer furniture as well as pillows or art. A vintage library cart is functional storage while the round table holds the essentials you need by the bed.

MALIBU BEACH

menu

SHRIMP QUESADILLAS

PICO DE GALLO

HIBISCUS ICED TEA

FISH TACOS

MANGO TART

Does Malibu even need an explanation?
It's what you think it is . . . beaches, surfer dudes, and
movie stars. It swells with Angelenos and tourists
all summer, but during the off-season, the short (twenty-
one miles long) stretch feels like a small town.

MIDCENTURY BOXES NEXT TO CLAPBOARD COTTAGES
and the occasional Mediterranean mansion all perch over
the waves of the Pacific. And even with its celebrity and
billionaire locals, it always feels chill.

BEACHSIDE TAQUERIA

Having lived in Malibu for years, I've done this menu
countless times, because it was fun, relaxed, and a huge hit
with everybody. Obviously, I love beach parties. I'd always
ask everyone who came to sun and surf to stay for dinner.
Why not extend the good times? And a beach dinner is
the most relaxed and natural entertaining can be.

It's always important to remember where you're
entertaining. Whether it's on the beach or in your
backyard, don't overthink it. Natural elements are at
play, so don't try to fight them. Nature is part of the
setting, so let it work for you. If you think ahead and
plan, you can make any setting as comfortable and
special as an indoor space.

I like to set up both a dining table and a little lounge
area where people can sit back, eat, and enjoy the sunset.
For the lounge, I pull up two low rattan chairs (any
beach chairs will work) and throw a blanket and lots
of seat cushions in front. (It's easier and lighter than
dragging out more chairs.) A galvanized pail turned

upside down makes an instant table. Or you can use a
handled tray to carry out plates and drinks.

Have you ever tried to eat on a table at the beach?
Exactly. It's totally unstable. But I have a trick that works
every time. I "bury" a table in the sand. Mark the legs
where you want them to go, dig holes, and lower the
table until it's even. (This is a great job for a kid or two—
I always call on my nephew Henry.)

Allow enough room between the table and the sand so
that guests can fit their legs underneath. (Oh, and be sure
to do this well before or after high tide!)

I cover the top with a piece of striped canvas fabric
and surround the table with lots of cushions and pillows
for people to sit on. I use lots of marine blues with some
sand-and-shell-inspired beige. Why fight the gorgeous
natural color around me?

I fill heavy glass jars with sea grass and sprinkle shells
down the center of the table. It's pretty and keeps the
cloth secure on the table. Glass jars filled with sand hold
tiny white votives for casual lighting after sunset.

The place settings are super simple and sturdy. I use
striped plates and navy-handled silverware that looks like
it came out of a picnic basket. I go classic with napkins:
white linen edged in a bright blue. And I always have two
large water bottles at the table, because who wants to
trudge back to the house?

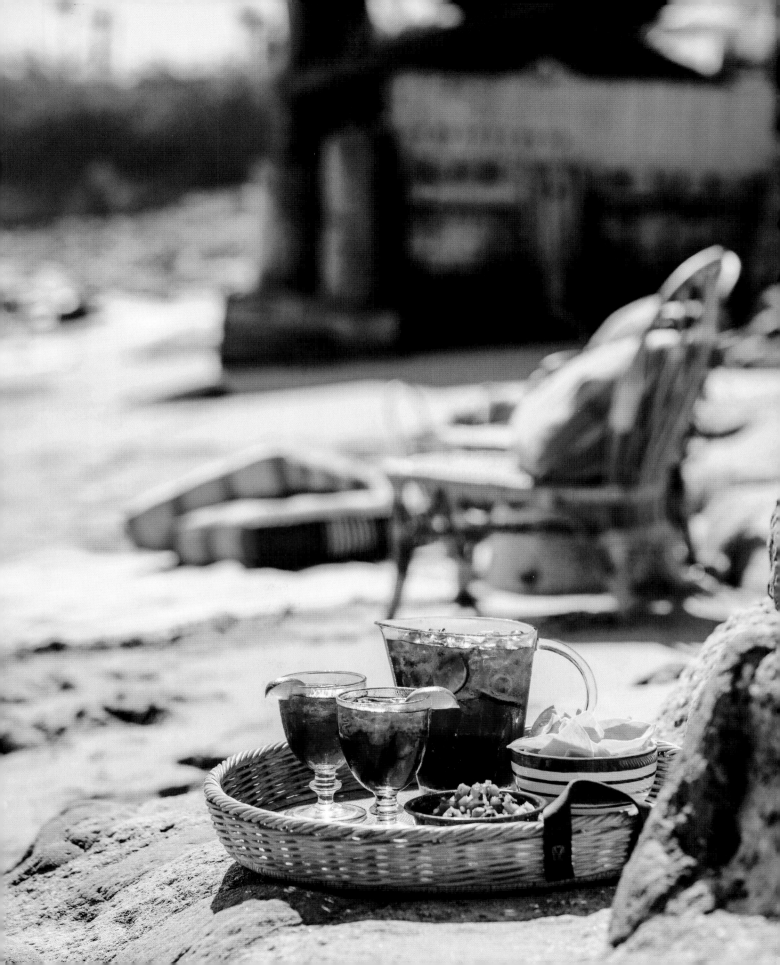

First rule of beach food? Forget staged courses. I like to just make the food and let people enjoy it when they like. Just say "shrimp quesadillas" and most people will be there. I learned to make these from an amazing cook in Carreras, Mexico, while staying at a friend's house. Wherever I travel, I find my way into the kitchen and end up cooking. My host Sophie's cook was making these, and her technique was a game changer.

It sounds straightforward . . . shrimp, cheese, and tortillas. But it's the process—cooking down the pico de gallo with a little butter to baste the shrimp—that takes it to the next level. I sauté the pico de gallo with butter and the shrimp until there's this heavenly sauce.

Baja-style fish tacos are a requirement in Southern California—it may be illegal to *not* eat them. Plus, they are a total crowd pleaser and easy to make. You can bring out a big platter family style or serve them in little boats lined with white paper like I do. (It reminds me of the first time I had them at a tiny shack in Laguna Beach.)

Every (legitimate) Baja taco has coleslaw and creamy pico de gallo. I often make the slaw and serve it over any fish I'm grilling. And the creamy pico de gallo is the traditional recipe, which I first learned to make in my twenties, from page 167 with crema Mexicana swirled in. (Add plenty to experience the thrill of having it run down your arm as you tip the taco to eat it.)

To drink, there's hibiscus iced tea. In Latin countries, *jamaica* is a cold beverage sold everywhere. I make this variation all summer long. And it's not bad spiked with vodka or tequila, either. It's tart by nature, so you can sweeten to suit your taste.

Another dish I learned from the lovely senora in Carreras was a fresh mango tart. It was so delicious that I had to come home and create my own version.

It's almost like a mango cheesecake, but lighter. So, of course, I had to add the whipped cream. I serve it on something rustic to match the setting, like an old beat-up cutting board. I also pile on the plates, whipped cream, and forks for easy transport from the kitchen to the sand. ★

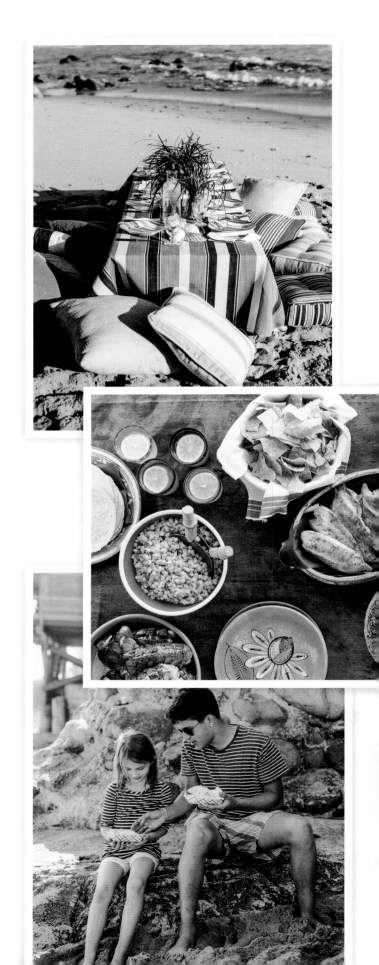

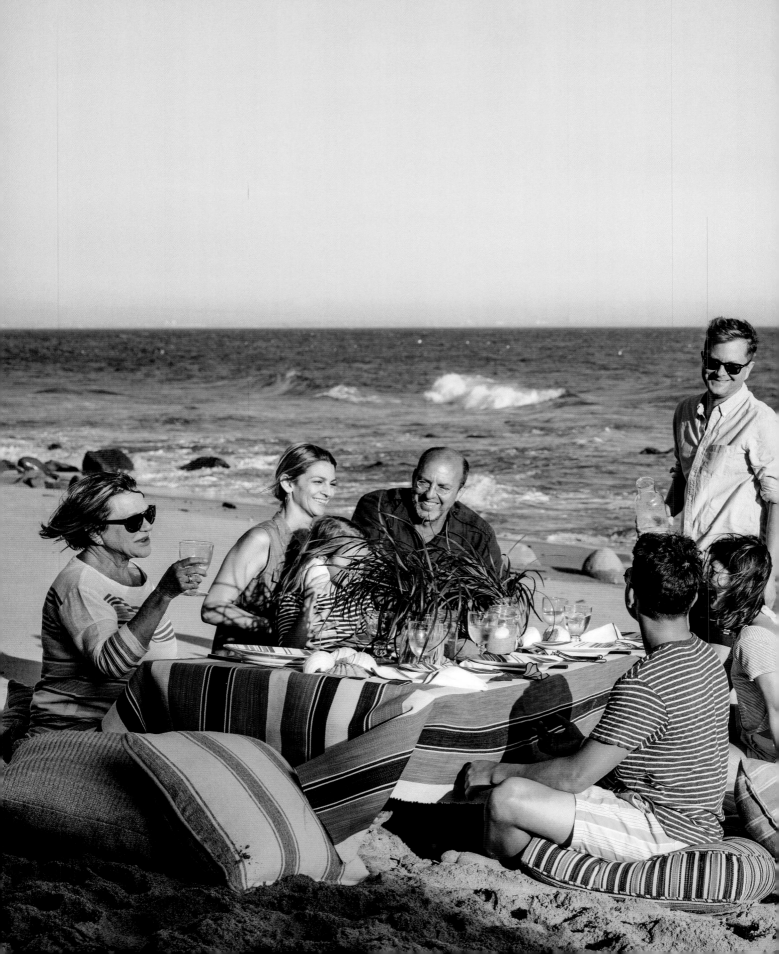

MY BEACH ENTERTAINING ESSENTIALS KIT

There's nothing that brings the fun to a halt at a beach BBQ like realizing you don't have an opener for the beer or a blanket when the sun sets. Here's what I have on hand for a long-lasting party.

SUNSCREEN (obviously)

A BIG JUG OF TAP WATER (to clean sandy hands and feet)

FLASHLIGHT (to find your way off the beach)

GALVANIZED BUCKET (use it to transport things, then turn it upside down to make a table)

TRASH BAGS (you should only leave behind footprints)

BEER/WINE BOTTLE OPENER (make sure to also have nonalcoholic options)

BLANKETS, SWEATERS (it gets surprisingly chilly when the sun sets)

BEACH ROCKS (essential for holding down your table linens or a stack of napkins)

UMBRELLA OR CANVAS CANOPY (no matter how much you want to get your tan on, you should always give people shade)

EXTRA BLUE-AND-WHITE STRIPED SHIRTS (in case someone forgets . . . just kidding)

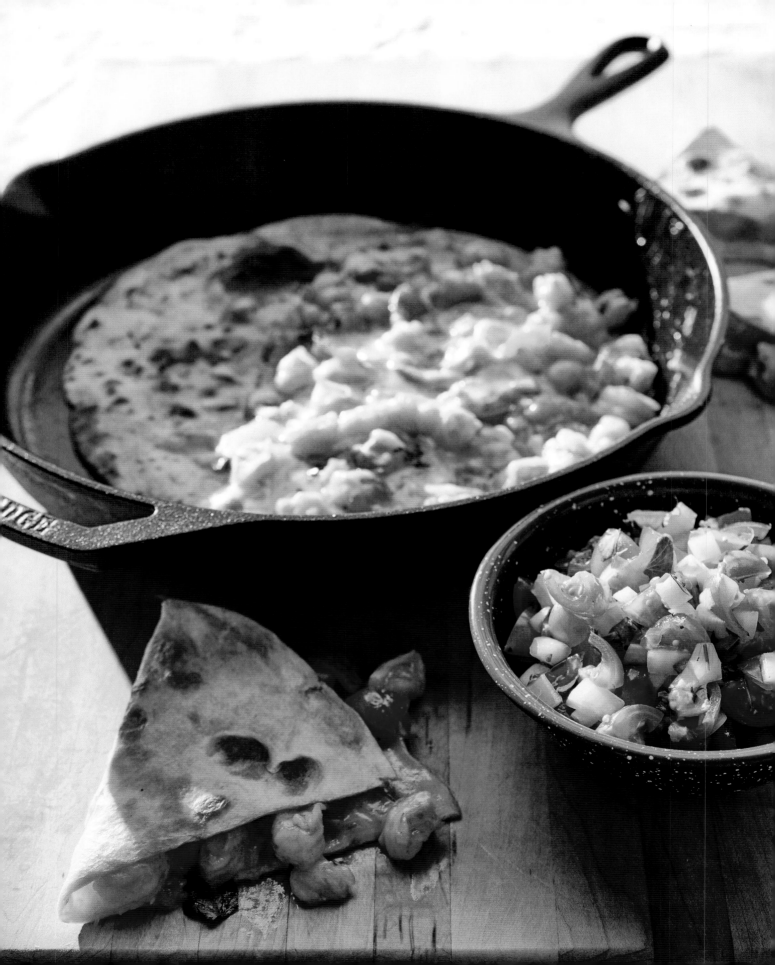

shrimp quesadillas

SERVES 6

You can adapt these for any occasion. Make them bite-size
for a nice appetizer or use one giant tortilla
for lunch. (Well, lunch for me.) If you prefer, substitute
crab, lobster, or any shellfish you like.

4 TABLESPOONS (55 G) UNSALTED BUTTER, DIVIDED

1 CUP (227 G) PICO DE GALLO

10 LARGE SHRIMP, SHELLED,
DEVEINED, AND CHOPPED

⅛ TEASPOON SALT

6 LARGE FLOUR TORTILLAS

4½ CUPS (361 G) SHREDDED QUESO CHIHUAHUA

In a medium skillet, melt 1 tablespoon of the butter. Add pico de
gallo and cook over medium heat for 2 minutes, until some of the
liquid evaporates. Add shrimp and reduce to a simmer. Cook for
5 minutes or until shrimp turns pink. Set aside shrimp mixture
and wipe out skillet. Melt ½ tablespoon butter in clean skillet and
add one tortilla. Lightly toast for 2 minutes and flip. Sprinkle with
¾ cup (60 g) cheese and ½ cup (113 g) filling and fold over to
create a half-moon. Toast for 2 to 3 minutes per side or until golden
brown. Remove from skillet and let cool for 1 minute before cutting
into wedges to serve. Repeat with remaining tortillas and filling.

pico de gallo

MAKES ABOUT 4 CUPS

I usually make a ton of this on a Friday night to enjoy
all weekend. It's great with chips at cocktail hour,
on my eggs on Sunday morning, or over a salad. Like
ketchup, it goes with practically everything.

6 ROMA TOMATOES, CHOPPED

1 SMALL WHITE ONION, PEELED AND CHOPPED

¼ CUP (10 G) FRESH CILANTRO, CHOPPED

JUICE OF 1 LIME

1 TABLESPOON DICED JALAPEÑO CHILE

1 TEASPOON SALT

1 TEASPOON HOT PEPPER SAUCE

Mix all ingredients together in a bowl. Let sit for at least
15 minutes before serving.

hibiscus iced tea

SERVES 8 TO 10

This is a nice alternative to lemonade or traditional iced tea. It's so refreshing. You can control the sweetness by varying the amount of agave or sugar. I brew mine cold instead of adding boiling water, which tends to bring out the bitter side of the hibiscus.

1 CUP (85 G) DRIED HIBISCUS FLOWERS

6 TABLESPOONS (90 ML) AGAVE SYRUP

JUICE OF 1 LIME

ICE, FOR SERVING

Combine 8 cups (2 L) water and the flowers in a pitcher and refrigerate overnight. Strain and discard flowers, then add agave and lime. Stir well and serve over ice.

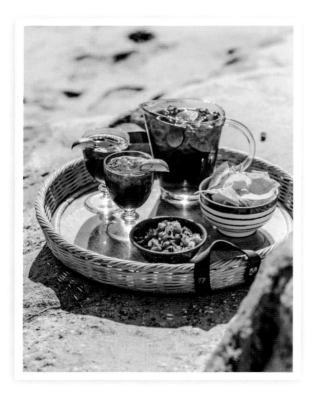

fish tacos

SERVES 4

A Southern California staple. After years of filets falling in and losing bits of crumbling fish on the grill, I decided it would be so much easier to just broil the fish in the oven. Another upside to this is they get a nice little crunch on top. I use a cookie sheet to broil the fish. Feel free to cook them in advance and then keep warm in the oven set on low until you are ready to assemble the tacos.

The coleslaw is the perfect topper for the fish tacos. I also often serve it as a side when I cook any kind of Mexican food at home.

2 TEASPOONS CHILI POWDER

2 TEASPOONS PAPRIKA

2 TEASPOONS GROUND CUMIN

1 TEASPOON ONION POWDER

2 TEASPOONS SALT, DIVIDED

2 CUPS (190 G) SHREDDED GREEN CABBAGE

3 GREEN ONIONS, THINLY SLICED

½ CUP (113 G) PICO DE GALLO (PAGE 167)

¼ CUP (60 ML) CREMA MEXICANA

1½ POUNDS (680 G) COD FILETS

2 TABLESPOONS OLIVE OIL

8 CORN TORTILLAS, WARMED

2 LIMES, CUT INTO WEDGES

Preheat broiler.

In a small bowl, combine chili powder, paprika, cumin, onion powder, and 1 teaspoon of the salt.

In a medium bowl, combine cabbage, green onion, pico de gallo, crema, and remaining salt and mix well. Set aside.

Rub cod with olive oil on a greased baking sheet and sprinkle evenly with spice rub, coating all sides. Broil for 6 minutes per side.

Serve fish in tortillas topped with Baja slaw and lime wedges.

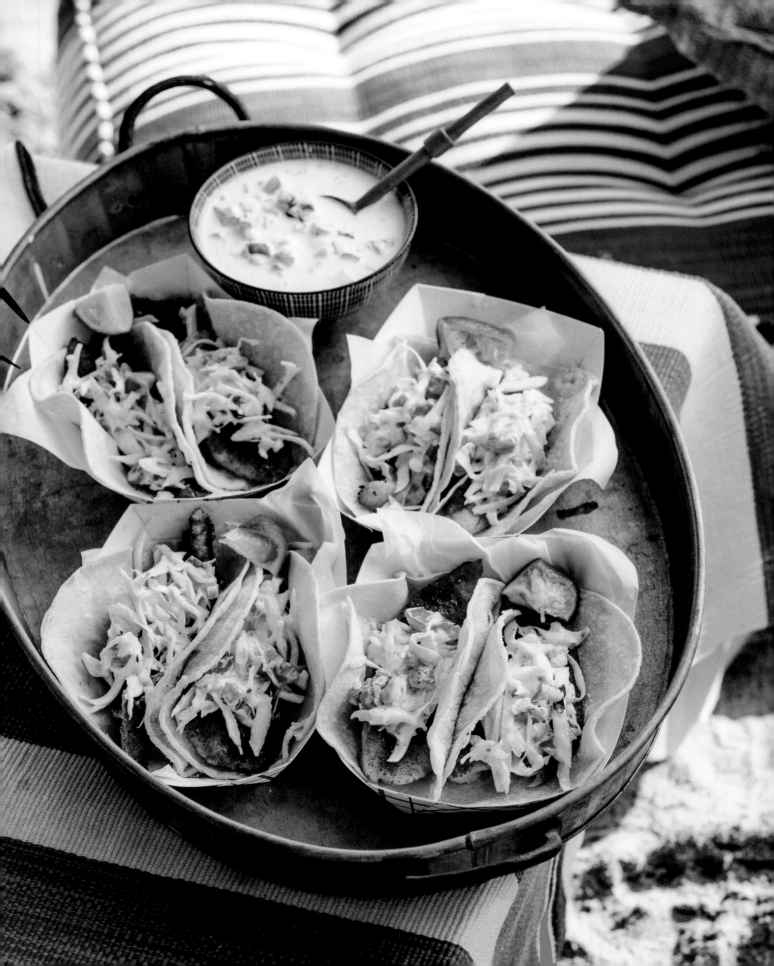

mango tart

SERVES 8 TO 10

This is almost like a mango cheesecake but lighter. (So of course,
I had to add the whipped cream.) You can also make it with pineapple.

2 CUPS (255 G) ALL-PURPOSE FLOUR

1 TEASPOON SALT

¾ CUP (170 G) COLD UNSALTED BUTTER,
CUT INTO ½-INCH (12-MM) CUBES

2 TABLESPOONS CREMA MEXICANA

2 TO 3 TABLESPOONS ICE WATER, PLUS MORE AS NEEDED

1 (8-OUNCE/225-G) PACKAGE CREAM CHEESE, SOFTENED

¼ CUP (50 G) GRANULATED SUGAR

1 LARGE EGG

1 CUP (240 ML) HEAVY CREAM, DIVIDED

1 TEASPOON VANILLA EXTRACT

1 MANGO, PEELED, PITTED, AND THINLY SLICED

2 TABLESPOONS CONFECTIONERS' SUGAR

Preheat oven to 350°F (175°C).

Combine flour and salt in a food processor and pulse to mix.
Add butter and pulse until mixture resembles a coarse meal.
Add crema and ice water and process until moist clumps
form and dough begins to form a ball, adding more ice water
if necessary. Gather dough into a ball and flatten into a disk.
Wrap in plastic and refrigerate for at least 1 hour.

Roll out dough to a 10-inch (25-cm) circle and carefully
transfer to a 9-inch (23-cm) round fluted tart pan with a
removable bottom. Prick bottom of crust all over with a fork
and bake for 15 to 20 minutes or until light golden. Let cool.

With an electric mixer, cream together cream cheese and
granulated sugar until fluffy. Add the egg, ½ cup (120 ml) of
the cream, and the vanilla and mix until combined. Transfer
to the cooled crust and smooth top with an offset spatula.
Arrange mango slices on top of tart and bake for 10 to 15
minutes or until just set.

Whip remaining cream and confectioners' sugar until stiff
peaks form, and serve with cooled tart.

MALIBU COUNTRY

★

menu

MARINATED TRI-TIP STEAK

BROCCOLI WITH GARLIC
AND RED PEPPER FLAKES

PANCETTA-ROASTED POTATOES

FALL SALAD

GERMAN APPLE CAKE

Beyond Malibu's beaches, there is another side
to the small town that speaks to my ranch roots:
a community of working farms and vineyards
in the foothills of the Santa Monica Mountains.

THESE PLACES ARE AS BEAUTIFUL AND INSPIRING AS the ocean just across the PCH. I love this semi-secret side to Malibu and feel right at home in the saddle.

RANCH STYLE BARBECUE

Nestled two miles above the PCH is a spot that blends all of my favorite things about California: ocean views, farm life, and laid-back style. It's One Gun Ranch, a working biodynamic farm with horse trails and Instagram-worthy views wherever you turn.

The setting allowed me to fulfill a California-rancher-meets-Malibu-style party. It's truly a little bit of everything that I love here. I wanted it to be super rustic and casual but to also have a lot of layers and touches that were unexpected but ultimately worked together.

The palette reflects the natural surroundings. The dusty browns and greens mimic the colors of the mountains, with a bit of sandy beige that calls to mind the beach just across the way. With such a muted palette, I want the textures to be strong but still comfortable and welcoming, like a natural wood picnic table with a bench and armchairs added to the other side and at each end. I always want guests to be comfortable at my parties, so I add pillows to chairs and cover the bench with serapes, or Mexican shawls. I love to infuse hits of Mexican style whenever I can—the wood candelabras are also from Mexico.

The embroidered linen tablecloth reminds me of an old-fashioned curtain you'd find on a ranch. The plates and napkins are cast in beige ceramic and linen. I use strips of leather to mimic a hand-tooled belt for the napkin rings. There's a little fanciness with the silverware and etched glassware, but I think every table needs some juxtaposition to keep it from being too one-note (i.e., boring).

To decorate the table, I use persimmons (just like the dried ones in the salad) for a hit of color and rustic simplicity. I'll lay some eucalyptus branches down the center of the table alongside the fruit. Two small pitchers at either end hold more eucalyptus, clover, and herbs—so fragrant and organic. Something too bright or fussy just doesn't work here.

Overall, I love the way this looks, and it's super easy to replicate. This style works for any casual outdoor dinner or barbecue. The muted table lets the food and the surroundings shine. Who can top Mother Nature in the end? I know I don't want to try.

One Gun Ranch also inspired this menu. I thought, what would a hungry crowd of ranchers do if they were plopped down near the beach in Southern California? It's a hearty meal, but it has a SoCal veggie influence too.

Page 172: A literal truckload of biodynamic produce at One Gun Ranch. Opposite: You can set up a bar literally anywhere, as seen here with our chubby little friend.

The marinated tri-tip steak and pancetta-roasted potatoes are my Cali version of a midwestern meat-and-potatoes supper. We used to grill steaks regularly growing up at the ranch (naturally), and I love this cut of beef for grilling. If you've never had it, just ask your butcher. It's perfect for a barbecue because it feeds a crowd. The marinade is a family secret (shhh . . .)—it's tart, sweet, and fresh all at the same time.

The pancetta (which is Italian bacon) gives normally bland potatoes the extra kick of crunch and salt they need. So delish, you could make a meal just out of those. When I was a kid, my grandmother made broccoli like this, and it was the only way I would eat it. So she added fresh, sweet garlic to it and I started to gobble it down. It's such an easy way to jazz up an ordinary vegetable.

Speaking of vegetables, I had to include this fall salad here—but feel free to make it any time of year. It's a great example of what I like to call "bite building." Bet you didn't know I was a builder as well as a decorator. Bite building is combining flavors and textures on a fork until it's perfect (a little salty, a tad sweet, something soft, a bit of crunch). Here, the dried persimmons, blue cheese, walnuts, grainy farro, and citrusy dressing make for just such an amazing bite.

To finish, another ranch classic: German apple cake. The recipe comes from my mother, whose maiden name is Tromanhauser, so she comes by this cake naturally. ★

This page and opposite (clockwise from top right): Tuesday and Louis on the steps of a vintage Airstream; my favorite cowgirls: Tessa, Minnie, and Zoe; personalized bracelets do double duty as napkin rings and party favors; vintage ceramic plates get dressed up with Ralph Lauren's Kings silverware. Following spread: Cocktails with Achilles before people gather at the table.

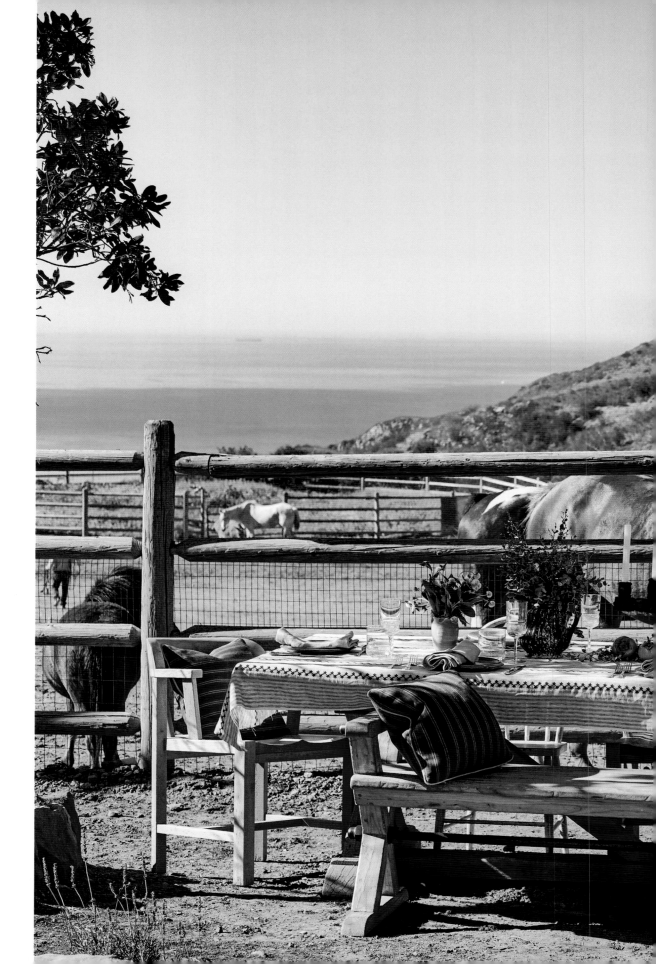

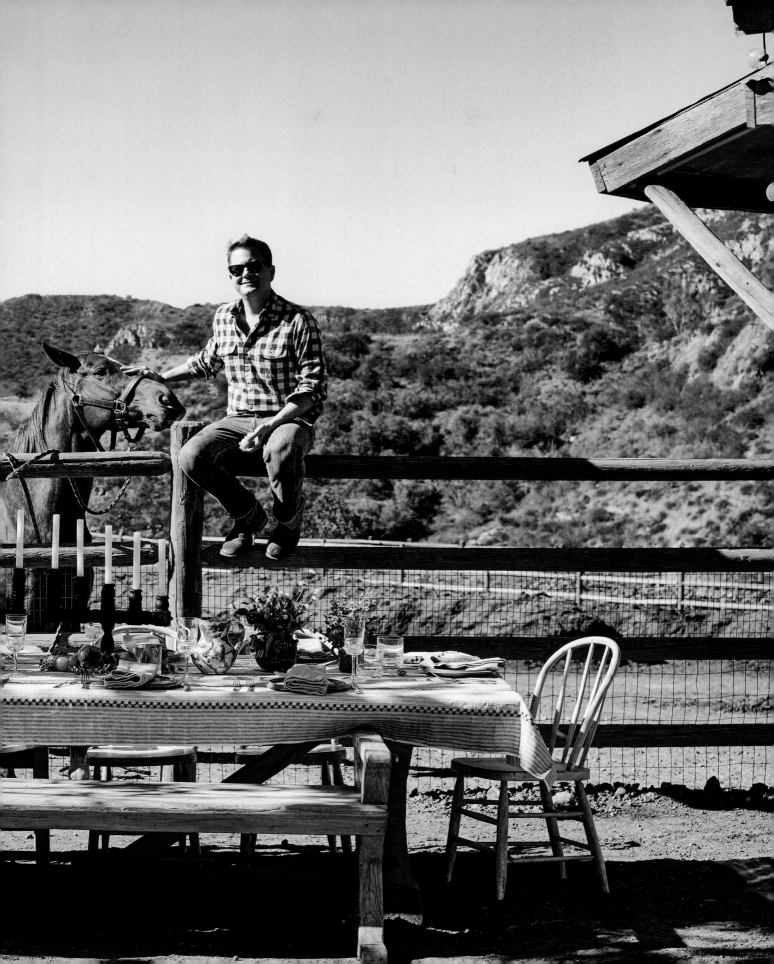

marinated tri-tip steak

SERVES 6 TO 8

Tri-tip steak is a particularly California cut of meat and is ideal for grilling.
It is cut from the tri-tip roast, the triangular portion of the sirloin. Ask your butcher
for the California cut or tell him it's where the sirloin meets the round and flank.

1 (28-OUNCE/795-G) CAN CRUSHED TOMATOES

½ CUP (120 ML) OLIVE OIL

½ CUP (120 ML) APPLE CIDER VINEGAR

¼ CUP (55 G) LIGHT BROWN SUGAR

¼ CUP (7 G) CHOPPED FRESH OREGANO

5 CLOVES GARLIC, MINCED

2 TABLESPOONS LEMON JUICE

1 TABLESPOON SALT

1 TABLESPOON LIME JUICE

1 TEASPOON GROUND BLACK PEPPER

1 TEASPOON HOT PEPPER SAUCE

1 (2½-POUND/1.2-KG) BEEF TRI-TIP STEAK

In a large bowl, combine all ingredients except tri-tip and stir well. Add tri-tip and let marinate for at least 4 hours or overnight.

Remove meat from marinade and transfer marinade to a medium saucepot. Heat a grill to medium-high heat and sear tri-tip on all sides. Cook for 30 minutes or until a meat thermometer reaches 130°F (55°C) for medium-rare or 140°F (60°C) for medium. Let rest for 10 minutes before slicing. Meanwhile, heat marinade until boiling and cook for 5 minutes. Serve sauce on the side.

broccoli with garlic and red pepper flakes

SERVES 6 TO 8

3 CLOVES GARLIC, MINCED

½ TEASPOON RED PEPPER FLAKES

3 TABLESPOONS OLIVE OIL

6 CUPS (545 G) BROCCOLI FLORETS

In a large pan, sauté garlic and red pepper flakes in olive oil for 2 minutes or until fragrant. Add broccoli and cook for 12 minutes or until desired doneness.

pancetta-roasted potatoes

SERVES 6 TO 8

As with anything you place under the broiler,
remember to keep an eye on it and to give it
a good shake halfway through. These can go from
golden and crunchy to inedible fast.

3 POUNDS (1.4 KG) MEDIUM YUKON GOLD
POTATOES, SCRUBBED

5 OUNCES (140 G) DICED PANCETTA

2 TABLESPOONS OLIVE OIL

3 TABLESPOONS CHOPPED FRESH SAGE

½ TEASPOON SALT

¼ TEASPOON GROUND BLACK PEPPER

Preheat broiler.

Bring a large pot of water and the potatoes to a boil. Cook for
15 minutes or until just tender. Drain and rinse with cold water.
Once cool, cut into 1-inch (2.5-cm) chunks.

Heat a small sauté pan over medium-high heat and add pancetta.
Cook for 8 to 10 minutes or until crispy. Drain on a paper towel.

Toss potatoes, olive oil, sage, salt, and pepper on a greased
sheet tray and broil for 5 minutes or until beginning to get crispy
and golden. Garnish with pancetta before serving.

fall salad

SERVES 10 TO 12

Persimmons are seasonal. That's why I like to use the
dried variety so I can make this salad anytime (and I
do.) If you can't find either, use dried cherries or pears.
Both work equally for an autumnal taste.

for the orange vinaigrette:

¼ CUP (60 ML) APPLE CIDER VINEGAR

¼ CUP (60 ML) FRESH ORANGE JUICE

1 SHALLOT, FINELY CHOPPED

1 TABLESPOON LIGHT BROWN SUGAR

¼ TEASPOON SALT

¼ TEASPOON GROUND BLACK PEPPER

½ CUP (120 ML) EXTRA-VIRGIN OLIVE OIL

for the salad:

10 OUNCES (280 G) BABY KALE

2 HEADS GREEN-LEAF LETTUCE, TORN INTO BITE-SIZE PIECES

1 CUP (200 G) COOKED AND COOLED FARRO

½ CUP (70 G) CRUMBLED POINT REYES BLUE CHEESE

½ CUP (60 G) WALNUTS, TOASTED AND COARSELY CHOPPED

¼ CUP (21 G) DRIED PERSIMMONS

In a large bowl, combine vinegar, orange juice, shallot, brown
sugar, salt, and pepper. While whisking constantly, slowly drizzle
in olive oil until emulsified. Set aside.

In a large bowl, toss together all salad ingredients. Add dressing
and toss to coat. Serve immediately.

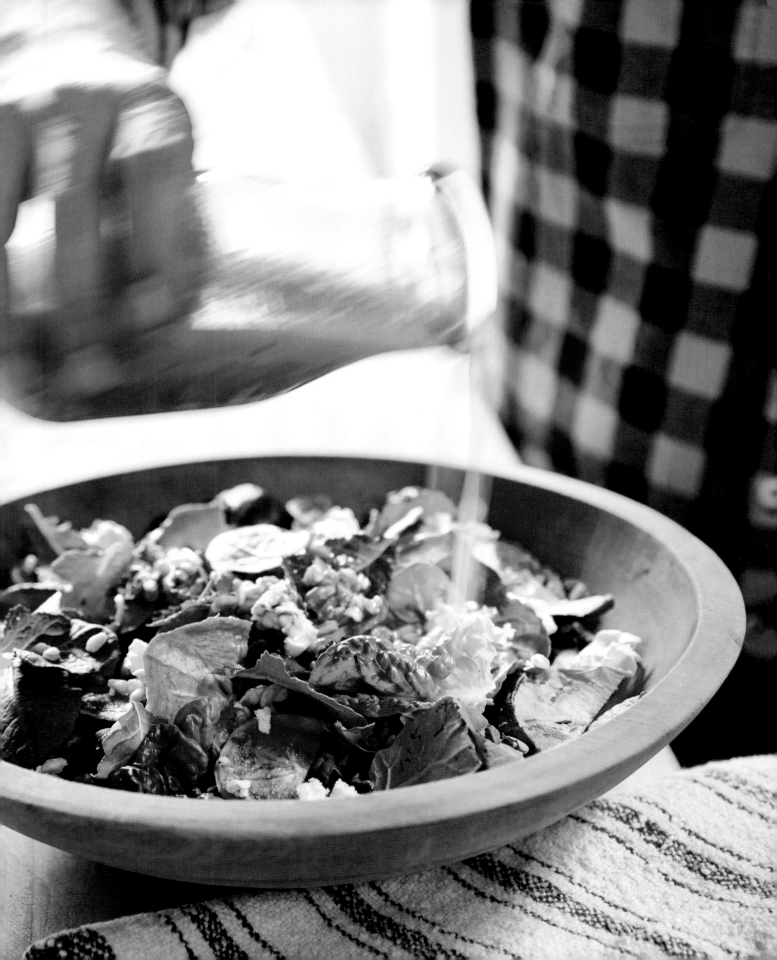

german apple cake

SERVES 9

I like a versatile dessert. And this is equally delicious whether you
serve it with vanilla ice cream or fresh whipped cream.
I also wouldn't say no to it with a cup of coffee at breakfast.

3 MEDIUM GRANNY SMITH APPLES,
PEELED, CORED, AND SLICED ¼ INCH (6 MM) THICK

1 TEASPOON LEMON ZEST

2 TABLESPOONS LEMON JUICE

½ CUP (115 G) UNSALTED BUTTER, AT ROOM TEMPERATURE

1 CUP (200 G) GRANULATED SUGAR

2 LARGE EGGS

1 TEASPOON VANILLA EXTRACT

1¼ CUPS (160 G) ALL-PURPOSE FLOUR

1½ TEASPOONS BAKING POWDER

1 TEASPOON SALT

1 TEASPOON GROUND CINNAMON

½ TEASPOON GROUND NUTMEG

½ CUP (120 ML) SOUR CREAM

Preheat oven to 350°F (175°C). Grease an 8-inch (20-cm) square
baking pan and line with parchment paper.

Combine apple slices with lemon zest and juice and set aside.

In a stand mixer fitted with the paddle attachment, cream butter
and sugar for 5 minutes, until pale and fluffy. Add eggs one at a
time, beating well after each addition. Stir in vanilla. In a medium
bowl, whisk together flour, baking powder, salt, cinnamon, and
nutmeg. Gradually add flour mixture to butter mixture, alternating
with sour cream, and stir until just combined. Pour batter into
prepared pan and arrange apples on top.

Bake for 35 to 40 minutes, until a toothpick inserted into the center
comes out clean. Let cool completely.

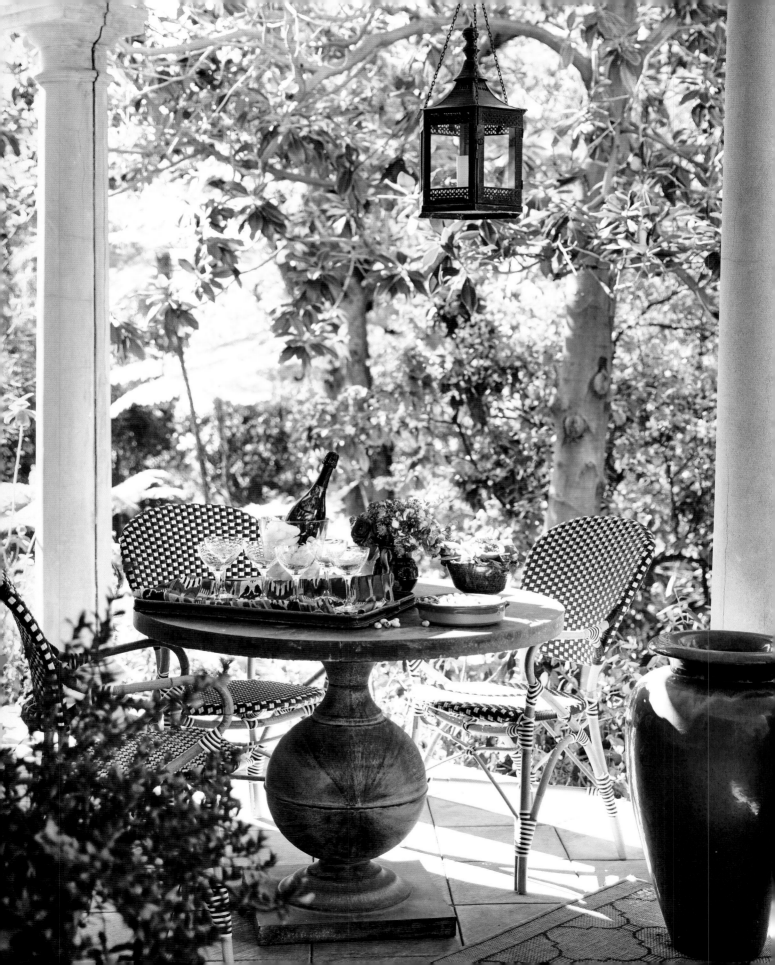

LOS ANGELES

menu

POMEGRANATE CHAMPAGNE COCKTAILS

ROASTED LEEK HUMMUS

ROASTED BEET HUMMUS

CHICKEN TAGINE

BASMATI RICE WITH ALMONDS
AND GOLDEN RAISINS

RICE PUDDING

Yes, LA is Hollywood, and Hollywood is LA. But it's also
a complex, super diverse city with as many sides as any
other major metropolis. That's why I am never bored here.
I believe in being an adventurer . . . even in your own city.
You can always stumble upon something new.

RELAXED EXOTIC FEAST

THERE ARE SO MANY AMAZING, DIVERSE NEIGHBORHOODS
in Los Angeles: Koreatown, Boyle Heights, and Pico-
Robertson—where I love to browse all of the Middle
Eastern markets. I can seriously spend a day (and have)
walking down the endless aisles of exotic spices, nuts,
and dried fruits. You forget you are in LA, not Istanbul.
It was these shopping trips that inspired this Moroccan
feast. Well, that and some wallpaper . . .

My boyfriend, Eric, decorated this incredible dining
room using Iznik-patterned wallpaper and fabrics. It is
one of my favorite rooms in LA. It's a Middle Eastern
fantasy inside of California Spanish architecture. This
mix of styles is one of my favorite design combinations.
I've used it in many of the homes I've decorated.

For this table, I really let the home decor inspire and
set the scene. And that is something to remember for any
party. Look around and let your surroundings influence
the menu, the table . . . the overall mood of your meal.
After all, when you are entertaining, you want to show
friends a fun, festive time and make it personal. Your
rooms can become a beautiful backdrop. Then you can
add layers with the dishes, flowers, and accessories.

The room had to have this Moorish vibe, and the
amazing pattern gets me halfway there. So I just add
things to keep it going. A note here on creating tables in
general: I often let the table happen spontaneously. What
I mean is I might have an idea, but as I put things out, I'll
change things up a bit from what I'd pictured in my head.

It's not unlike decorating a room. I like to have a bit
more freedom so adjustments can be made when I see
everything together. If the white napkins aren't working,
I'll switch to a darker blue. If the candles feel heavy, I'll go
with a skinny taper. It's about creating a final table that
works and feels finished to you.

This is probably the most fancy table you'll see me set
in this book (or anywhere), but it seems to work with
the Middle Eastern fantasy theme. I start with an ivory
tablecloth with a subtle blue pattern. It is delicate enough
not to clash with the walls, but it matches the vibe.

The place settings are classic: antique English silver;
modern, graceful glassware; simple china plates with a
gold edge; and white linen napkins. Since I know there is
going to be color in the flowers, fruit, and candles, I want
a clean base.

I use black candles in turned white holders because
it feels unexpected, moodier, and exotic. Just like your
flowers don't have to match, neither do your vessels. To
make the table look lush, I tuck flowers into brass genie

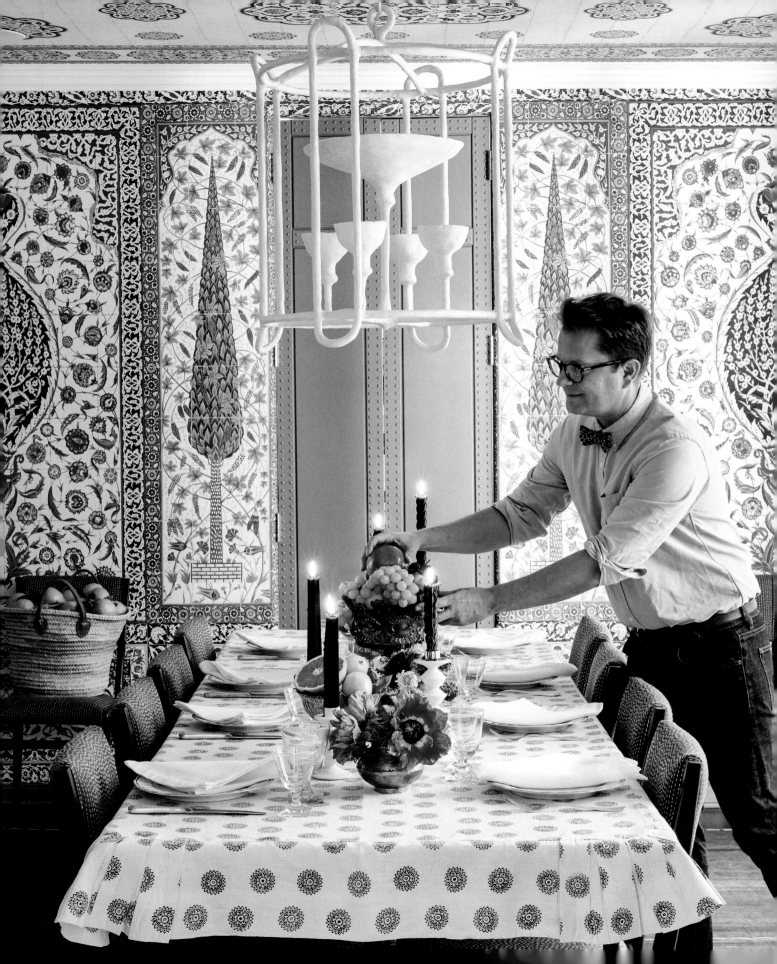

bottles and gilded vases, then mix in glass and pottery bowls overflowing with fruit. It's the array of textures (pottery, brass, glass, silver, linen, and fine china) that gives the table interest here, even though there is very little pattern.

The fruit and flowers echo the colors of the meal. They're deeper, more organic shades.

I collect brass vessels and vases from trips to Morocco and Istanbul, but you can use what you have or find inexpensive ones at a Middle Eastern shop. These markets are such an untapped resource for entertaining. It's a quick way to make your table look and feel different and special. So don't be afraid to try new things. Believe me, I have had some bombs before, but I have also discovered some amazing things.

The menu is slightly exotic, but it's not too spicy or so weird as to alienate anyone. What I love is how abundant the table looks—a warm, welcoming display, and you get to eat it all!

First, I set up a *mezze*, or appetizer, table outside or in another room to accompany drinks (see how to create one at right). I'm a sucker for a themed cocktail. Here, it's champagne accented with pomegranate—a ruby-colored Middle Eastern fruit. It could not be prettier (or easier). The bright seeds pop against the pale champagne and just make it feel special. You can also do a nonalcoholic version with sparkling water.

The main course is a chicken tagine, which refers to the earthenware dish the food is cooked and served in (another pot-to-table situation, my favorite). It's comforting, like a stew but with a twist. The blend of bright lemons with briny olives is one of those heavenly pairings. You can also cook this in a Dutch oven if you don't have a tagine. But I don't think you'll regret investing in one. And the dish becomes part of the table decor.

Basmati rice is *the* classic accompaniment. It makes the perfect base to sop up every last bit of the stew.

Is there anything more homespun and comforting than rice pudding? If so, I've not found it. For desserts, I often stick to the classics but add something that makes it special. Here, I add stewed apricots and slivered pistachios. (And don't crack and slice them yourself—get them from the Middle Eastern market.) You can arrange little bowls on a silver tray and serve from a sideboard, or bring out a large dish and let guests help themselves at the table, always my preferred method. Just be prepared for a fight for the last bite. ★

COCKTAIL TABLE MIX
(See image on following page)

A **WOODEN TRAY** with a piece of African cloth (adds texture and a bit of exotic pattern)

Clear **CHAMPAGNE BUCKET** (with so much going on, always have something simple and clear)

FOOTED BOWL with open pomegranates, oranges, lemons (keep it open so people can pick at them over drinks and dinner)

Tuck a few **LEAVES** in between for a pop of green (and a different texture).

Put everything in **POTTERY BOWLS** (offers a good contrast to glass and brass).

Another pottery bowl holds a tiny arrangement of **LOOSE FLOWERS** (wild ones feel more lush).

Pick a **COLOR PALETTE**, then go up and down in tones—deep pinks, mauves.

LIGHT SNACK: Pistachios and other nuts are pretty and look slightly exotic.

pomegranate champagne cocktails

SERVES 6

1 (750-ML) BOTTLE CHAMPAGNE, CHILLED

6 TABLESPOONS (90 ML) POMEGRANATE JUICE

6 TEASPOONS COINTREAU

¼ CUP (50 G) POMEGRANATE ARILS

Divide champagne between six flutes and top each with 1 tablespoon pomegranate juice, 1 teaspoon Cointreau, and a few arils for garnish.

roasted leek hummus

SERVES 8

1 LARGE LEEK, CLEANED AND SLICED

2 CLOVES GARLIC, MINCED

4 TABLESPOONS (60 ML) OLIVE OIL, DIVIDED

1 (15-OUNCE/430-G) CAN CHICKPEAS, RINSED AND DRAINED

2 TABLESPOONS TAHINI

1 TEASPOON LEMON JUICE

1 TEASPOON SALT

1 TEASPOON GROUND WHITE PEPPER

Preheat oven to 400°F (205°C). Toss leeks, garlic, and 2 tablespoons of the olive oil on a rimmed baking sheet and roast for 20 minutes, until softened and light golden. Let cool.

In a blender, combine chickpeas, tahini, lemon juice, salt, pepper, and remaining 2 tablespoons olive oil and pulse to combine. Add cooled roasted leeks and garlic and blend until smooth, adding water 1 tablespoon at a time to thin mixture to desired consistency.

roasted beet hummus

SERVES 8

I usually make hummus way in advance. That way, I can stash it in the fridge and forget about it until it's time to make a mezze platter or have on hand for entertaining in a pinch.

1 LARGE RED BEET, PEELED AND COARSELY CHOPPED

2 CLOVES GARLIC, MINCED

4 TABLESPOONS (60 ML) OLIVE OIL, DIVIDED

1 (15-OUNCE/430-G) CAN CHICKPEAS, RINSED AND DRAINED

2 TABLESPOONS TAHINI

1 TEASPOON LEMON JUICE

1 TEASPOON SALT

1 TEASPOON GROUND WHITE PEPPER

Preheat oven to 400°F (205°C). Toss beet, garlic, and 2 tablespoons of the olive oil on a rimmed baking sheet and roast for 30 minutes, until softened. Let cool.

In a blender, combine chickpeas, tahini, lemon juice, salt, pepper, and remaining 2 tablespoons olive oil and pulse to combine. Add cooled roasted beets and garlic and blend until smooth, adding water 1 tablespoon at a time to thin mixture to desired consistency.

MAKING A MEZZE

A *mezze* is the Middle Eastern term for what we call an appetizer tray.
It's a bunch of little dishes to accompany drinks for a first course.
The fun is shopping for, gathering, and arranging all of the ingredients
until you have this brimming tray of beautiful snacks to share.

I've done my fair share of these, so I'm showing you what I like to do.
But I switch it up a little each time. So experiment and have fun.
Find things you love and add something you've never tried. Everything should
be simple and tasty. What makes it beautiful is how you put it together.

mezze ingredients

RAW VEGETABLES
(PEPPERS, TOMATOES, CUCUMBERS, CARROTS)

ROASTED BEET HUMMUS

ROASTED LEEK HUMMUS

GREEN AND BLACK OLIVES

DRIED FRUITS (FIGS, APRICOTS, PLUMS, PEACHES)

NUTS (ALMONDS, PISTACHIOS)

SOFT CHEESES (BEEMSTER, FETA)

TORN TOASTED PITA SHARDS

YOUR FAVORITE CHARCUTERIE
(I ADDED HARD SALAMI)

YOUR FAVORITE CHEESES
(I DID A MIX OF HARD AND SOFT
VARIETIES WITH BOURSAULT, BRIE,
FETA, GRUYÈRE, AND GOUDA)

putting it together

1 Gather a bunch of small bowls and baskets, and one large tray. It doesn't have to all fit on one platter. It's better to have things on and off in various bowls.

2 Cluster things together to go along with the main tray. I use a vintage cutting board with fig leaves as the base for the cheeses.

3 I make sure to have a big bowl of vegetables. This adds some freshness and infuses some color.

4 Decant the hummus, nuts, and olives into smaller bowls. (Don't forget to include an empty bowl for the pits.)

5 Sprinkle dried fruits in the empty spaces on the board.

6 Add a basket full of toasted pita.

7 Instead of flowers, try a pot of fragrant herbs like rosemary or thyme.

chicken tagine

SERVES 4

It's not necessary, but I would suggest making this
the day before or at least a good six to eight hours ahead of time.
The longer the flavors have to sit, the better it tastes.

1 TABLESPOON OLIVE OIL

1 WHOLE CHICKEN, CUT INTO 8 PIECES

1 TEASPOON SALT

1 TEASPOON GROUND BLACK PEPPER

1 LARGE YELLOW ONION, THINLY SLICED

4 CLOVES GARLIC, MINCED

1 TABLESPOON PAPRIKA

1 TABLESPOON GROUND CUMIN

1 TEASPOON GROUND CINNAMON

1 TEASPOON GROUND GINGER

1 CUP (240 ML) CHICKEN BROTH

1 CUP (240 ML) WHITE WINE

1 LEMON, CUT INTO WEDGES

1 CUP (155 G) PITTED GREEN OLIVES

In a Dutch oven, heat olive oil over medium-high heat. Season chicken with salt and pepper and brown on all sides until golden. Remove and add onion. Sauté for 5 minutes, until softened. Add garlic, paprika, cumin, cinnamon, and ginger and cook for 2 minutes. Add broth and wine and bring to a boil. Add chicken and lemon wedges, cover, and reduce to a simmer. Cook for 45 minutes or until chicken is cooked through.

Remove chicken and place on a platter or in a tagine. Add olives to pan and increase heat to medium-high. Boil uncovered for 5 to 8 minutes, until sauce is thickened. Pour over chicken and serve immediately.

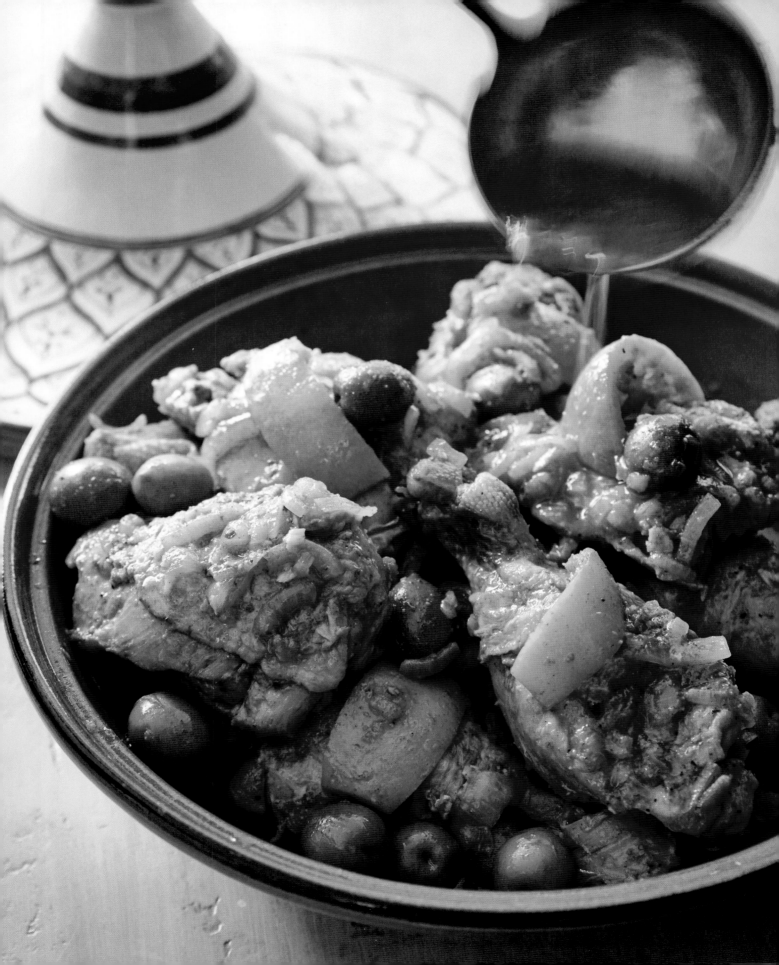

basmati rice with almonds and golden raisins

SERVES 6

1 TABLESPOON UNSALTED BUTTER

1 CUP (180 G) BASMATI RICE

1 CLOVE GARLIC, MINCED

1 CUP (240 ML) CHICKEN BROTH

1 TEASPOON SALT

2 GREEN ONIONS, CHOPPED

¼ CUP (25 G) SLICED ALMONDS, TOASTED

¼ CUP (35 G) GOLDEN RAISINS

3 TABLESPOONS GRATED PARMESAN CHEESE

1 TABLESPOON CHOPPED FRESH FLAT-LEAF PARSLEY

1 TEASPOON GROUND BLACK PEPPER

In a medium pot, melt butter over medium-high heat. Add rice and garlic and sauté for 2 minutes or until lightly toasted and fragrant. Add 1 cup (240 ml) water, broth, and salt and bring to a boil. Reduce to a simmer, cover, and cook for 15 to 20 minutes or until liquid is absorbed and rice is tender. Remove from heat. Let sit for 10 minutes before stirring in green onions, almonds, raisins, cheese, parsley, and pepper.

rice pudding

SERVES 6 TO 8

This is another old recipe from the ranch.
At its base is a classic rice pudding, but adding the apricots
and pistachios makes it feel instantly more unique.

1 CUP (200 ML) SHORT-GRAIN WHITE RICE, RINSED

½ CUP (100 G) GRANULATED SUGAR, DIVIDED

1 TABLESPOON BROWN SUGAR

½ TEASPOON SALT

1 CUP (240 ML) HALF-AND-HALF

½ TO 1 CUP (120 TO 240 ML) WHOLE MILK, DIVIDED

1 TABLESPOON UNSALTED BUTTER

1 TEASPOON VANILLA EXTRACT

½ TEASPOON GROUND CINNAMON

1 CUP (130 ML) DRIED APRICOTS, CHOPPED

1 TABLESPOON FRESHLY GRATED LEMON ZEST

¼ CUP (30 G) CHOPPED PISTACHIOS

In a medium pot, combine rice, ¼ cup (50 g) of the sugar, brown
sugar, salt, and 2 cups (480 ml) water. Bring to a boil, reduce to a
simmer, and cook for 15 minutes or until water is absorbed and rice
is tender. Add half-and-half and ½ cup (120 ml) milk and bring to a
boil. Reduce to a simmer, stirring often. Simmer for 10 minutes, until
thick and creamy, adding additional milk to reach desired consistency.
Remove from heat and stir in butter, vanilla, and cinnamon.

While rice is cooking, prepare apricots. In a medium pot, combine
apricots, remaining ¼ cup (50 g) sugar, and lemon zest with ½ cup
(120 ml) water. Bring to a boil and reduce to a simmer. Cook for 8 to
10 minutes or until thick and syrupy. Cool completely.

Serve rice pudding warm, topped with cooked apricots and chopped
pistachios.

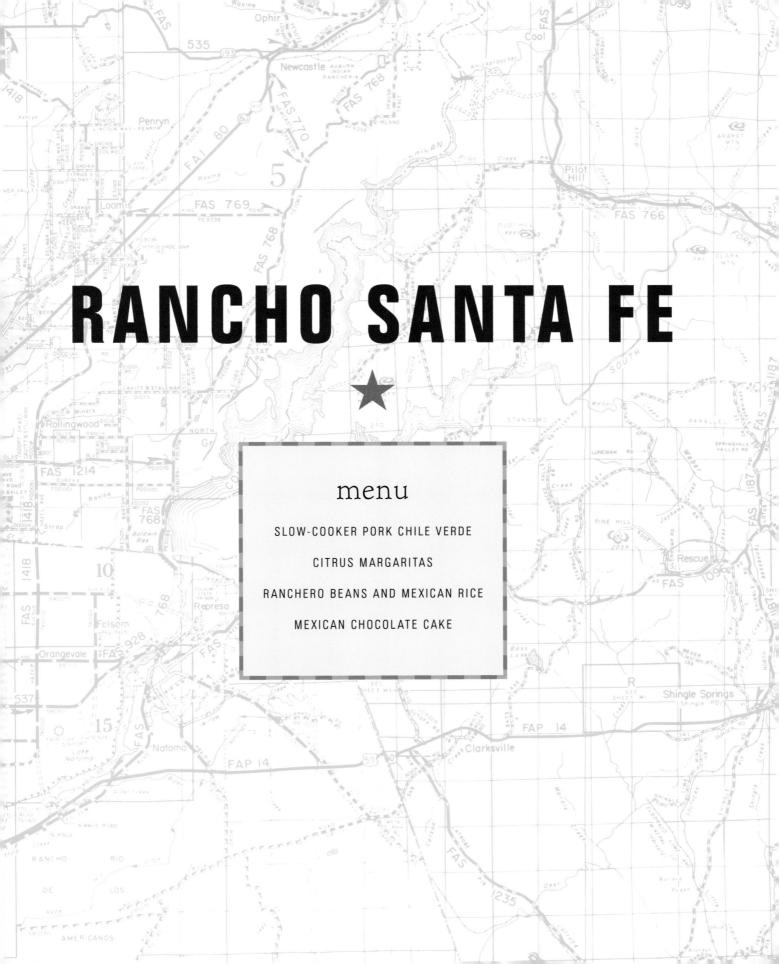

RANCHO SANTA FE

★

menu

SLOW-COOKER PORK CHILE VERDE

CITRUS MARGARITAS

RANCHERO BEANS AND MEXICAN RICE

MEXICAN CHOCOLATE CAKE

Just north of San Diego is a uniquely old-fashioned
Spanish-style California town. Brief history lesson: California
was a Spanish colony from 1769 to 1821 and part of
Mexico from 1821 to 1850. We forget that California has
not been a part of the United States for very long.
And being in Rancho Santa Fe really does transport you.

THE VILLAGE IS LINED WITH OLD SPANISH-STYLE
buildings (my favorite) and hot pink bougainvillea
climbing up the walls. Its history still influences every
aspect of life here: the landscape, the architecture, and
(most importantly, to me) the food.

FIESTA FOR THIRTY (OR FEWER . . .)

In California, not just Mexican but all Latin food is part
of our day-to-day life. It's not exotic to us. It's what we
eat. (One of the reasons I lasted only about six months
living in New York City was that I missed Mexican food.
True story.)

Rancho Santa Fe is the natural backdrop for my
Mexican menu. It's the kind of food you want piled high
on your plate, food you want to dig into for seconds or
even thirds. So I always go big when I do it. That means a
gorgeous, overflowing self-serve buffet that can be adjusted
to feed your family or a small town (OK, thirty people).

The setting is so inspired by my time spent in town and
at parties in and around San Diego. While many visitors
only see the beach, there's an incredibly diverse group of
ranchers and farmers who know how to throw a fun party.

For such a large crowd, I create stations and a big buffet
instead of setting a table. People just sit where they want.

Obviously, you have to start with a margarita. It's my
go-to drink, and I don't know anyone who doesn't love
one . . . and I don't want to.

I like to put my margarita bar outside because
margaritas taste better alfresco. I put a table in front
of a tangle of ivy and bougainvillea (I love how the hot
pink color fades into a soft red from the sun). I drape a
colorful Mexican textile over half the table, then gather
blue-rimmed glasses and vibrant purple napkins. (Full
disclosure: This party look is super colorful.) I add some
purple and orange flowers in vintage Mexican pottery,
but you could use any kind of vase or vessel you have.

The buffet table is all about beauty balanced with
efficiency. I want it to look pretty, but I also want people
to have everything they need when they sit down. For
seating, I make sure to leave a dining table clear for people
to sit together. I also clear off coffee and side tables so
people will have a place for their drinks and plates.

Accessorize your buffet like you would a room. Think
about color, pattern, texture, and scale. For height and
texture, I fill a tiered tray with oranges, lemons, and

Opposite: Indoor-outdoor living at its best in Rancho Santa Fe.

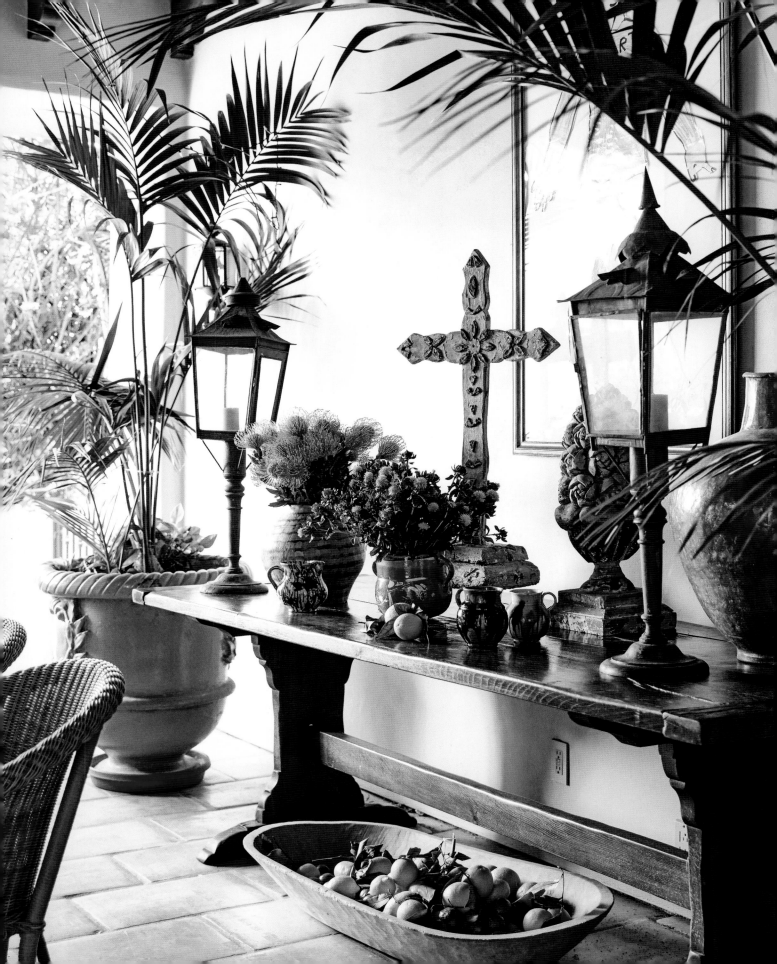

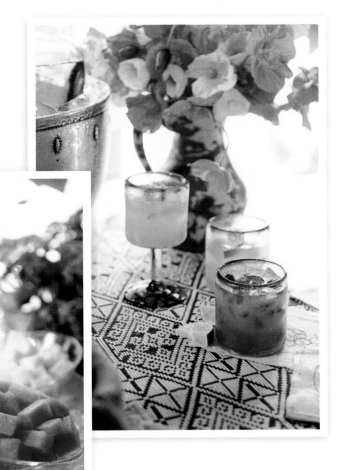

This page (clockwise from top left): My pal Wendy always brings the laughs; fresh fruit prepped and ready for the margarita bar; color-blocked flowers create a major punch against bright Otomi fabric.

limes. Add decorative items from around your house. I love this vintage wood cross. It is unexpected and feels like one you'd see in an old church here. I also prop up an oil painting—a still life of tropical fruit. (Just don't use anything irreplaceable, as it might get splattered with food.) I serve everything in a mix of ceramic dishes and woven baskets. I put the hot sauces and toppings on a cake stand. (To me, hot sauce is one of the most important things on a table.) The napkin rings are an online find: bright paper flowers with twist ties to wrap around the denim napkins.

The party obviously starts with a margarita, but I like to take it a bit further and create a spicy-and-sweet fixings bar.

Yes, you are seeing a theme here. I love a self-serve station. And I have done enough of them to know that guests love it too. For my citrus margarita bar, I put out homemade margarita mix, then fill a silver (or tin) bucket with fresh fruit (berries, pineapple, watermelon) on ice for everyone to muddle into their drink. It's such a crowd pleaser. I've seen people skip the mix and just blend fresh fruit and tequila, or omit the tequila for a refreshing fruit drink. It just makes people happy.

My pork chile verde is so simple; I'm almost embarrassed to put it in the book. I buy pork butt or shoulder, put it in a slow cooker, and cover it with salsa verde to cook overnight. Done! The beans are another old ranch recipe. You have to have them with pretty much any Mexican meal, along with rice, but I will make them to eat on their own, topped with grated cheese and sour cream and scooped into chips. (Spicy and rich, they're worth making just to fill your kitchen with the scent of bacon.)

The Mexican chocolate cake is not your typical overly sweet dessert. It has a little heat and spice from the cayenne pepper, and the mascarpone frosting is light,

fluffy, and the perfect amount of sweet. Don't send anyone home with extra so you can have it the next day.

I set up the dessert table in another area. For large gatherings, these separate stations ensure that everyone is not congregating in one place and there's a better flow to the party. I set the cake out and surround it with store-bought cookies and pastries. It's nice to have something fresh too, like figs. I don't care so much about matching it all. The blue plates, green tablecloth, pink and yellow cookies—it's colorful and pops against terra-cotta, silver, and woven plates and bowls.

You can set this all up at the same time as your bar and buffet. This way, there is no set dessert time. I'd choose to eat chocolate cake before dinner anyway. ★

Opposite: I've been collecting Mexican ceramic dishes and woven bowls forever. I gather them on the buffet table to create an interesting, eclectic look.

DON'T MAKE IT ALL

My Mexican chocolate cake is something my friends crave, but I don't always make my own dessert. And if I do, I add other things to round it out (see page 212). That goes for most of my menus. I really believe you should give yourself a break and supplement homemade dishes with things you buy. If I'm having a big crowd, I stop in a *dulcería*, or Latin bakery, for some sweets to add to my buffet. It's unexpected, and everyone always loves to see lots of things on a table, especially dessert. The more colors and shapes the better. Don't be afraid to go a little loco—I always do.

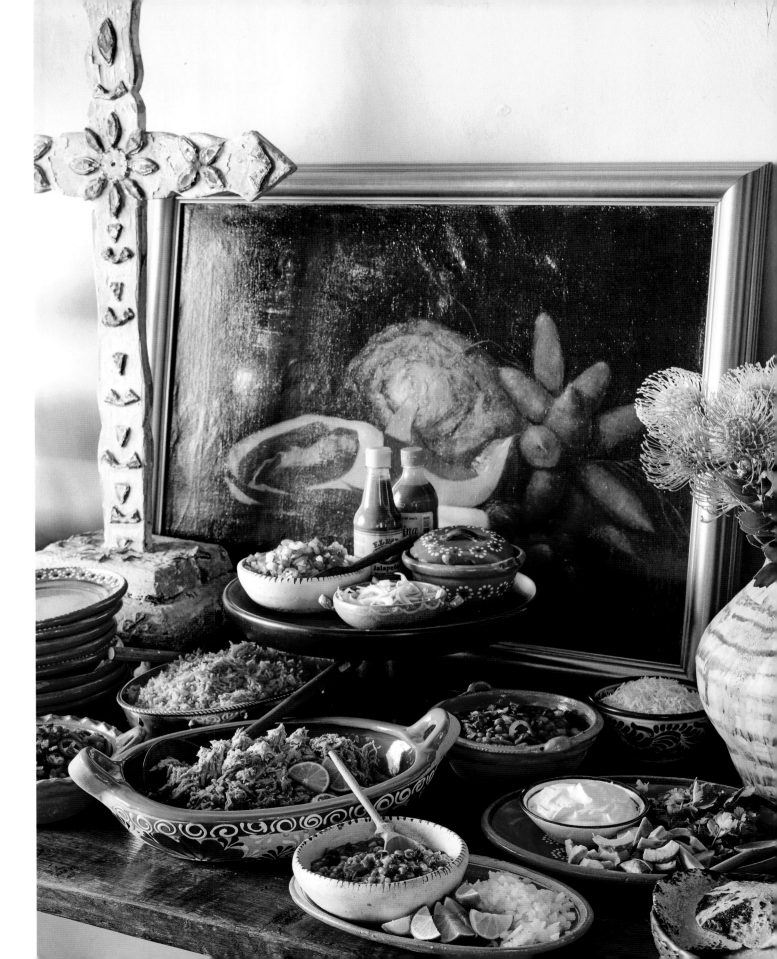

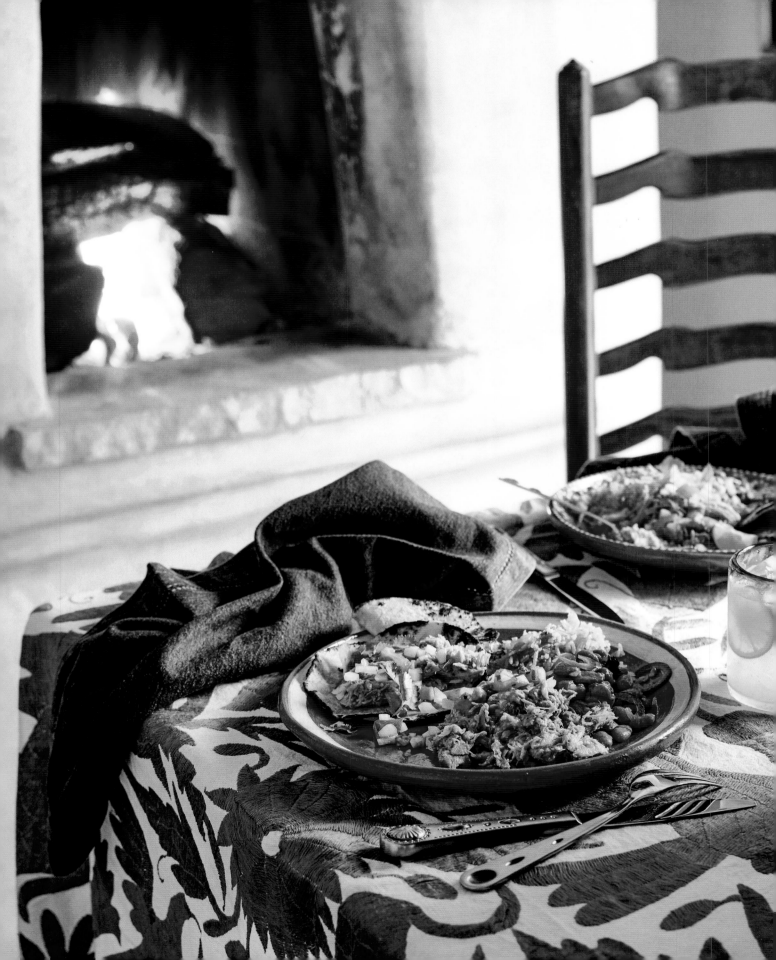

slow-cooker pork chile verde

SERVES 12

1 (3 TO 4-POUND/1.4 TO 1.8-KG) PORK SHOULDER

1 TEASPOON SALT

1 TEASPOON GROUND BLACK PEPPER

2 (16-OUNCE/455-G) JARS SALSA VERDE

CORN TORTILLAS, CRUMBLED COTIJA CHEESE,
CHOPPED WHITE ONION, FRESH CILANTRO, DICED AVOCADO,
SOUR CREAM, PICO DE GALLO (PAGE 167), FOR SERVING

Season pork all over with salt and pepper. In a large sauté pan, sear over medium heat on all sides. Place pork in a slow cooker and cover with salsa. Cook for 8 hours on low. Remove and let cool slightly. Shred and add some sauce back in to keep the pork moist.

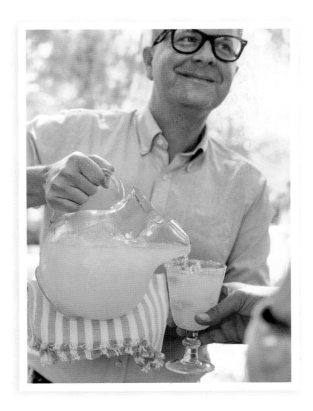

citrus margaritas

SERVES 6 TO 8

Like most Californians, I'm a margarita purist. I find premade mix, though easy, way too sweet and intense, and it doesn't actually taste like a margarita. And really, it's not much harder to make your own. Prepare a pitcher or two of this and you'll have plenty to serve and some extra to have after a particularly rough Monday.

1 CUP (240 ML) FRESH LIME JUICE

½ CUP (120 ML) FRESH LEMON JUICE

½ CUP (120 ML) FRESH ORANGE JUICE

5 TABLESPOONS (75 ML) AGAVE SYRUP

1 CUP (ABOUT 150 G) EACH CUBED
WATERMELON, PINEAPPLE, HONEYDEW MELON,
AND MIXED BERRIES

ICE

1 (750 ML) BOTTLE SILVER OR REPOSADO TEQUILA

1 (375 ML) BOTTLE COINTREAU

3 LIMES, CUT INTO WEDGES

In a large pitcher, combine lime juice, lemon juice, orange juice, 3 cups (720 ml) water, and agave and stir. Chill until ready to use.

Make your own margarita by muddling assorted fruit in the bottom of a glass. Add ice, 2 ounces (60 ml) tequila, 1 ounce (30 ml) Cointreau, and top with citrus mixer. Stir well and garnish with lime and more fruit if desired.

ranchero beans

SERVES 12

½ POUND (225 G) BACON, CHOPPED

1 MEDIUM WHITE ONION, CHOPPED

2 CLOVES GARLIC, MINCED

3 ROMA TOMATOES, CHOPPED

2 ANAHEIM CHILES, SEEDED AND CHOPPED

½ CUP (120 G) CRUSHED TOMATOES

½ CUP (120 ML) CHICKEN BROTH

4 (15-OUNCE/430-G) CANS PINTO BEANS, RINSED AND DRAINED

JUICE OF 1 LIME

1 TABLESPOON HOT PEPPER SAUCE

1 TEASPOON CHILI POWDER

1 TEASPOON SALT

½ TEASPOON GROUND BLACK PEPPER

In a large pot over medium-high heat, cook bacon for 10 minutes or until crispy. Remove with a slotted spoon and drain on paper towels. Sauté onion in bacon fat for 5 minutes, until beginning to soften. Add garlic and sauté for 2 minutes more. Add tomatoes, chiles, crushed tomatoes, and broth and bring to a boil. Reduce to a simmer and add beans, lime juice, hot pepper sauce, chili powder, salt, pepper, and reserved bacon. Simmer for 30 minutes or until thick and warmed through.

mexican rice

SERVES 12

Another dish that is best made a day before you are going to serve it. It will be that much better for it.

2 TABLESPOONS OLIVE OIL

1 CUP (110 G) CHOPPED WHITE ONION

2 CUPS (400 G) SHORT-GRAIN WHITE RICE

3 CLOVES GARLIC, MINCED

2 CUPS (480 ML) CHICKEN BROTH

1 CUP (240 G) CRUSHED TOMATOES

2 TEASPOONS SALT

1 TEASPOON GROUND CUMIN

1 TEASPOON CHILI POWDER

1 TEASPOON GROUND BLACK PEPPER

1 TEASPOON DRIED MEXICAN OREGANO

In a medium saucepan, heat olive oil over medium heat. Add onion and sauté for 5 minutes, until beginning to soften. Add rice and garlic and sauté for 5 minutes, until fragrant and toasted. Add chicken broth, tomatoes, salt, cumin, chili powder, pepper, and oregano and bring to a boil. Reduce to a simmer and cook, covered, for 25 to 30 minutes, until liquid is absorbed and rice is tender. Turn off heat and let sit for 10 minutes before fluffing with a fork.

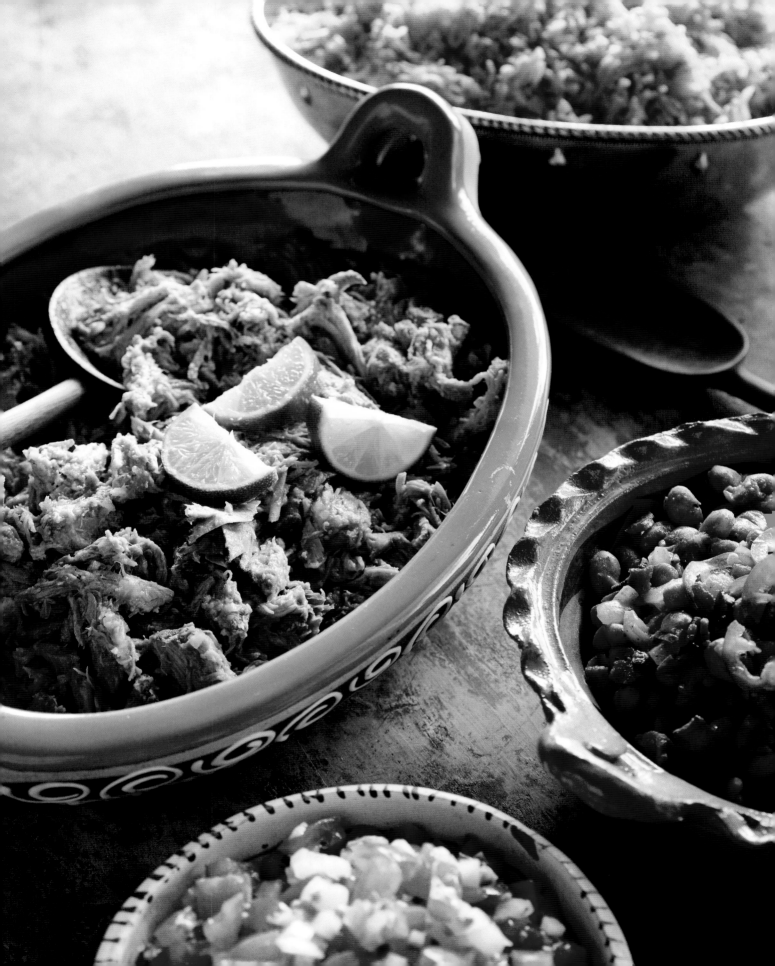

mexican chocolate cake

SERVES 10 TO 12

A note about the cayenne pepper: Please adjust it your taste, but don't omit it.
I promise it is not a heat that will burn your tongue; instead, it will
enhance the chocolate and the cake overall. It's really not the same without it.

for the cake:

2¾ CUPS (350 G) ALL-PURPOSE FLOUR

1 CUP (95 G) UNSWEETENED COCOA POWDER

1 CUP (200 G) GRANULATED SUGAR

1 CUP (220 G) LIGHT BROWN SUGAR

1 TABLESPOON INSTANT COFFEE

1 TABLESPOON GROUND CINNAMON

2 TEASPOONS BAKING SODA

1 TEASPOON CAYENNE PEPPER

½ TEASPOON SALT

2 LARGE EGGS, BEATEN

1¼ CUPS (300 ML) WHOLE MILK

1 CUP (240 ML) CANOLA OIL

1 CUP (240 ML) SOUR CREAM

2 TEASPOONS VANILLA EXTRACT

for the frosting:

2 CUPS (480 ML) HEAVY CREAM

1 (8-OUNCE/225-G) CONTAINER MASCARPONE, SOFTENED

1 CUP (125 G) CONFECTIONERS' SUGAR

1 TABLESPOON GROUND CINNAMON

2 TEASPOONS VANILLA EXTRACT

½ TEASPOON SALT

1 TABLET ABUELITA MEXICAN CHOCOLATE, CHOPPED

Preheat oven to 350°F (175°C). Line two 9-inch (23-cm) round cake pans with parchment paper and grease well.

In a large bowl, whisk together flour, cocoa powder, granulated and brown sugars, coffee, cinnamon, baking soda, cayenne pepper, and salt until combined. In a medium bowl, combine eggs, milk, oil, sour cream, and vanilla. Add wet ingredients to dry ingredients and mix until well combined. Divide the batter between prepared pans and bake for 30 to 35 minutes or until a toothpick inserted into the center comes out clean. Let cool for 15 minutes before removing from pans and cooling completely on a rack.

Beat cream until stiff peaks form and set aside. Cream together mascarpone, confectioners' sugar, cinnamon, vanilla, and salt until smooth. Fold whipped cream into mascarpone mixture until combined. Dollop half the frosting on bottom layer of cake and spread evenly. Top with remaining cake layer and spread with remaining frosting. Sprinkle with chopped chocolate.

CARPINTERIA

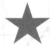

menu

CITRUS PUNCH

YOGURT HERB DIP AND CRUDITÉS

ASPARAGUS AND LEEK QUICHE

GREENS WITH GREEN BEANS

ROASTED CHICKEN SALAD

CRAB SALAD SANDWICHES

MINI CHOCOLATE
AND BANANA CREAM PIES

Carpinteria is a town fifteen miles southeast of
Santa Barbara with the same look and feel.
It's just as beautiful with a lush, Mediterranean
vibe and lovely, Spanish-style homes.

BUT IT'S SLIGHTLY SLEEPIER. I LOVE IT BECAUSE IT IS
such a friendly town and boasts some of the most beautiful
vistas and beaches anywhere. It's also home to one of my
favorite farms that doesn't grow food.

BOHO GARDEN BRUNCH

I first discovered Rose Story Farm when I needed flowers
for a Turkish-themed party I was throwing at my store.
When I arrived, I saw a fifteen-acre oasis where all they
cultivate is roses (more than 120 varieties). I thought, this
is bananas . . . and breathtaking.

In addition to the twenty-five thousand rose bushes,
there's an amazing nineteeth-century Victorian house,
gravel paths, and trellis-covered cottages around the
property. Whenever I take someone there, I say, "This is
the ultimate California dream."

Rose Story had a big impact on the style of this table.
I describe it as Boho Garden. It's super colorful and full of
pattern. I love a rustic vibe but always want a touch of
the exotic and glam. Guests will love this table because
it's cheerful with lots of fun details, like tassel fringe on
the napkins.

The best part is, you don't need to go anywhere to enjoy
it. Serve it up on your own patio, porch, barn, or garden.

For colors I go with dusty rose pinks (what else?)
with hits of turquoise and gold. I love to keep the plates
and linens really rustic and natural. Rattan chargers have
great texture and make a table seem special while reading
casual. A colored plate is so unexpected, and there are so
many great options out there. These seemed so California,
like you'd find them at a ceramist's studio.

I use a mix of colored glass goblets for punch and
some stemless globes for water. The blue cotton napkins
are fringed in hot pink—so festive and summery. When
creating a table like this, remember you don't have to use
a defined set of china or glasses or flatware. Break sets up;
mix the old with some new pieces. Think of it like a room:
It looks better when you have layered color and texture,
and both old and new pieces. I found a piece of linen fabric
with an old-fashioned border to use as a tablecloth.

Crackled pottery vases hold flowers down the center
of the table. Keep them low enough so people can see
across. And to save time, gather one variety or color for
each vase. No arranging needed.

There's no rule that says the buffet has to be next
to the table. I actually like it in another place to give a
party energy. And I love to give it a backdrop—which
can be bold wallpaper, a fence covered in flowers, or an
old painted wall like here. Just make sure the table is long

enough to fit the food and shallow enough so people don't have to bend over to reach what they want.

I set up a punch station on a nearby hutch so everyone can help themselves. Try surrounding the punch bowl with elements of the table (pink plates, a vase or two of flowers), and sprinkle rose petals around the punch bowl and glasses. It's so pretty and smells amazing—just like a rose farm.

The menu is made up of old and new recipes. It's like the lunches we would have at my grandparents' ranch. Chicken salad, lots of fresh veggies, and, of course, pie. The chicken salad was a family favorite. Instead of poaching the chicken, it's roasted with lemon and rosemary, left skin-on, and chopped into hearty chunks—a manly chicken salad. Quiche is a nostalgic dish for me. It's so eighties but still such a great thing for a crowd. Mine has asparagus because it's in such abundance here. These days, you can get it year-round everywhere. And eggs and asparagus are a yummy combo.

Crab salad was a favorite of my grandmother's. It's the ladylike version of chicken salad. I also love the crunch of the sweet peas in it. I serve it on fluffy, buttery croissants. (They're mini, so don't feel guilty.)

Either salad is great on its own, and I often make just one, but if you're feeding a crowd, it's nice to have both so everyone can choose—or, like me, have some of each! I add a salad because I always like something green on the table. First, it looks good. And the hit of acid from the dressing cuts through the richness of the crab. It's also an option for someone who doesn't eat meat or shellfish. (While having tons of salad and veggies has always been a California thing, *everyone* is eating healthier now.)

SoCal is citrus country, so it's a no-brainer to make a refreshing punch. I love how pretty this combo of orange, lemon, and grapefruit looks, and it's nice to offer a nonalcoholic beverage.

I had the idea for the pies when I couldn't decide which one to make, chocolate or banana cream. I thought, I'll do both but make them in these cute mini tins. After lunch, I arrange them down the center of the table and have at it. Communal baby pies! Trust me, this goes over really well. ★

PRETTY AS A PICTURE

People always ask me, "How did you make things on a table look good?" It's easier than you think, like with the crudités platter on the opposite page. I like it to look rustic, so I often leave the tops of radishes, carrots, and cherry tomatoes. Mixed juice glasses hold some of the veggies and give the area some height and texture. The small, footed bowl full of tomatoes adds a little polish. No matter what you are serving, remember to vary height, color, and texture, and you'll always end up with a lovely display.

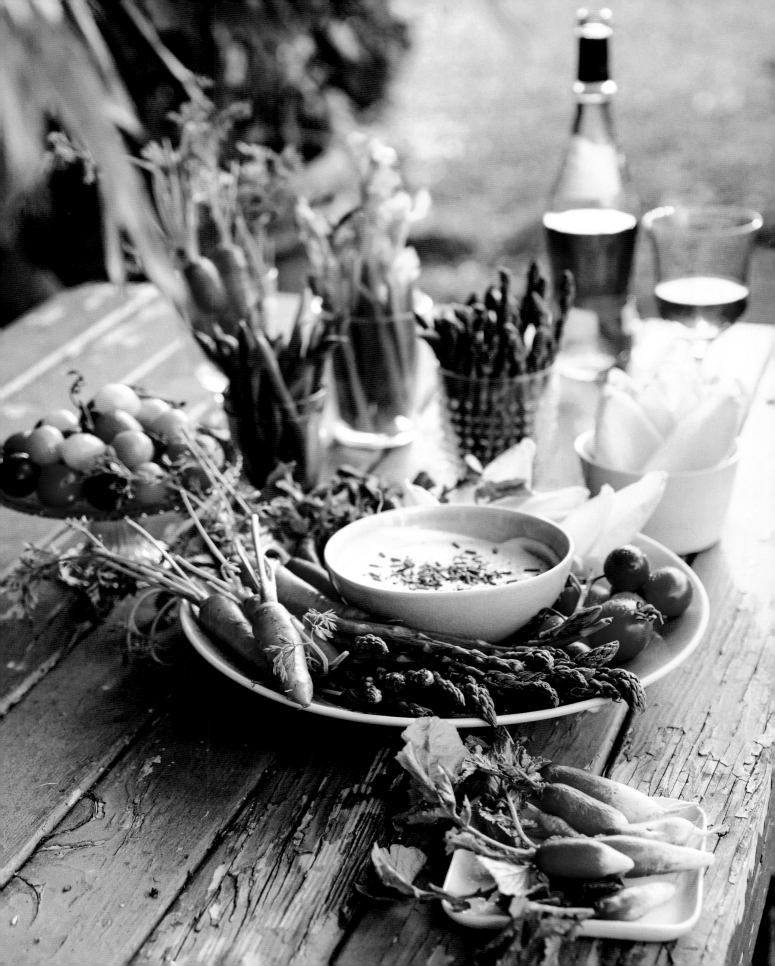

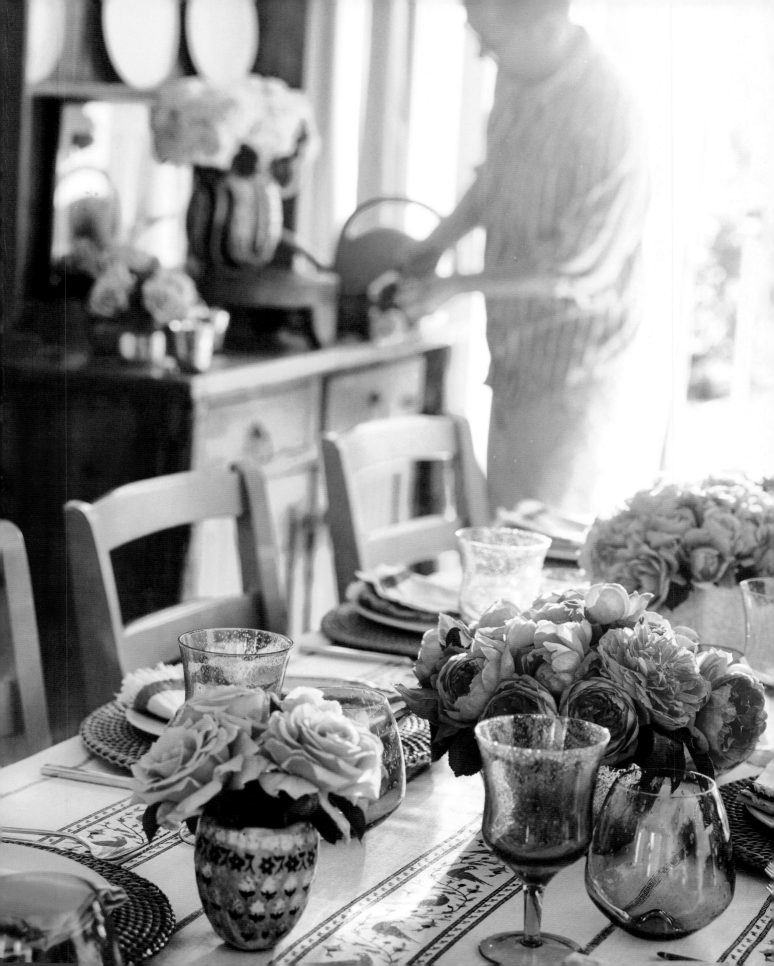

CREATE EFFORTLESS ARRANGEMENTS

FIRST THINGS FIRST
Arrangements don't have to mean flowers. I love and often use greens, grasses, herbs, fruits, vegetables, branches, leaves, and nuts.

WHEN IN DOUBT, GO SIMPLE
One flower, one arrangement. Or use several varieties of flowers in one color palette (e.g., blush pink to deep raspberry).

SOMETIMES, LESS IS MORE
A line of bud vases with small blooms arranged down a table has the same punch as a big arrangement. Economical too.

KEEP IT LOW
There's nothing more annoying than trying to talk to someone across the table behind a massive arrangement. Keep your table arrangements low so guests can chat and interact.

SPREAD IT OUT
If you love a high arrangement, place it somewhere other than the table, like in the entry or on the buffet. It makes the whole house feel festive and special.

TURN IT UP
There's a simple way to add major impact: Grab the brightest, lushest flowers you can find, gather by color, and group them all on a table. Total wow factor.

MAKE IT PART OF THE DECOR
Look for unexpected ways to bring flowers into a room. Try intertwining pretty ivy around a chandelier. Or use some longer greens like palms or flowers like bougainvillea on the mantel (it's not just for Christmas). I love the way it gives the space a beachy, tropical look.

VARY YOUR VESSELS
Any vessel is fair game for me. I will put flowers in anything, and I love to mix it up—simple juice glasses mixed with a pitcher or a shallow porcelain bowl. It's one more interesting element of your table and adds to the atmosphere you are trying to create.

CUT AND CHANGE
Flowers will last so much longer if you change the water daily. And remember to recut the stems when you bring them home before you arrange.

citrus punch

SERVES 12

This is a super refreshing, light drink to have at lunch. Don't wait until
a special occasion. This is something you will find in my refrigerator on any given
Wednesday. When I want to punch it up, pun intended, I add some vodka.

½ GALLON (2 L) FRESH-SQUEEZED ORANGE JUICE

½ GALLON (2 L) FRESH-SQUEEZED GRAPEFRUIT JUICE

2 CUPS (480 ML) FRESH-SQUEEZED LEMON JUICE

½ CUP (120 ML) LIGHT AGAVE SYRUP

1 LITER SPARKLING WATER OR SELTZER

2 LEMONS, THINLY SLICED

2 SMALL RED GRAPEFRUIT, THINLY SLICED

2 ORANGES OR TANGERINES, THINLY SLICED

ICE, FOR SERVING

Chill all ingredients well. In a large punch bowl, combine
orange juice, grapefruit juice, lemon juice, and agave and stir
well to dissolve the syrup. Top with sparkling water before
serving and stir gently. Garnish with lemons, grapefruit, and
oranges and serve over ice.

yogurt herb dip and crudités

SERVES 8

This is a lighter, nicer version of the typical cater-waiter dip.
Feel free to mix it up when arranging the crudités and dip (see Pretty
as a Picture on page 220). To me, it should look like a still life.

1 CLOVE GARLIC

¼ CUP (13 G) FRESH MINT LEAVES, PACKED

¼ CUP (13 G) FRESH FLAT-LEAF PARSLEY LEAVES, PACKED

1 GREEN ONION, CHOPPED

1 ANCHOVY

2 CUPS (480 ML) PLAIN GREEK YOGURT

1 TEASPOON LEMON JUICE

½ TEASPOON SALT, PLUS MORE FOR SALTED WATER

½ TEASPOON HOT PEPPER SAUCE

½ CUP (55 G) GREEN BEANS, TRIMMED

½ CUP (70 G) ASPARAGUS, WOODY ENDS TRIMMED

10 RADISHES WITH TOPS, CLEANED

10 BABY CARROTS WITH TOPS, CLEANED

14 CHERRY TOMATOES

1 HEART CELERY, INCLUDING LEAVES, CUT INTO STICKS

1 ENDIVE, LEAVES SEPARATED

In a food processor, combine garlic, mint, parsley, green
onion, and anchovy and pulse to chop. Add yogurt, lemon
juice, salt, and hot pepper sauce and puree until smooth.
Refrigerate for 1 hour before serving.

Prepare an ice bath in a large bowl and set aside. Fill a
large pot with salted water and bring to a boil. Blanch and
shock green beans and asparagus. Serve dip with chilled
vegetables on a large platter.

asparagus and leek quiche

SERVES 8 TO 10

Full disclosure: I have been known to buy rollout piecrust dough. It is a huge time-saver, and no one will know. And if you do buy one, this quiche can be made in minutes. Your secret is safe with me.

1 STORE-BOUGHT PIECRUST, AT ROOM TEMPERATURE

2 TABLESPOONS OLIVE OIL

2 LEEKS, CLEANED AND SLICED

2 CUPS (270 G) ASPARAGUS, CUT INTO 1-INCH (2.5-CM) PIECES

2 CUPS (480 ML) HALF-AND-HALF

4 LARGE EGGS, BEATEN

1 TABLESPOON FRESHLY GRATED LEMON ZEST

1 TEASPOON SALT

½ TEASPOON GROUND BLACK PEPPER

1½ CUPS (160 G) SHREDDED GRUYÈRE

Preheat oven to 350°F (175°C).

Unroll piecrust to fit in a 9-inch (23-cm) round tart pan with a removable bottom. Press the crust into the sides. Line with parchment and pie weights and bake for 12 minutes. Let cool completely and remove parchment and weights.

In a large sauté pan, heat olive oil. Sauté leeks for 5 minutes over medium-high heat, until they begin to soften. Add asparagus and sauté for 5 minutes more. Set aside.

In a large bowl, whisk together half-and-half, eggs, zest, salt, and pepper.

To assemble the quiche, layer the bottom of the cooled crust with 1 cup (110 g) of the cheese and then the vegetable mixture. Pour the cream mixture over the vegetables and sprinkle with remaining cheese.

Bake for 30 minutes or until set in the center. Let cool and serve warm or at room temperature.

greens with green beans

SERVES 8

To me, this is as good as a side salad gets. I serve it with countless meals because it feels just a little more dressed up than your classic lettuce, tomato, and cucumber variety.

½ POUND (225 G) GREEN BEANS, ENDS TRIMMED

¼ CUP (60 ML) OLIVE OIL

3 TABLESPOONS LEMON JUICE

½ TEASPOON SALT

½ TEASPOON GROUND BLACK PEPPER

1 LARGE HEAD GREEN-LEAF LETTUCE, WASHED AND TORN INTO BITE-SIZE PIECES

½ CUP (25 G) CHOPPED FRESH FLAT-LEAF PARSLEY

Bring a large pot of water to a boil over high heat. Blanch green beans for 1 minute or until bright green. Drain and rinse under cold water to stop the cooking. Cut into 1-inch (2.5 cm) pieces.

In a small bowl, combine olive oil, lemon juice, salt, and pepper and whisk well. Set aside.

In a large bowl, combine lettuce, parsley, and green beans. Just before serving, add dressing and toss to coat.

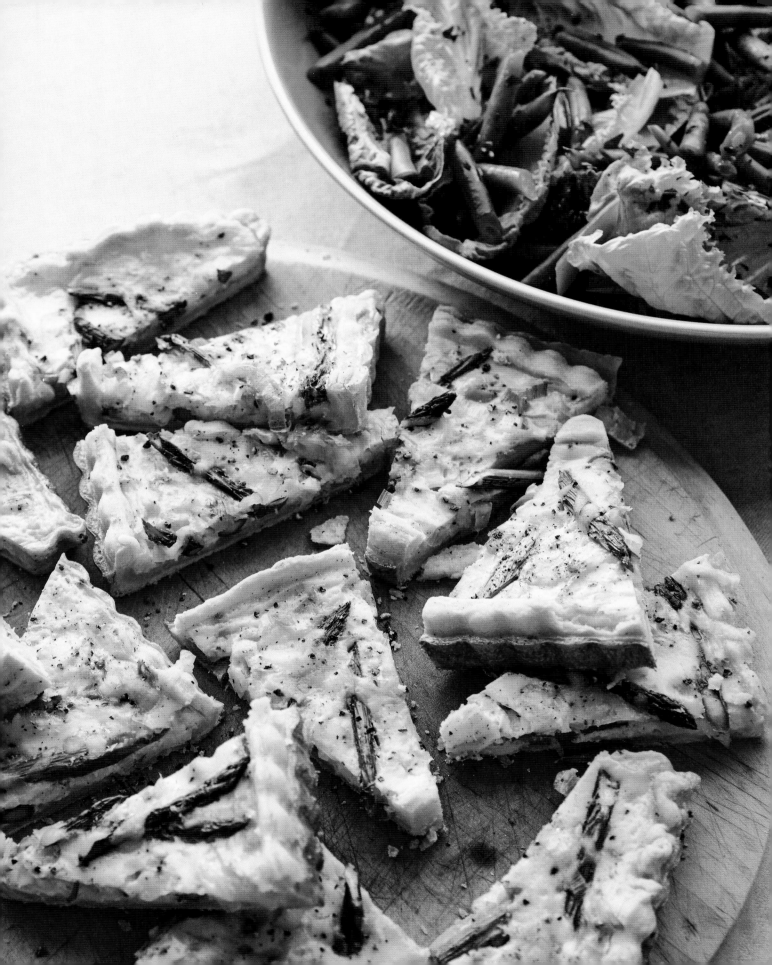

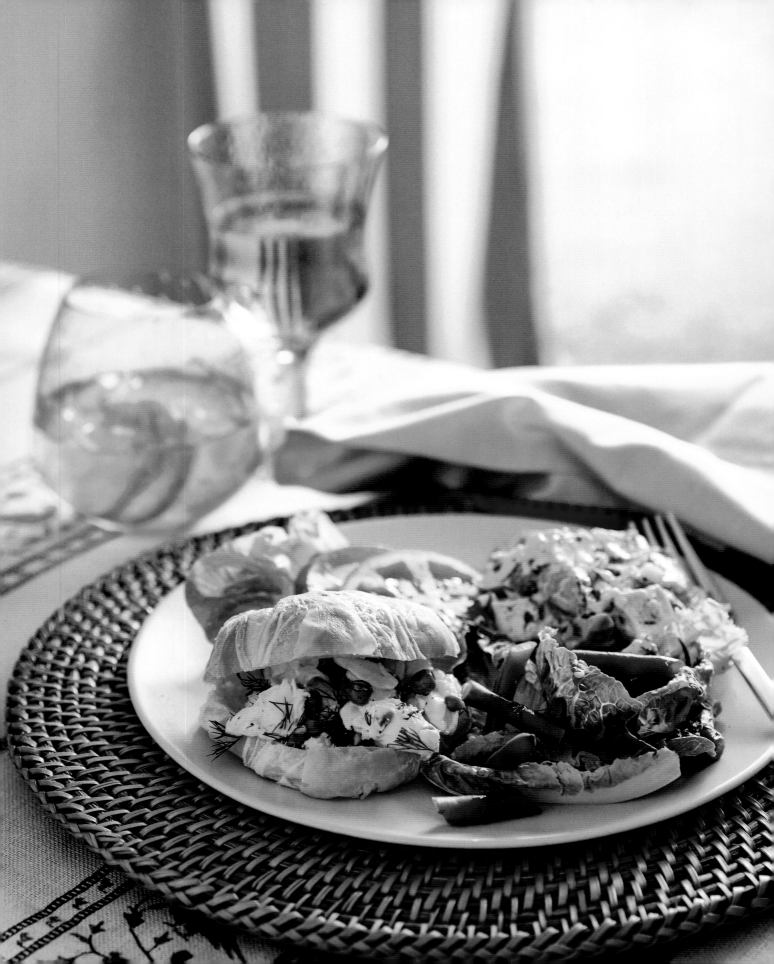

roasted chicken salad

SERVES 8

When I have time, I roast a chicken for this.
When I don't, I buy the best roast chicken I can find.

1 ROTISSERIE CHICKEN

½ CUP (50 G) DICED CELERY

¼ CUP (35 G) DICED RED ONION

¼ CUP (13 G) CHOPPED FRESH FLAT-LEAF PARSLEY

½ CUP (120 ML) MAYONNAISE

1 TABLESPOON DIJON MUSTARD

1 TABLESPOON LEMON JUICE

1 TEASPOON SALT

1 TEASPOON GROUND BLACK PEPPER

1 TEASPOON CELERY SALT

1 HEAD BUTTER LETTUCE, LEAVES SEPARATED

2 MEDIUM TOMATOES, SLICED

2 AVOCADOS, SLICED

Leaving the skin on the chicken, dice white and dark meat; discard bones. Add to a large bowl and combine with celery, onion, and parsley. In a medium bowl, whisk together mayonnaise, mustard, lemon juice, salt, pepper, and celery salt. Add to chicken mixture and stir until coated. Serve on a platter with lettuce, tomato, and avocado.

crab salad sandwiches

SERVES 8

If you want to go a bit lighter, nix the croissants and serve a scoop of this on salad greens like the Greens with Green Beans (page 226).

2 (8-OUNCE/225-G) CANS LUMP CRABMEAT, DRAINED

1 CUP (135 G) FROZEN PEAS, DEFROSTED

½ CUP (120 ML) MAYONNAISE

2 TABLESPOONS CHOPPED FRESH DILL

1 TABLESPOON LEMON JUICE

1 TABLESPOON HOT PEPPER SAUCE

1 TEASPOON SALT

1 TEASPOON GROUND BLACK PEPPER

8 MINI CROISSANTS

In a large bowl, combine crab, peas, mayonnaise, dill, lemon juice, hot pepper sauce, salt, and pepper and gently stir together. Slice croissants in half lengthwise and serve alongside crab salad so guests can make their own sandwiches.

mini chocolate cream pies

SERVES 10

This and the banana cream pie (opposite) are my great-grandmother's original recipes. I did not change or add anything because they are perfect. I hope you agree.

for the crust:

2½ CUPS (295 G) GRAHAM CRACKER CRUMBS

¼ CUP (55 G) LIGHT BROWN SUGAR

1 TEASPOON SALT

¼ CUP (55 G) UNSALTED BUTTER, MELTED

for the filling:

3 LARGE EGG YOLKS

½ CUP (100 G) GRANULATED SUGAR

¼ CUP (30 G) CORNSTARCH

½ TEASPOON SALT

2 CUPS (480 ML) HEAVY CREAM, DIVIDED

1½ CUPS (360 ML) WHOLE MILK

4 OUNCES (115 G) BITTERSWEET CHOCOLATE, CHOPPED, PLUS MORE FOR GARNISH

½ TEASPOON VANILLA EXTRACT

2 TABLESPOONS UNSALTED BUTTER

2 TABLESPOONS CONFECTIONERS' SUGAR

Preheat oven to 350°F (175°C).

In a large bowl, combine graham cracker crumbs, brown sugar, and salt and stir well. Add melted butter and stir until combined. Divide mixture equally among ten 5-inch (12-cm) mini pie tins and press into an even layer all the way up the sides. Bake for 10 to 12 minutes or until golden and fragrant. Let cool.

In a medium bowl, whisk together yolks, granulated sugar, cornstarch, and salt. In a medium saucepan, heat 1 cup (240 ml) of the cream and the milk over medium heat until warm. Whisking constantly, slowly drizzle hot cream mixture into egg mixture to temper the eggs. Return to saucepan and add chocolate. Heat over medium-low heat, stirring constantly, until chocolate melts and mixture begins to thicken enough to coat the back of a spoon. Remove from heat and stir in vanilla and butter. Transfer to a bowl and cover with plastic wrap, gently pressing the plastic against the surface of the custard to prevent a skin from forming. Let cool completely.

In the bowl of a stand mixer, whip remaining cream and confectioners' sugar until stiff peaks form. Gently fold ½ cup (120 ml) whipped cream into cooled custard.

To assemble pies, fill cooled crusts with custard and smooth the tops. Dollop with whipped cream and garnish with grated chocolate. Refrigerate for at least 1 hour before serving.

mini banana cream pies

SERVES 10

for the crust:

2½ CUPS (295 G) GRAHAM CRACKER CRUMBS

¼ CUP (55 G) LIGHT BROWN SUGAR

1 TEASPOON SALT

¼ CUP (55 G) UNSALTED BUTTER, MELTED

for the filling:

3 LARGE EGG YOLKS

½ CUP (100 G) GRANULATED SUGAR

¼ CUP (30 G) CORNSTARCH

½ TEASPOON SALT

2 CUPS (480 ML) HEAVY CREAM, DIVIDED

1½ CUPS (360 ML) WHOLE MILK

1 TEASPOON VANILLA EXTRACT

2 TABLESPOONS UNSALTED BUTTER

2 TABLESPOONS CONFECTIONERS' SUGAR

10 TABLESPOONS (150 ML) DULCE DE LECHE OR CARAMEL SAUCE

4 RIPE BANANAS, CUT INTO ¼-INCH- (6-MM-) THICK SLICES

Preheat oven to 350°F (175°C).

In a large bowl, combine graham cracker crumbs, brown sugar, and salt and stir well. Add melted butter and stir until combined. Divide mixture equally among ten 5-inch (12-cm) mini pie tins and press into an even layer all the way up the sides. Bake for 10 to 12 minutes or until golden and fragrant. Let cool.

In a medium bowl, whisk together yolks, granulated sugar, cornstarch, and salt. In a medium saucepan, heat 1 cup (240 ml) of the cream and the milk over medium heat until warm. Whisking constantly, slowly drizzle hot cream mixture into egg mixture to temper the eggs. Return to saucepan and heat over medium-low heat, stirring constantly, until mixture begins to thicken enough to coat the back of a spoon. Remove from heat and stir in vanilla and butter. Transfer to a bowl and cover with plastic wrap, gently pressing the plastic against the surface of the custard to prevent a skin from forming. Let cool completely.

In the bowl of a stand mixer, whip remaining cream and confectioners' sugar until stiff peaks form. Gently fold ½ cup (120 ml) whipped cream into cooled custard.

To assemble pies, layer each cooled crust with 1 tablespoon dulce de leche and a few slices of banana. Fill with custard and smooth the tops. Dollop with whipped cream and top with a few more slices of banana. Refrigerate for at least 1 hour before serving.

THINGS I LOVE 🩶 SOUTHERN CALIFORNIA

1 **MALIBU FARM** "BURGER AND A COCKTAIL ON THE PIER."

2 **RANCH AT THE PIER** "ONE-STOP SHOPPING FOR THE BEACH EXPERIENCE AT THE END OF THE MALIBU PIER."

3 **THYME IN THE RANCH** "SOME OF THE BEST CAKE I HAVE EVER HAD."

4 **ROSE STORY FARM** "FIFTEEN ACRES OF GARDEN ROSES . . . ENOUGH SAID. (AND YOU CAN RENT A GUEST HOUSE AND STAY TOO!)"

5 **OJAI TORTILLA HOUSE** "THEIR SPECIALTY TACO IS WORTH THE HOUR-AND-A-HALF DRIVE FROM LA."

6 **ONE GUN RANCH** "TRULY SPECIAL."

7 **LA SUPER-RICA TAQUERIA** "MY FAVORITE BURRITO IN SOCAL . . . JULIA CHILD AGREED!"

8 **CATALINA'S MARKET** "MY FAVORITE LATIN SUPER-MARKET AND BUTCHER . . . DULCE DE LECHE, GUATEMALAN CHOCOLATE, AND READY-TO-COOK MILANESE!"

9 **CHINO FARM** "SMALL BUT INCREDIBLE FARM STAND THAT PROVIDES SPAGO AND CHEZ PANISSE WITH THEIR SPECIALTY PRODUCE . . . I LOVE THEIR FRENCH MELONS AND WHITE CORN!"

10 **THE STAND** "OG HIPPIE FOOD; I LIVED OFF THEIR HUMMUS BOWLS WHEN I WAS YOUNG."

11 **THE IVY & INDIGO SEAS** "THE ICONIC IVY IS ONE OF MY FAVE SPOTS IN LA FOR LUNCH. I NEVER GO WITHOUT A VISIT TO OWNER LYNN VON KERSTING'S SHOP, INDIGO SEAS, RIGHT NEXT DOOR."

12 **HOLLYWOOD BOWL** "MY FAVE SPOT TO CATCH A CONCERT OUTDOORS, AND YOU BRING YOUR OWN DINNER!"

13 **DU VIN WINE & SPIRITS** "MY GO-TO FOR WINE. THEIR STAFF KNOWS IT ALL."

14 **CAPE SEAFOOD & PROVISIONS** "ALL MY SEAFOOD DISHES START HERE!"

15 **KIP'S TOYLAND** "OPEN SINCE 1945, THIS IS *THE* PLACE FOR THE NEWEST FAD OR CLASSIC STANDBYS."

16 **GRAND CENTRAL MARKET** "WITH NEARLY FORTY FOOD VENDORS, IT'S MY FAVORITE PLACE TO OVEREAT!"

TRAVEL GUIDE

northern california

CHEZ PANISSE
1517 Shattuck Avenue, Berkeley

FERRY BUILDING MARKETPLACE
One Ferry Building, San Francisco

HEATH CERAMICS
400 Gate Five Road, Sausalito

HOG ISLAND OYSTER CO.
20215 Shoreline Highway, Marshall

JOHN MUIR NATIONAL HISTORIC SITE
4202 Alhambra Avenue, Martinez

LARKMEAD VINEYARDS
1100 Larkmead Lane, Calistoga

LUCCA RAVIOLI CO.
1100 Valencia Street, San Francisco

MARCH
3075 Sacramento Street, San Francisco

NICK'S COVE
23240 Highway 1, Marshall

PETALUMA SEED BANK
199 Petaluma Boulevard North, Petaluma

R&G LOUNGE
631 Kearny Street, San Francisco

SHED
25 North Street, Healdsburg

SPENGER'S FRESH FISH GROTTO
1919 Fourth Street, Berkeley

TADICH GRILL
240 California Street, San Francisco

YANK SING
101 Spear Street, San Francisco

ZUNI CAFÉ
1658 Market Street, San Francisco

central california

EL TORO BRAVO
123 Monterey Avenue, Capitola

GROVER HOT SPRINGS
3415 Hot Springs Road, Markleeville

HEARST CASTLE
750 Hearst Castle Road, San Simeon

KIT CARSON LODGE
32161 Kit Carson Road, Kit Carson

**THE MAJESTIC YOSEMITE
(FORMERLY AHWAHNEE HOTEL)**
1 Ahwahnee Drive, Yosemite National Park

NATIONAL HOTEL
2 Water Street, Jackson

NEPENTHE RESTAURANT
48510 Highway 1, Big Sur

PEZZINI FARMS
460 Nashua Road, Castroville

POOR RED'S BAR-B-Q
6221 Pleasant Valley Road, El Dorado

POST RANCH INN
47900 Highway 1, Big Sur

RED'S DONUTS
433 Alvarado Street, Monterey

**SAN SIMEON'S
PIEDRAS BLANCAS ROOKERY**
San Simeon

SEQUOIA HIGH SIERRA CAMP
65745 Big Meadow Road, Giant Sequoia
National Monument

SORENSEN'S RESORT
14255 Highway 88, Hope Valley

SUNBUGGY
328 Pier Avenue, Oceano

southern california

CAPE SEAFOOD & PROVISIONS
801 North Fairfax Avenue, Los Angeles

CATALINA'S MARKET
1070 North Western Avenue, Los Angeles

CHINO FARM
6123 Calzada Del Bosque, Rancho Santa Fe

DU VIN WINE & SPIRITS
540 North San Vicente Boulevard,
West Hollywood

GRAND CENTRAL MARKET
317 South Broadway, Los Angeles

HOLLYWOOD BOWL
2301 North Highland Avenue, Los Angeles

THE IVY / INDIGO SEAS
113/123 North Robertson Boulevard, Los Angeles

KIP'S TOYLAND
(in the Farmers' Market at The Grove)
6333 West 3rd Street, Los Angeles

LA SUPER-RICA TAQUERIA
622 North Milpas Street, Santa Barbara

MALIBU FARM / RANCH AT THE PIER
23000 Pacific Coast Hwy, Malibu

OJAI TORTILLA HOUSE
104 North Signal Street, Ojai

ONE GUN RANCH
22634 Mansie Road, Malibu

ROSE STORY FARM
5950 Casitas Pass Road, Carpinteria

THE STAND
238 Thalia Street, Laguna Beach

THYME IN THE RANCH
16905 Avenida de Acacias, Ranch Santa Fe

ACKNOWLEDGMENTS

TO SAY THAT PUTTING THIS BOOK TOGETHER WAS A group effort is a massive understatement . . . there were so many people involved and so many moving parts, but through it all I never lost sight of my love of cooking, entertaining, and my home state of California!

Thank you from the bottom of my heart to all the individuals who helped me realize this book . . . I'm in awe of your talent.

I wouldn't be writing this acknowledgments page if it weren't for the best publisher a guy could ask for . . . Abrams! Especially my editor and friend, Rebecca Kaplan. A special thanks to Jennifer Brunn and Holly Dolce as well.

My creative dream team . . . photographer extraordinaire Victoria Pearson, John Nakano, Joni Noe, Tamara Rosenblum, Sarah Gifford, Ray Kachatorian, Carrie Purcell, Michelle Reiner, Carla Schuessler, Veronica Leon, and Kerstin Czarra. Kerstin, thank you for keeping me so organized and sane . . . and for helping me get the book in my head on the page! Mai Le, you are the rock of this operation. And my team at ICM—Kari Stuart, Kristyn Keene, Rori Platt, and Carol Goll.

I was fortunate to shoot in soooo many exceptional locations and would like to thank all who allowed me into your homes and businesses. Dan O'Brien and everyone at Larkmead Winery, the Meehans, the Harrises, Danielle Hahn and everyone at Rose Story Farm, Wendy Walker, Alice Bamford, Anne Eysenring and the One Gun Ranch gang, the Patas, Lauren Graham, Eric Stonestreet, Hog Island Oysters, Nick's Cove, Serena Dugan, the Jiaravanons.

Sending a big shout-out to Melissa's Produce. Especially Aunty Sharon and Joe Hernandez for all the exceptional California produce and for always being incredibly supportive. Debra Kanabis, William Li, and Ralph Lauren Home for adding to the beauty on these pages. Range Rover, Serena and Lily, Williams Sonoma, and Casa Migos . . . thank you all for contributing.

My OG bestie since sixth grade, Jamie Frame, for being my partner in crime . . . in and out of the kitchen.

My mother for teaching me that there is no better way to show your love than at your table.

My family and friends for always letting me cook in your kitchens and test my recipes on you. My girls Minnie Mortimer, Tessa Benson, Zoe de Givenchy, and Stephanie Turner for always being game for a photo shoot!

And Eric . . . my biggest champion. Your unwavering support made this possible. Thank you for being my ultimate recipe tester . . . we can go on a diet now! ★

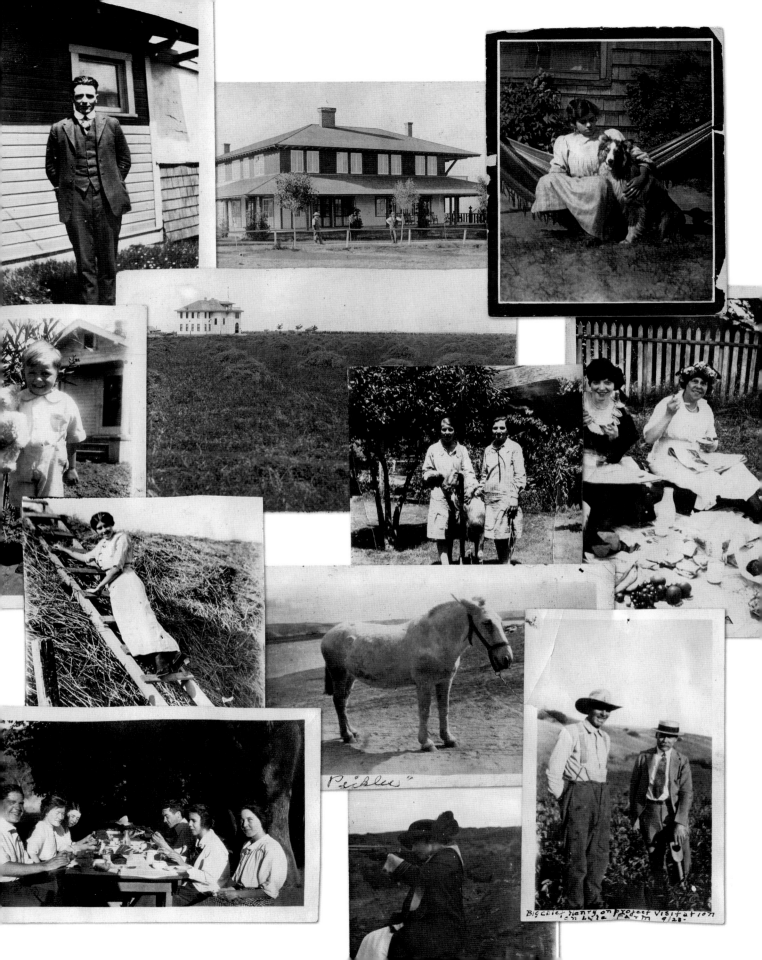

"Peebles"

Big Chief Henry on Project Visitation
Chilula Farm 9/23

EDITOR rebecca kaplan

DESIGNER sarah gifford

PRODUCTION MANAGER rebecca westall

PHOTO RESEARCH tamara rosenblum

FOOD STYLIST carrie purcell

Library of Congress Control Number: 2017944953

ISBN: 978-1-4197-2899-0
eISBN: 978-1-68335-229-7

Text copyright © 2018 Nathan Turner
Photographs copyright © 2018 Victoria Pearson unless otherwise noted

Cover © 2018 Abrams
Photograph by Victoria Pearson

Published in 2018 by Abrams, an imprint of ABRAMS. All rights reserved. No portion of this book may be reproduced, stored in a retrieval system, or transmitted in any form or by any means, mechanical, electronic, photocopying, recording, or otherwise, without written permission from the publisher.

Printed and bound in the United States
10 9 8 7 6 5 4 3 2 1

Abrams books are available at special discounts when purchased in quantity for premiums and promotions as well as fundraising or educational use. Special editions can also be created to specification. For details, contact specialsales@abramsbooks.com or the address below.

ABRAMS The Art of Books
195 Broadway, New York, NY 10007
abramsbooks.com

PHOTO CREDITS

Pages 6 (*I Love You California*), 70, 235 (LA farmers' market and Hollywood Bowl): Courtesy of the California History Room, California State Library, Sacramento, California. Pages 10, 15 (pink Victorian house), 20, 73 (oak woodlands near Mount Diablo); 147 (Grover Hot Springs): Frank S. Balthis. Page 15: (Chinatown) Rebeca Anchondo; (Japanese Tea Garden) Photo by Andrea Niederer, www.igardendaily.com, @a_igardendaily; (cable car) Gary Crabbe/Enlightened Images; enlightphoto.com. Pages 15 (redwoods), 136: Esther JuLee, localadventurer.com. Pages 15 (Point Reyes Lighthouse), 140 (Big Sur coast - clear day, Big Sur flowers, Big Sur beach, Big sur coast - foggy day, Big Sur architecture): Emma K. Morris/EmmaKMorris.com. Page 68: Courtesy of the National Park Service. Pages 73 (Martinez Marina), 86, 90–91 (Rio Grande train and mountain landscape), 122, 126 (Castroville sign, artichoke farm, and Pezzini Farms sign), 139, 140 (tailgate and tailgate with Nathan), 141, 153 (poppy field), 163 (photo collage and wall of dog portraits), 177 (cacti): Eric Hughes. Pages 84–85: (Hog Island Oyster Co.) Victoria Pearson; (Spenger's Fresh Fish Grotto) Robby Virus; (Heath Ceramics) Aya Brackett Photography; (Ferry Building Marketplace) Aaron Kohr; (Chez Panisse) Patricia Curtan; (Lucca Ravioli) Courtesy of Lucca Ravioli; (Nick's Cove) Mike Norquist; (Zuni Café) Courtesy of Zuni Café. Image by Eric Wolfinger; (Petaluma Seed Bank) Baker Creek Heirloom Seeds/RareSeeds.com; (Yak Sing) Kingmond Young Photography; (Tadich Grill) Courtesy of the Tadich Grill, San Francisco; (March) Michael Graydon. Pages 146–147: (Sorensen's Resort) Courtesy of Sorensen's Resort; (The Majestic Yosemite) Courtesy of Yosemite Hospitality; (Hearst Castle) Photograph by Victoria Garagliano/©Hearst Castle®/CA State Parks; (Post Ranch Inn - tree house exterior) Kodiak Greenwood; (SunBuggy) Courtesy of SunBuggy Fun Rentals, photograph by Eric Bowen; (National Hotel, Jackson) Courtesy of the National Hotel; (San Simeon seal) Phil Adams, Friends of the Elephant Seal; (Nepenthe Restaurant) © 2014, Tom Birmingham; (Sequoia Sigh Sierra Camp) Courtesy of Sequoia High Sierra Camp; (Poor Red's Bar-B-Q) Courtesy of Poor Red's Bar-B-Q. Page 148: Rubber Face Media. Page 150: Illustration by Chandler O'Leary. Pages 152–153: (Mission San Juan Capistrano) Courtesy of Mission San Juan Capistrano; (Laguna Beach lifeguard tower) Courtesy Travelblanc.com/image by Curtis C. Smith; (surfers - Newport Beach) Brian Bott @ fakelegphotography. Pages 234–235: (The Vegetable Shop) Wendy Walker; (Malibu Farm) Martin Löf; (Catalina's) Courtesy of Catalina's Market; (Thyme in the Ranch) Emily Taplin Photography; (Cape Seafood and Provisions) Courtesy of Cape Seafood and Provisions; (Grand Central Market) Courtesy of Grand Central Market; (The Ivy & Indigo Seas) Richard Irving; (Ojai Tortilla House) Nathan Turner; (The Stand) Courtesy of The Stand; (Ranch at the Pier) Courtesy of The Ranch at the Pier.